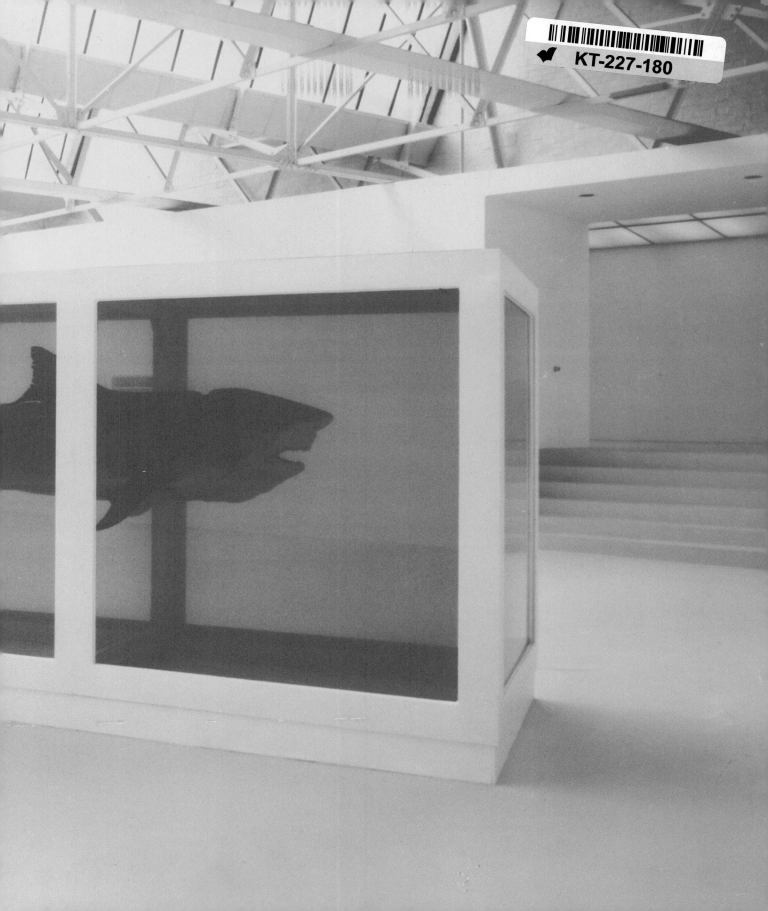

SHARK INFESTED WATERS

SHARK INFESTED WATERS
THE SAATCHI COLLECTION OF BRITISH ART IN THE 90s

TEXT BY SARAH KENT

ZWEMMER

I would like to thank Jenny Blyth at the Saatchi Gallery for her encouragement and warm support; Ariane Bankes at Philip Wilson for her enthusiastic response and subtle editing; Anthony Kingsley, my Alexander teacher, for releasing tense muscles, and my friends and relatives who have not forgotten me, despite my seven months' retreat.

Sarah Kent

Compiled by Jenny Blyth, Curator

Designed and typeset by Christopher Matthews and Ian Muggeridge

Cover photograph by Anthony Oliver of Damien Hirst's
The Physical Impossibility of Death in the Mind of Someone Living

Inside front cover: Young British Artists I; photograph by Anthony Oliver

Inside back cover: Young British Artists III; photograph by Anthony Oliver

Text and introduction © Sarah Kent 1994

First published in 1994 by Zwemmer an imprint of Philip Wilson Publishers Limited

26 Litchfield Street London WC2H 9NJ

ISBN 0 302 00648 6

LC 94-067104

Printed and bound by Snoeck-Ducaju & Zoon, NV, Ghent, Belgium

CONTENTS

INTRODUCTION

Art today makes approaches toward the unknowable...artists reflect something both psychological and social off that gaze, something that may hint at the face the future will present. In this activity artist and critic are linked in an intimate collaboration. The artist makes unverifiable hypotheses or intuitive proposals about the unknown, and the critic drives out into the verbal open their networks of implications. Thomas McEvilley [1]

1 Thomas McEvilley, 'Father the Void' in *Tyne International: a new necessity*, Tyne International, 1990, p.133

The name of this book is derived from Damien Hirst's extraordinary sculpture *The Physical Impossibility of Death in the Mind of Someone Living*, 1992 (p.152), a fourteen-foot tiger shark suspended in a tank of formaldehyde. It is appropriate that Hirst should introduce this anthology, since he was responsible for making visible many of the artists included in these pages and, in many people's minds, has come to epitomize the wild boy whose shock tactics and cool media manner give art a high profile and a bad name. His presence emphatically colours the water.

In 1988 while still a student at Goldsmiths', Hirst organized 'Freeze', an exhibition that included sixteen of his fellow students. This marked the beginning of a vital period of optimism and enthusiasm. The recession provided a plentiful supply of empty factories, warehouses and offices and young artists seized the initiative, raised funds and mounted further shows such as 'Modern Medicine' and 'Gambler' in these dramatic spaces.

Charles Saatchi had been collecting their work and bought Hirst's first major piece, *A Thousand Years*, with its rotting cow's head and flies. Support of this kind is of incalculable value; it sustains energy and optimism. Whereas struggling in a vacuum is soul-destroying, the prospect of having one's work enter a major collection provides both a goal and a context; it generates hope. Damien Hirst's shark swam into view in the first show of Young British Artists mounted at the Saatchi Gallery in 1992 and attracted unprecedented media attention.

At first sight there seem to be few links between the 35 artists represented in this book. What possible preoccupations could be shared by a minimalist painter and a pickler of sharks? In writing about them, I was determined not to impose artificial groupings. Despite their work being lumped together under the rubric of 'conceptualism', often by those hostile to it, these artists do not form a group or a school. Many of them studied at Goldsmiths' and some are friends, but others have never met nor even heard of one another. Kerry Stewart graduated only recently, Jenny Saville lives in Scotland, Carina Weidle has returned to Brazil and, although most of the others live in London, it is a big city. There is no café society or artists' meeting place and these people do not form a cosy coterie.

I chose to write about each person individually, a decision that was the beginning of a fascinating process of interaction and discovery. Each essay is based on

a studio visit to look at and discuss the work. As a former artist, my interest lies in the creative process – in the ideas, aspirations and attitudes that inform the work and the way that these are manifested in the end product. As a critic and writer, I see it as my role to elucidate this process and to unpick my own responses, so that others can engage both with the objects and the ideas that inform them.

Nothing exists in a vacuum; work always comes about in response to personal issues or public debates. Two questions that continually engage me are what motivates an artist to make an object; and how do personal thoughts, feelings and recollections mesh with collective concerns and get transcribed into statements that have resonance for others? The process is mysterious, but it is not magical; it involves a great deal of effort and the perennial possibility of failure.

Hadrian Piggott elucidates the activity, when he writes about his work: 'There is a strong element of autobiography, the details of which should remain more or less private…a viewer might guess at the experience of the artist (there is an element of standing up naked in front of the crowd), but I believe that the artist can choose how much to reveal – there is a degree of stagework or performance even in the production of static objects. A large part of what I do prior to, during, and after making a piece is bring in as many outside referents as possible – constructing a 3D network of ideas around the object that holds it up to scrutiny from as many viewpoints as possible, and detaches it from the purely personal.' [2]

2 Hadrian Piggott in a letter to the author, September 1994

Given the intelligence and complexity of such an approach, it seems more appropriate for a writer to elucidate ideas than to confer brownie points. Recently I have become increasingly reluctant to award medals and throw brickbats; passing judgement does not seem either a relevent or an adequate response. The New York critic Thomas McEvilley confirms these feelings. 'The living critic comes to realize', he writes, 'that the least interesting thing he or she has to offer is a value judgement – that such dicta are finally about as relevant to the rest of the world as if the critic publicly and authoritatively declared what flavour of ice cream he or she preferred. The critic will come to see art as culture and culture as anthroplogy. Anthropology in turn will increasingly become a means of critiquing one's own inherited cultural stances rather than firing value judgements in all directions like Zeus or Apollo observing from Olympus. The critic will see that he or she may investigate, analyze, interpret, compare, gather together and sever apart – but not make value judgements.' [3]

3 Thomas McEvilley, op. cit., p.134

These essays are an example of that rewarding task of investigation, analysis, interpretation and comparison. Art-making has become less to do with the production of objects and more with employing that process to grapple with ideas and issues that are troubling or important. This does not mean that art has become merely a repository for existing beliefs; the illustration of ideas. On the contrary, artists are frequently unaware of the issues that concern them until they

have emerged in physical form.

One's responses to art are immediate. You like it or you don't; you want to know more, or you turn your back. Once you decide to engage with a work, a dual process is set in motion which involves unravelling your own responses and uncovering the feelings and ideas embodied in the piece.

The essays in this book are the result of that dialogue. Many of these artists will, I predict, be major figures of the future. But even if, by some misfortune, they were all to disappear, this anthology would still, I hope, be valuable as a record of the issues on artist's minds during this fruitful and creative period in British art.

Although their work looks very different, it quickly became apparent in my discussions with them that many of the artists are preoccupied with similar issues. The painters are concerned with the question of authenticity and originality. At a time when the notion of subjectivity is under attack, is it possible to have something unique or original to say, and to find an appropriate form for its expression? Or is there no option but to rehearse existing concepts using known gestures and styles? Fiona Rae, Glenn Brown, John Wilkins, Marcus Harvey and Abigail Lane each explores the possibility of revitalizing the language of painting, without subscribing to discredited notions of the expressive potential of a gesture or brushmark.

It is ironic that artists pursuing such an enquiry are often accused of cynicism when, by grappling with the issue, they avoid self-delusion and arrive at fresh and honest solutions. Gary Hume and Alex Landrum adopt the language of minimalism, pollute its utopian purity and revitalize it in the process. Jenny Saville, Joanna Price and Simon English employ the traditional language of painting, but use it to radical ends – to elucidate the view from the periphery rather than the centre.

Individual identity is a vexed question. At a time when society seeks to reduce us to ciphers, consumers and statistics, and philsophers such as Michel Foucault argue that our innermost being has been colonized by received opinion, who is the 'I' that hopes to say something worthwhile?

Simon Callery, David Leapman and John Greenwood posit the belief that the self can be (re)claimed through the activity of painting, since it offers an arena in which to establish autonomy. For them painting is a search for subjectivity, rather than an expression of it.

Marc Quinn, Rod Dickinson and Glenn Brown mourn the loss of subjectivity or, rather, the loss of belief in the sovereign being of the soul. Their work can be seen as an attempt to identify that part of a person that refuses to be defined by the collective and insists on asserting its individual existence. The work of Alex Hartley and Marcus Taylor offers sanctuary to those hopes, dreams and aspirations that can find no other place to go.

Kerry Stewart's sculptures embody the erosion of identity in a society that

espouses the notion of individualism, while actually invading privacy and spreading the net of restrictions wider each day with the help of information technology and the media. Stephen Murphy examines the way that the manipulation of the truth affects our individual and collective sense of identity. Brad Lochore deals with the encroachments of advertising and the effects of virtual reality on our judgement. Mark Wallinger looks at the social construction of identity and the way that ideology is embedded within images.

Damien Hirst is preoccupied with death and the quality of life; Hadrian Piggott's self-polluting vessels are metaphors both for frustration and global contamination; Rachel Whiteread deals with memory and its encapsulation within objects and architecture.

Several of the artists make work that relates to architecture. Langlands & Bell reveal the ideologies embedded within the design of buildings; Richard Wilson introduces peripheral structures that comment on the institutions that house them; John Frankland is interested in the formal interface between architecture and sculpture; Rose Finn-Kelcey's room-sized sculptures are physical equivalents of emotional and bodily states and Renato Niemis builds small rooms that indicate the degree to which the environment shapes our thoughts and behaviour.

Gavin Turk treats art as though it were an empty category and adopts numerous strategies for examining the hole, filling it up or papering it over. Sarah Lucas holds a mirror up to misogyny and invents new games for women players. Emma Rushton looks at the foibles and fantasies of men and turns them into the object of art rather than its speaking subject. Jane Simpson discovers forms to embody the feminine; Carina Weidle's poetic sculptures map the body's processes and allude to issues of freedom and self-realization.

Those hoping to find the solace of consoling ideas and images in these pages will be disappointed. We are cursed (or blessed) by living in interesting times and at such moments artists are important because they assert unpopular views, put things in a different perspective, pose awkward questions or simply say what they feel. These artists mainly use their work as a kind of research tool; to probe, query and uncover; to feel their way into the future; to vent their spleen or give voice to unease. They do not stake any claims; at a time of rapid change, only those fighting a rearguard action cling to aesthetic or moral positions. Nor do they have overblown expectations about changing the world. But by asking questions, they alert others to some of the pressing issues of the day. By demonstrating vigilance, scepticism and the refusal to be fobbed off, they offer an example of intelligent enquiry; of how to stand up and be counted; of refusing to let genuine individualism die.

GLENN BROWN

The expressionist quest for immediacy is taken up in the belief that there exists a content beyond convention, a reality beyond representation…the contradictions of expressionism are those of a language that would be immediate, a cultural form that would be natural. Hal Foster [1]

1 Hal Foster, *Recodings*, Bay Press, 1985, pp.63-4

Glenn Brown appropriates the imagery of other painters. His preferred sources are Frank Auerbach, Karel Appel and Salvador Dalí, whose pictures he selects from reproductions in catalogues and books. He is drawn to paintings which feature anguished heads with large, frightened eyes: 'I'm attracted', he says,' to the Gothic notion of a figure trapped somewhere between the psyche of the model, the artist, the photographer, the printing process and me.' He photographs or photocopies the reproduction and projects or prints the image onto the canvas to act as a guide for the painting he painstakingly renders over the top. Occasionally he works directly from the reproduction, considerably modifying the picture in the process.

Dalí-Christ, 1992 (p.113), his version of Dalí's *Soft Construction with Boiled Beans*, 1936, is painted on a canvas measuring nine feet by six. Since the original is slightly less than three and a half feet square, the change required major adjustments. By starting top left and working diagonally across the canvas with no guidelines, Brown was not copying so much as elaborating on a theme. This decision was a response to the melodrama of the tortured central figure of Dalí's work, whose impact leads one to imagine a bigger painting.

Reproductions inevitably give imperfect information. They are able to convey little of the painting as a physical object: its size, colour, smell, surface texture and, above all, the quality of the paint handling. You can capture the look of a brushmark but not its speed, energy and entrapment in the paint, all indications of effort and engagement. Signs of ageing – of dirt and fracture – are also hidden in the printed image.

It is this process of glamorization that interests Brown. Removed from the realm of brute reality into the exotic terrain of the imagination, the painting appears almost hallucinatory, effortless; as though it had made itself. His choice of reproduction is based not on verisimilitude to an original he may not even have seen, but on personal preference. The colours of a reproduction may differ wildly from the originals and Brown modifies them further, to the point where they approach kitsch.

In my catalogue Dalí's painting has a greenish cast which tinges the flesh with

the sickness of putrefaction. The clouds have a livid opacity and the desert floor is the purplish-brown of dried blood. Over the thigh of the central figure hangs a piece of raw meat the shape of a tongue or internal organ.

Brown's version is slicker and more palatable. He has elongated the central figure, lightened the sky so that clear blue is visible between clouds irradiated by lemon sunshine, and warmed the flesh and floor tones to robust health. One buttock now has a rosy glow as though it had been spanked, the other has the warm highlights of plump fleshiness. He has also enriched the meat hung on the thigh with a tumescent, blood-red energy. Rotting flesh covered in offal is converted into seductive curves inspiring sexual fantasy; titillating melodrama replaces the anguish and nausea of sexual confusion and disgust.

'Dalí's paintings are terrible,' says Brown; 'tacky, vulgar, gruesome, full of adolescent self-loathing. That's why I like them!' He relives, by proxy, the painful passions of adolescence and represents them with the glamour of an Athena reproduction, sanitized into exotic spectacle.

Brown's fascination with Frank Auerbach stems from 'the heavy melancholy in the paintings and also his nasty streak. The myth of the tortured artist is very strong. I was brought up on films like *Lust For Life*, the Hollywood version of Van Gogh's life. Although I don't believe in it, I am still hooked on the equation between creativity and desperation.'

Van Gogh has become the archetype of the crazed genius or the 'man possessed', as he is described in a leaflet at the Van Gogh Museum, Amsterdam. Griselda Pollock has shown that the myth became popular soon after the Second World War,[2] when Jackson Pollock was developing the drip technique that allowed an unmediated flow of feeling from psyche to canvas: a literal and metaphoric outpouring. The Van Gogh story, or its glamorized version, obviously matched the mood of the moment.

In ecstatic, quasi-religious prose the American critic Harold Rosenberg affirmed the mythic dimension of Abstract Expressionism. 'What matters always is the revelation contained in the act,' he wrote; 'the new movement is, with the majority of painters, essentially a religious movement...it attempts to initiate a new moment in which the painter will realize his total personality.' Rosenberg's affirmation indicates the degree to which reverence for expressionist painting depends on belief in the unique relationship between artist and canvas: 'The result has been the creation of private myths. The tension of the private myth is the content of every painting of this vanguard.' [3] To sceptics, however, this tension might not be visible.

Arguments against Rosenberg's claims are legion. 'Unmediated expression is a philosophical impossibility,' insists Paul de Man.[4] According to Jacques Lacan, the unconscious is structured along the principles of language, so there can be no

2 Griselda Pollock in a lecture at the National Gallery, February 1992

3 Harold Rosenberg, 'The American Action Painters' in Herschel B. Chipp, *Theories of Modern Art*, University of California Press, 1968, pp.569, 570

4 Paul de Man, 'Criticism and Crisis', quoted by Hal Foster in *Recodings*, op.cit., p.59

unmediated inner life and no expression innocent of its cultural context. Roland Barthes summed it up with the jaundiced remark that 'sincerity is merely a second-degree Image- repertoire.' [5] If these caveats are right, no claims can be made for painting on the grounds of emotional authenticity, and Expressionism becomes a style like any other, with no monopoly on emotional truth and profundity.

5 Roland Barthes, 'Deliberations', quoted by Hal Foster, op.cit., p.75

Brown's paintings are like an act of mourning and expiation for the loss of meaning and affect which results from these conclusions. His appropriation of Frank Auerbach and Karel Appel, a member of the postwar French COBRA group, is tinged with the pathos of nostalgia and with sympathy for the failure of a misguided enterprise.

Both these artists employ brush strokes laden with thick paint to conjure rapidly the presence of a solitary figure whose generalized features convey fear, pain and vulnerability. They are ciphers rather than individuals, symbols of suffering humanity. 'I find it hard to believe that Appel took his heads seriously,' says Brown. 'They are so obviously comical. I give my paintings science fiction titles, like 'The Body Snatchers', to emphasize this absurdity. Auerbach's portraits are like cartoons. He has a set way of doing the eyes, nose and mouth with brushmarks that he has perfected over the years. He copies himself, everyone does. The notion of self-parody and plagiarism is in everyone's work; Picasso did second-rate Picassos.'

Brown closes in on the heads, frequently enlarging them against an out-of-focus ground so as to dramatize the anguish of the isolated figure. He may turn the image on its side to enhance its existential agony. The paint surfaces of the original churn with raw emotion, the speed and energy of the brushmarks giving the impression that the paint has scarcely had time to coalesce into an image. By contrast, Brown's surfaces are as slickly uniform as a photograph. Working with very fine brushes and paint thinned with linseed oil, he painstakingly simulates the excited brushmarks and thick, juicy paint of the originals, but eliminates all traces of his own hand by lightly brushing the surface with a dry brush. This self-erasure is an ironic act of resignation to the fact that since the brushmark is no longer seen to be a unique manifestation of feeling, artists have been robbed of a cherished myth. Stroking the lifeless image is like caressing the cheek of a corpse; a meditation on separation and loss.

Brown's pictures resemble reproductions printed on canvas to imitate the painted surface, while being completely devoid of texture, movement or vitality. As though to compensate for this inertia, he heightens the colours. The sombre browns and blacks preferred by Auerbach and the torrid violence of Appel's palette are replaced by seductive rainbow hues, reminiscent of Gerhard Richter's dragged abstractions. The paint surface is dead, but the body has been decorated with a livid semblance of vitality. Brown's paintings are clones – Stepford wives, their external appearance smoothly immaculate, their spirits evacuated. A

profound rift is opened up between author and image, appearance and meaning.

The American artist Sherry Levine achieved a comparable dislocation by re-photographing and signing Walker Evans' photographs and re-presenting paintings by Egon Schiele and Franz Marc. But although they prise apart artist and product and query notions of authorship, her appropriations do not invalidate the original images. Brown, on the other hand, makes the paintings that he copies seem like rhetorical acts of self-delusion.

In order to strip the brushmark of overblown claims made on its behalf, Desmond Morris provided some chimpanzees with paper, paint and the opportunity to create a masterpiece. In his most ironic undertaking to date, Brown has simulated the chimpanzee pictures. Working behind his back with his left hand, in an attempt to make marks beyond his control, he made a bid to achieve the unmediated expression of childhood. The loss of that unselfconscious spontaneity is, I suspect, the real sadness which informs the melancholy humour of Glenn Brown's meticulously controlled paintings.

SIMON CALLERY

Simon Callery lives on the fifth floor overlooking the Limehouse Basin where the air is saturated with damp and the rooftops of London are visible through a veil of moisture.

His paintings are about light, air, weather and views over the city. The film of cloudy white which envelops many of his canvases evokes misty days, pollution haze and, for those old enough to remember, the pea-soupers that brought befuddled traffic to a halt in post-war London. The pallor of *E14SE10*, 1992 (p.118), whose title refers to the extent of the view from Callery's window, suggests flurries of snow. But the image also seems retrospective, as though it were ensconced in memory. His grey-buff surfaces are the colour of concrete and Portland stone as well as of fog and river mist. These paintings are not simply cityscapes; their relationship to the environment is more complex and more conceptual.

Callery used to draw the views from his balcony, but the building fragments now visible in his compositions – the angle of a roof, the edge of a wall, the line of a chimney or the curve of an architrave – are not records of specific buildings and locations so much as ciphers, generalized evocations of the city's fabric. Architectural details play an integral part in structuring images whose function is

more evocative than descriptive; in which a parallel is established between the language of architecture and the grammar of drawing. Lines may delineate forms, but they also function physically, as marks made in charcoal or pastel. Dribbles of paint evoke rain-soaked concrete, but they also make one conscious of the artist's actions – of paint trickled down canvas.

Callery shares affinities with Euston Road painters, such as William Coldstream and Patrick George, who employ marks as coordinates to map the precise relationship between the painted surface and the visual field; but he does not work in front of the model nor does he pin his imagery onto a specific encounter. He argues that his paintings are not pictures of the urban landscape, but graphic equivalents of the fabric and texture of the city, their structure echoing that of the urban environment. His evocations of place are generalized in the same way that Agnes Martin evokes the light and spaces of the Canadian prairies with a lyrical geometry that remains resolutely abstract and self-referential.

Kasha Linville's observation about Martin's relationship with nature: 'she isn't interested in the way objects look, but their feel; she doesn't exploit nature as a subject matter, she evokes it intimately for each viewer',[1] is also an apt description of Callery's approach to the city as subject. His paintings are ruminations on the theme; condensations of thought, feeling and experience.

1 Kasha Linville quoted by Germano Celant in *Agnes Martin*, Serpentine Gallery, 1993, p.7

Crucial to one's understanding of these canvases is their physicality; one's awareness of them as surfaces with a history, worked on and modified over a substantial period of time. Callery insists that they should be seen as objects rather than as pictures. The base colour, which may be bright blue, red or yellow, dictates the 'temperature' or 'weather' of the final image, but it may be obscured by as many as twenty layers of pigment, thinned to translucence with turpentine, so that one can only glimpse the information buried within its depths.

The paintings are like palimpsets: records whose imagery has accrued gradually and, despite being continually modified, corrected and redrawn, survives as a testament to human endeavour. In this respect they mirror the life of a city whose patina is created by a constant process of attrition, reclamation, demolition and reconstruction; as an organism the city is subject to an endless regime of decay and rebirth, while retaining a continuity that allows identification and recognition.

Comparison with the work of other artists is instructive. The Catalan painter Antoni Tàpies is inspired by the fabric of the city, though in a more literal way. Encrusted with sand or sacking, his canvases acquire the materiality of walls whose crumbling surfaces are seen as a metaphor for historical processes, an arena for political and social struggle and a blackboard onto which are inscribed the pain, outrage and ambitions of the populace. Tàpies' paintings are conceived in terms of substance and gesture – the stains of history and graffiti scrawled as a cry of rage or a call to arms.

Callery's city is more anonymous. In place of street level close-ups, he offers high-rise overviews that show the metropolis as an organism, a maze of streets and buildings. His paintings are less sensuous, tactile and gestural than the Spaniard's. The paint is less juicy, the surfaces are drier, more restrained and cerebral; concerned with structure and balance rather than with expressive substance. Tàpies views the city in human terms, as an arena for action; Callery perceives it formally, as a set of relations, an interplay of open and closed spaces, a communications network. The tightly knit planes of *4G and Justice*, 1992, are like transparent laminates or shattered planes of glass. They induce a sense of claustrophobia, of urban enclosure.

Callery does not employ emotive gesture. Horizontal lines are drawn with the aid of a spirit level, curves with a piece of string – methods closer to the approach of a draughtsman than an artist. The fluorescent pink of his pastel lines evokes neon signs rather than graffiti scrawls; authorised communications rather than underground outbursts.

Callery's cool way of working is closer to the measured approach of Mondrian. The patterns and rhythms of city architecture, translated into linear equivalents, take precedence over depth and volume. Grey tones and semi-translucent surfaces remind one of steel structures, whose glass skins make ambiguous the relationship between interior and exterior space. They bring to mind Mondrian's fragmentation of space into transparent planes in his Paris paintings of 1912-14 and his interest in the relationship between things, rather than in the objects themselves.

In Callery's paintings space and scale are both ambiguous. The vastness of the topography – views stretching to distant horizons – is countered by an emphasis on the canvas as a surface traversed by hand-made lines, sometimes extending to nine feet long. In *39°*,1992 (p.119) for instance, attention is focused on the surface to the point where spatial illusion is almost completely denied. The painting could be read as an abstract. Callery's paintings are ruminative rather than analytic, his working processes introspective. One is never allowed to forget the intimacy of the studio encounter, to lose sight of the artist working.

Not only do the paintings have a personal dimension; in a sense, they are autobiographical. Callery has lived in London all his life and the city has become integral to his sense of identity. The lengthy process of refinement, adjustment, modification and modulation to which he subjects his canvases is like a meditation on his life spent in a changing city whose recent history is contiguous with his own.

ROD DICKINSON

In the view initiated by the romantic sensibility…art becomes a statement of self-awareness – an awareness that presupposes a disharmony between the self of the artist and the community. Indeed the artist's effort is measured by the size of its rupture with the collective voice (of 'reason'). *The artist is a consciousness trying to be.* Susan Sontag [1]

1 Susan Sontag, *Under the Sign of Saturn,* Writers & Readers, 1993, p.16

A recent government White Paper has denied the existence of satanic ritual abuse, because no successful case has yet been brought to trial. 'The implications', says Rod Dickinson, 'are either that there is a cover-up or that the government is right and we are witnessing mass hysteria. Both are of equal interest to me; along with serial killings, child abuse and alien abductions, they are symptomatic of the current cultural climate.'

Dickinson is also interested in paranormal phenomena or, rather, in the fact that so many people believe in them. *Anatomy of a Sky Creature* ,1993 (p.121) is a portrait of an alien, based on descriptions by those who claim to have seen or been abducted by them. The thin, oval face is dominated by large, blank eyes; pools of shining darkness. The thin nose and narrow lips are inexpressive. Across the copper-coloured surface is written 'skin like sulphur', 'stolen memories' and 'this is the dreamer, you are the dream'; echoes of the belief that sky creatures are predators who feed off human experience. The portrait is a cliché, but, says Dickinson, 'it is a composite of repugnant characteristics, an image onto which thousands of people load their anxieties. It may be totally ridiculous or genuinely uncanny; that's a line I'm happy to cross.'

Victims of alien abduction speak of various forms of violation; of rectal probes, rape and buggery, organs being exchanged, needles being inserted through the navel, or through the temporal lobe into the brain and so on. There are striking similarities between their claims and those made, in the past, by people reporting satanic possession or abduction by demons. Fewer cases of alien abduction are reported in Catholic countries where, instead, people manifest the stigmata or claim contact with the Blessed Virgin. Is belief in aliens a form of mass hysteria? Is Dickinson's *Sky Creature* a portrait of another species or is it an emblem of millenial anxiety?

Dickinson makes crop circles in conjunction with Gavin Turk and numerous other artists. He has gone public on circles in the form of the symbol for the disabled, made near Silbury Hill on 15 August 1993, and near West Overton. He sees the activity as an extension of his work as an artist: 'They are warning signs, a

contribution to mass hysteria, to the culture winding itself up and falling apart.' But his attitude is ambivalent. He also claims to have witnessed flashing lights and loud buzzing noises and has taken photographs of discs, resembling flying saucers, above crop circles at Goulds Hill, Maiden Castle.

Just as the crop circles are 'signs', so the paintings are 'symptoms, rather than commentaries. They are not diagnostic,' says Dickinson. The stretchers measure six feet by seven or seven feet square, are three inches deep and covered with linen – clear indicators that these objects are to be seen as art. The surface of *Jinx*, 1990 (p.123) looks like burnt flesh. The canvas has been discoloured, stained, defiled. Raised pustules made from special effects make-up adhere to the surface like suppurating sores, and weep trickles of blood. Scabs and blisters are dabbed on in a paste made with beeswax, varnish and linseed oil; the dark blotches are a mixture of spectra gel and oil paint.

This is the scorched ground of the disturbed psyche over which are scrawled the paranoid utterances of schizophrenics, satanists and people who claim to be possessed or to have been abducted. The writing, enlarged from scruffy jottings, is stencilled onto the canvas so as to look like the diary notations of a tortured soul. *Jinx* reads 'From Hell… Yes, I too have been touched by the hand of the devilish one… I have anger in my head and hatred in my heart. And for this you will perish by my hand. Shut your eyes – and you will burst into flames. You will be engulfed in fire.'

Gleaned from various sources, the words science fiction are genuine, though their melodramatic tone is like the screenplay of an over-the-top film and the camp theatricality of the ensemble stretches credibility. The scrawled spontaneity is self-evidently staged.

The paintings may be portaits of psychic disturbance, but they are not expressionist outpourings. The images are not dredged from the recesses of the artist's psyche. Rather than searching within, Dickinson monitors collective unease as the end of the millenium approaches. Freud founded psychoanalysis in Vienna roughly a hundred years ago, as the last century was drawing to a close. Were his researches prompted by an increase in neurotic behaviour? Are we witnessing a cyclical phenomenon, a centennial disorder; or are the aliens really on our doorstep?

The romantic model, summarized by Susan Sontag, sees the artist as a uniquely sensitive outsider, excluded by the collective voice of reason, searching within his or her psyche to retrieve significant insights. But what if, rather than manifesting excessive reason, society is gripped by growing hysteria? Are the positions then reversed; does the artist stand alone as a small voice of sanity?

Dickinson's paintings are filled with ambivalence. His indulgence in theatrical angst, in a dramatized evocation of a dishevelled *zeitgeist*, begs the question as to

how clear-cut the distinction is between the artist as the source of unique ideas, and the artist as a conduit: a reflection of his or her times.

Dickinson flirts with sci-fi excess. The central image of *Testosterone Hallelujah*, 1992, (NIC) [not in collection] is an abdomen ripped open as though it had, like John Hurt, given birth to an alien. The torn flesh is a latex prosthesis cast from a clay mould and painted with theatrical make-up to look as gory as possible. *Egg Bag*, 1991 (p.124) is a self-portrait drawn in raised wax squeezed from a mastic gun. The face has been scribbled out and a prosthesis has been attached to the canvas to give the impression that the skull has been sliced open to expose the brain, from which grows a profusion of bright yellow flowers. Is this a portait of the artist as a man possessed, his personality erased and his brain colonized – used by aliens as the seedbed for planted thoughts?

One thinks of the self-portraits made by Antonin Artaud, creator of the Theatre of Cruelty, after leaving the mental asylum at Rodez in 1946. But whereas, according to Jean Dequeker, Artaud 'worked with rage, broke crayon after crayon, enduring the throes of his own exorcism',[2] the fever of madness is completely absent from Dickinson's work. The psychotic states that he conjures may be extreme, but they are evoked in a spirit of calm enquiry. The impetus seems to be the same as for the crop circles; they are 'warning signs; a contribution to mass hysteria', rather than descriptions of states experienced by the artist.

'Artaud appears to have been afflicted with an extraordinary inner life', writes Susan Sontag, 'in which the intricacy and clamorous pitch of his physical sensations and the convulsive intuitions of his nervous system seemed permanently at odds with his ability to give them verbal form.'[3] The flowers growing from Rod Dickinson's brain are more like an exotic headdress than the paranoid efflorescence of madness.

2 Jean Dequeker, 'Birth of the Image', quoted in *Aftermath*, Trefoil Books, 1982, p.122

3 Susan Sontag, op.cit., p.21

KATHARINE DOWSON

The universe is seen as a web of interrelated events. None of the properties of any part of this web is fundamental; they all follow from the properties of the other parts, and the overall consistency of their interrelations determines the structure of the entire web. Fritjof Capra [1]

1 Fritjof Capra, *The Turning Point*, Fontana, 1983, p.84

Katharine Dowson began using glass in 1979. She had tried sump oil and soap bubbles, but neither material had the qualities she wanted of being transparent yet solid, tangible yet delicate. In *Bubbling Glass*,1990 (p.125) a number of irreg-

ular glass vessels lies on a table, coated with wax to resemble skin. Air, bubbling through water inside the containers, creates loud sucking and gurgling noises and water occasionally spurts from the neck of the central vessel. The crumpled and folded forms look disturbingly vulnerable and their resemblance to internal organs – lungs, stomachs, wombs and intestines – creates indelible associations with the body's interior which are reinforced by the noises and orgasmic leakage.

At once sensual and grotesque, beautiful and disquieting, Dowson's work arouses ambivalent feelings. Glycerine glides down the undulating tube of *Drip 2*, 1990 and drips into the mouth of a glass vessel reminiscent of a uterus or stomach. Obvious associations are with feeding and sexuality, but other levels of meaning are suggested. The glass reminds one of laboratory equipment (test tubes, condensers and pipettes), arouses thoughts about *in vitro* fertilization and genetic engineering and stirs up a hornet's nest of moral issues.

Silicon Teats, 1992 (p.126) consists of two breast-like objects filled with pink liquid, one shaped like a mouth. Linking the nipples are segments of nobbly tubing that resemble a wind pipe. Associations range from breast and bottle feeding to force-feeding and the fear of asphyxiation. Dowson's simple, emblematic forms have the power not only to arouse strong responses but to provoke consideration of a range of issues fundamental to our well-being. A work ostensibly about the relationship between sexuality and nurture also invokes the spectre of the millions of infants who die each year, because Third World mothers have been persuaded to switch to bottle feeding.

Problems with breakage prompted the artist to place the sculptures inside lightboxes. Vulnerability is no longer an issue; instead one's thoughts turn to display. Incarcerated, the pieces remind one of specimens in a biology lab. The flower-like excrescences of *Twins*, 1992 are made of resin cast from seaweed. Umbilical chords join them to a womb-like glass vessel. Botany meets biology; links are made between human organs and other forms of growth. Dowson enjoys the formal similarities between objects as disparate as clouds, jellyfish, coral, sponges and rock formations.

Light Box 1, 1993 (p.126) contains a fungal flower cast from seaweed and covered with small nodules, so that it resembles the lining of a stomach. The stem is a glass column dipped in wax to give it an intestinal appearance. This 'grows' from an object that could be animal, vegetable or mineral. The ambiguity is deliberate, an indication of Dowson's belief in the links between living and inanimate things.

Interrelationship has become as familiar to Western scientists as to Buddhist monks and Jungian analysts. The idea has been developed by scientists James Lovelock and Lynn Margulis into the Gaia theory which demonstrates that 'the planet is not only teeming with life but seems to be a living being in its own right. All the living matter on earth, together with the atmosphere, oceans, and soil,

forms a complex system that has all the characteristic patterns of self-organiza-tion… The earth, then, is a living system; it functions not just *like* an organism but actually seems to *be* an organism.' [2] The theory has practical and moral implica-tions. If everything is interdependent, all our actions affect the planet's welfare and need to be considered in that light.

2 Fritjof Capra, op. cit., p.308

Katharine Dowson's work acts both as demonstration and provocation. Without in any way being didactic, it encourages us to reflect on our place in the 'dynamic web of interrelated events' now thought to make up our immediate environment and the larger universe.

SIMON ENGLISH

A figure is draped across an armchair, a see-through linear structure; a box of space as much as a piece of furniture. It could be a perfunctory drawing from a mail order catalogue, but minimalist sculptures, such as Sol Lewitt's open cubes, also come to mind. The chair is based on a cube and this small, square canvas is one of a series of ten – reinforcing the idea that a minimalist sensibility is at work.

But Expressionism has invaded; a powerful germ of disquiet is lodged at the core of these compositions. The figure is small, naked, vulnerable and upside down, a smudge of pigment that wriggles within its frame as ineffectually as a worm on a hook. The figure is indistinct, an anonymous scrap of humanity. Red paint seeps from the body into the fabric of the chair, as though its life blood were draining away. Others are less melodramatic; chair and figure change position in relation to one another and the canvas. The effect is a curious blend of choreog-raphy and martyrdom; the chair could be a prop in a sequence of dance moves; the figures might be studies for a modern Crucifixion, Deposition or Entombment.

Duality permeates Simon English's work. A dispassionate exploration of bodies in space is imbued with the tension of a disquieting subtext. References to the old masters and traditional iconography haunt paintings that have a contemporary flavour and subjectmatter. In other paintings clusters of figures are contained within transparent, room-sized frames isolated on washy grounds, as though a glass box had been placed at the centre of a painterly field. The device is familar from Francis Bacon's paintings, but there are significant differences in the way it is used. Bacon's chairs have individual characters and are often subject to the distor-tions affecting the sitter (as though the furniture were an extension of the sub-ject's psyche); English's chairs remain ciphers – neutral structures.

Bacon's space frames are like cages isolating a single figure or couple within a room, cell or bed; English's boxes define public spaces: bars, clubs or changing rooms – enclaves where men socialize in considerable numbers. Bacon portrays agonising solitude or sexual couplings in domestic interiors; English is concerned with the way social and sexual encounters are engineered within a public context.

His boxes play a metaphoric role; they represent the parameters (moral, legal, religious, political, etc.) that govern social intercourse and are invoked when policing its boundaries. Isolated on grounds divided by horizon lines to suggest location, the boxes define and protect their inhabitants, but they also segregate them.

In *Dress Circle,* 1993, a cylindrical frame is set on a gold ground in the central panel of a triptych. Within this formal but benign space a cluster of figures undresses in relaxed proximity. This could be the changing room of a football club or gymnasium infused with the camaraderie of team spirit. The arched backs of the bending figures repeat in rhythms suggestive of a dance. This and their concentration on various tasks remind one of Degas' pastels of women washing and dancers changing or rehearsing.

The figures on either flank of *Wall 1,* 1992 (p.127) seem embedded in the structure, as though they were part of an architectural frieze, a fragment of the Elgin marbles, or relief carvings from a war memorial frozen at a fixed point of action. The walls are like flats for a theatre production, while the raised legs of the line-up on the right encourages an absurd association with a chorus line, so alleviating the elegiac tone of the work. More than anything else, the figures resemble warriors anxious to enter the fray. They remind one of the men locked in mortal combat in Michelangelo's *Battle of Casina* relief of 1492, a crowded scene of mayhem and misery.

Box II, 1993 (pp.128-9) is crammed with a ripple of pale figures that appear trapped like frozen giblets, imprisoned within the cube. The work is permeated by an overwhelming sense of claustrophobia, of people locked together in unbearable circumstances, like those cast into limbo in Dante's *Inferno* or the damned herded towards Hell in Michelangelo's *Last Judgement* in the Sistine Chapel.

Skirmishes occasionally break out. In the central panel of *Box II*, a visceral tangle of figures suggests a wrestling match or a frenzy of wild dancing. The ground – a wash of red that drips down the canvas like a veil of blood – implies that passions are high, and a frisson of fearful excitement pulses through the picture. The action is flanked on the right by a line of figures set into the structure as in *Wall 1*, watching and waiting but unable to engage.

An element of theatre permeates this and other pictures. Performance is on the agenda – but it is clubland exhibitionism rather than dance, theatre or sport. In *Box Deep T*, 1993 (NIC) a single figure poses, centre stage, in front of a line of spectators hugging the left-hand wall, and a row of drinkers lounging against a

bar on the right. The composition is framed and dramatized by a dark voyeur who surveys the scene from the shadows. Is his presence benign or malignant?

Fear permeates many of the pictures, along with the tension of sexual excitement. Contained spaces, dramatic lighting and the nudity of the all-male cast suggest the enclosed world of a subculture which feels the need to protect itself from intruders – the nocturnal setting of a gay bar, perhaps. But the formality of the paintings and the lack of references to time and place avoid the literal or specific.

The figures in *Grid*, 1993 (p.130) are arranged on the squares of a perspective grid as though they were chess pieces that move according to specific laws, but are unable to make direct contact. An element of ritual is implied, as though access to and movement within the space required knowledge of a prescribed sequence of moves and counter-moves. Chess is, of course, a stylized war game. Negotiation of the social/sexual space within English's boxes seems fraught with potential conflict; false moves could prove fatal. The consequent loneliness and vulnerability of the individuals in these crowded interiors forms a subtext to many of the paintings. The central figure of *Grid* turns hopefully toward his fellows, yet seems absorbed in a moment of lonely introspection.

English restricts his palette to sepia tones enlivened with pale yellow or pinkish highlights that evoke drawings by Renaissance masters and the paintings of Rembrandt. The drama of *Box I*, 1993 (p.131) a transparent cube floating in the centre of a sepia ground, is achieved by silhouetting two dark figures against brilliant yellow lights. It reminds one of Rembrandt's *The Nightwatch*, 1642, a complex grouping of figures arranged in an architectural setting, as though on a stage. The compositon is articulated in terms of light/dark contrasts: pale yellow versus dark brown, enriched with mid-tones and areas of red.

While Rembrandt's characters are clothed, and can be identified by their faces and costumes as members of one of Amsterdam's civic guards, English's figures are generalized, naked and anonymous. Male nudity has no fixed meaning in the canons of art. It may be an indication of courage or vulnerability, of purity or sinfulness. In classical Greek statuary the male nude personifies virtue and heroism. In Christian iconography the damned are usually portrayed unclothed as an indication of sinfulness, but the elect may also appear nude as a sign of innocence. Simon English exploits this ambiguity to enrich the emotional timbre of his work; his nudes could be Homeric heroes, Christian souls called to Judgement or men hanging out in bars. The two black men standing like caryatids at the corners of the cube in *Box I* could be bouncers on the door of a club, but they might equally be sentinels guarding the mouth of Hades.

The strength of the paintings lies in this duality. On the one hand, they act as metaphors for the isolation of a subgroup forced by public censure to go underground. On the other, English attains a mythic dimension more usually associated

with history painting. That he manages to paint heroic pictures at a time when grandiloquence is normally laughed out of court, is quite an achievement.

Géricault attained a comparable meld in *The Raft of the Medusa* ,1819, which treats current affairs (a shipwreck) according to the Grand Manner. Nowadays that degree of romanticism would seem absurdly overblown. Careful orchestration, however, enables Simon English to mythologize contemporary reality without pomposity or pretension while, at the same time, speaking of individual experience. That is where the conviction lies.

ROSE FINN-KELCEY

A primary drive of human beings is towards order, that is, to perceive the environment as comprehensible and to make successful predictions about the future… (But) the very drive to order which qualifies man to deal successfully with his environment disqualifies him when it is to his interest to correct his orientation…the drive to order is also a drive to get stuck in the mud. Morse Peckham [1]

1 Morse Peckham, *Man's Rage for Chaos*, Schocken Books, 1967, p.xi

Rose Finn-Kelcey's work is usually created for a particular venue. *Steam Installation*, 1992 (pp.134-5) was initially made for Chisenhale, a gallery in East London whose white, windowless walls and concrete floor provide a bleak ambience, inert and cold. The artist wanted to animate the space by introducing a warm, volatile and formless element: steam. But how to contain it?

After numerous studio trials and consultations she designed, with the help of engineer Steve Steed and ducting designer Alex Hall, a stainless steel canopy suspended over a square base. Her largest and most sculptural object to date, this elegant structure has both industrial and domestic connotations. It resembles a giant waffle toaster or a huge steam press and reminds one that Chisenhale was once a veneer factory that used steam in the manufacturing process.

A cloud of vapour swirls between the hood and base. The wafting and surging of this unruly element within the rigid structure is an astonishing sight: an unexpected union between technology and poetry, stasis and spontaneity, order and chaos. The work can be seen as a metaphor for a state of balance between the masculine and the feminine principles or between the drive to order – the need, as characterized by Morse Peckham, to understand and control one's environment – and the necessity to be flexible, to embrace the unknown and the unexpected. The artist plays God: directing the wilful element, while celebrating its glorious energy and granting it a degree of freedom.

The sculpture operates according to a circular system. Breathing like a living organism, it establishes a dialogue between the enclosed space of the gallery and the outside world; between a carefully controlled, indoor environment and the more complex and seemingly disordered realm outside. Air is drawn in along the lower duct, channelled to the base of the sculpture and forced through slots around the rim to rise as an invisible curtain of cold that controls the expanding vapour. The quantity and behaviour of the steam – created by passing water over heating elements beneath the perforated steel floor – is affected by the temperature and humidity of the air so that, like the weather, it varies from minute to minute and from day to day. The hot air is sucked up through the hood and returned to the outer atmosphere along the upper duct, so completing the circle.

This fine sculpture exemplifies the principles of control and flexibility; the desire for order and the excitement of uncertainty. It also arouses disparate associations, such as rising through majestic, billowing clouds in an aircraft, or luxuriating in the sweaty lassitude of a sauna; the euphoria of apparent weightlessness, the deadweight of torpor; contrasting states of mind and body.

The Royal Box, 1992 (pp.132-3) is the antithesis of *Steam Installation*. Whereas the vapour is warm, moist, volatile, and open to view if not physically accessible, this sculpture is an enclosed vault – cold, dry, sterile and inert. If you venture between the heavy plastic strips that protect the doorway, you find yourself in a nine-foot square refrigeration unit kept at a temperature of minus 23° centigrade. The wafting steam seduces with its sensuous, womb-like plenitude, but this inhospitable container unnerves one with thoughts of freezers, mortuaries and even gas chambers.

One's discomfort at being confined in such a cold space is increased by the awareness that if you became trapped, at this temperature you would die. It would be a pleasantly langorous end – while working on the piece, the artist would gradually sink into a dreamy, hallucinatory state – but fear of incarceration, nevertheless, gives rise to anxiety and claustrophobia. Inside one encounters a U-shaped wall of ice cubes; beautiful, crystalline, pure and deadly. If you give yourself up to the embrace of this narrow enclosure, you feel the heat being drawn out of your body; as though you were lying in state in your own mausoleum, a witness to your own demise. This state of suspended animation is a metaphor for sterility; for blocked or frozen vitality.

The two sculptures epitomize the twin poles of animation and stasis – openness/closure, flexibility/rigidity, life/death. You may feel a desire to leap into the sweaty embrace of the first; the second will inexorably drive you out. Steam opens the pores, cold closes them. One sculpture invokes a state of relaxed communion between self and other, indoors and out, the gallery and the wider world; the second embodies introspection, enclosure, confinement and frigidity.

Earlier work took the form of performance and installation. *Openings*, 1990 (NIC), created for the Tyne International, Gateshead, was located in the empty shell of an unfinished council house that offered minimal protection or nurture. Finn-Kelcey set a number of doors into the walls at ground and first-floor levels, as though other rooms led off the meagre, central space. The sparse enclosure became little more than a hall or sterile antechamber, a comfortless waiting room in which the occupants marked time until they were able to leave – a comment on the inadequacy of the dwelling as a family home and a metaphor, perhaps, for the vortex that often exists at the heart of domestic life.

Recessed into the concrete floor was a concrete-coloured square of carpet. Transforming this meagre box into a home would require a greater leap of the imagination than just covering its surfaces with furniture and domestic bric-a-brac. The concrete would assert its mastery: jerry-built mediocrity invades the soul and dampens the spirits of those housed within.

As well as its general relevance, the work also had personal significance. As the daughter of refugees, Finn-Kelcey recalls feeling never quite at home. Much of her childhood was spent outdoors building tree houses and makeshift shelters. 'I still have a desire to make homes,' she remarks, 'but they are always temporary.' Her own home is an extension of the studio, a place in a state of perpetual flux. 'I feel distressed in an ordered home, it doesn't allow for change or freedom of thought. I like working in difficult, alienating spaces such as galleries. They provide an opportunity to question being part of somewhere, making yourself at home. Crossing the threshhold is the issue. Are you allowed in?'

All three sculptures touch on these issues. Security favours a safe haven; life requires flexibility, risk-taking and communication. Enclosure can mean incarceration; a home can become a sterile prison. No answers are afforded; the sculptures remain ambivalent. Finn-Kelcey's work is never didactic. Its strength lies in its multivalence and subtlety. The Gateshead installation also allowed a positive reading; the domestic realm provides numerous doors to the wider world. The steam installation has a dark side; it evokes the fear of dissolution into formlessness. The ice box offers a form of immortality.

Given the desire for order and the conflicting need, for the survival of the individual and the group, to embrace change and the unknown, Morse Peckham argued for a mechanism that forces one to overcome inertia. 'There must, it seems to me,' he wrote, 'be some human activity which serves to break up orientations, to weaken and frustrate the tyrannous drive to order… That activity, I believe, is the activity of artistic perception.' [2] Rose Finn-Kelcey's works exemplify the desire for order and containment versus the need for flexibility and openness. They are a series of poetic metaphors for physical and psychological states of being.

2 Morse Peckham, op. cit., p.xi

JOHN FRANKLAND

Since leaving Goldsmiths' in 1983 John Frankland has supported himself by working as a carpenter and decorator, mainly refurbishing old houses whose lumpy brickwork and sagging ceilings attest to their age, but also to their solidity. By contrast, most modern buildings consist of cladding – glass, steel, aluminium, plastic or polished stone – hung on to a steel armature. Their structure, in other words, resembles that of paintings: material stretched over a wooden frame. The emphasis is on surface; on smooth, seductive skins that are often highly reflective, rather than on substance or texture; on vision rather than touch. In this respect, too, they share similarities with paintings.

Frankland explores the interface between painting, sculpture and architecture, between object and environment, the real and the illusory, in objects and installations that refuse easy categorization. *Window*, 1992 (NIC) is a hand-made window frame and sill, painted in magnolia gloss. Clear polythene is stretched over the frame in reference to window panes, to the glazing on a picture and to the wrapping used to protect it in storage. In mimicking the look of a window and the structure of a painting, this paradoxical object parodies the traditional notion of a painting as a window onto an imaginary world. And in refusing to function either as an architectural element or as a picture, it demands to be placed in a third category: to be regarded as a sculpture.

The first large-scale piece that I encountered, in 1992, was a shining black wall spanning a thirty-foot gap between two cast iron columns in Spitalfields Market, a superb Victorian structure in London's East End. It looked as though it was made of steel; in fact, it was black polythene stretched over a wooden frame and heated drum tight. The frame was made in sections with bin-liner plastic stretched on both sides. Small protrusions made at regular intervals along the edges of each panel mimicked the heads of the rivets that would have held the sections in place had they been made of steel.

The piece was primarily an exploration of the nature of illusion, a vast drawing that occupied the same space as the object it portrayed. It also contrasted traditional and modern building methods and materials: a solid wall with a flimsy, non-structural partition; a heavy-duty industrial material with a cheap, light and pliable skin. And in so doing, it resisted identification as architecture, sculpture, painting or drawing, yet flirted with all four categories. The highly reflective plastic fitted as snuggly round the columns as if it were a liquid poured into place. It was like a magical recreation in a vertical plane of *20:50*, Richard Wilson's installation of

black engine oil which had been a key influence on Frankland.

Untitled, 1994 (p.136), looks like a garden shed, except that it is shining silver and the crude actuality of a hut is replaced by a shimmering, weightless splendour. Each of the 120 panels consists of a wooden frame stretched with a film of metalized polyester, a material normally used for wrapping food, heated to make it drum tight and absolutely smooth. Small indents on each panel mimic the screw heads that would keep them in place if they were aluminium. The structure is life-sized, but it cannot be used because the door and windows are false. The object is a skin, an illusion occupying the same space as the thing it portrays; a three-dimensional drawing rather than a sculpture or an architectural structure.

You Can't Touch This, 1992-3 (p.137), similarly defies categorization. A false wall traversed the space of Hales Gallery in Deptford, south east London. Covered in a golden skin of metalized polyester, the reverse side of the silver used on the shed, the structure exuded the vulgar opulence of a corporate lobby whose design was dictated by money rather than taste. Recessed into the gleaming surface was a pair of lift doors flanked by perfectly moulded buttons for summoning the imaginary elevator.

The material was again stretched over wooden frames and heated to become skin tight, so creating a gleaming phantom that belied its own reality. One of the cheapest materials on the market was used to mimic gold, the substance employed as a universal standard of value. An insubstantial throw-away film of plastic imitated a material which confers status and provides security.

Frankland is indicating the obvious parallels that exist between setting prices on the world market for precious metals and stones and establishing the saleroom value of works of art. Both depend on rarity and are susceptible to the vagaries of fashion; the value of an artwork can rocket or plummet overnight. Because plastics are non-biodegradable, the valueless materials used by Frankland ironically have the potential to outlive old master paintings. The artist also enjoys the fact that the packing cases built to store his work may cost more to make than the sculptures that they protect. With their insubstantial glamour, his silver shed and golden wall are the perfect embodiment of such ironies.

By their very nature, installations are modified by their context. In Deptford, one of the most economically depressed areas of London, *You Can't Touch This* was like a taunting vision of opulence, a mirage of false hope offered to those for whom wealth remains no more than an elusive dream. Installed in the lobby of the Saatchi Gallery, the piece will doubtless seem like a sardonic comment on the advertizer's art – on the promotion of dreams and the marketing of shimmering illusions.

JOHN GREENWOOD

1 Dawn Ades, *Dalí*, Thames & Hudson, 1982, pp.126-7

The illusionism of the most abjectly arriviste *and irresistible imitative art, the usual paralyzing tricks of* trompe l'oeil, *the most analytically narrative and discredited academiscism, can all become sublime hierarchies of thought…(producing) images which provisionally are neither explicable nor reducible by the systems of logical intuition or by the rational mechanisms.* Salvador Dalí [1]

John Greenwood describes *Enjoy Yourself*, 1991 (p.138) as a self-portrait: 'They are all self-portraits,' he says. A bizarre cluster of disconnected forms loosely delineates a reclining nude – not a seductive female lounging in languid anticipation, but a fragmented male figure in a state of considerable agitation.

The body parts are drawn with meticulous attention to detail but scant regard for human anatomy. Yet this grotesque assemblage of fleshy forms remains plausible, especially if one reads it metaphorically. The creature has, for instance, a centre of intelligence – a bright disc that sprouts yellow rays as though radiating thought, and a tangle of wires leading to four illuminated balls. The throat is a stack of funnels, the backbone a series of pipes through which vein-like wires carry energy to the outer margins of the body. Lower down the pipe becomes soft, fleshy and undulating like a large intestine. The hands and feet are drawn with relative realism while the rest of the body consists of bulbous pink forms: part flesh, part bone, part internal organs.

The ancestors of this hominid include the mechanical bride and the cluster of suitors from Marcel Duchamp's *Large Glass*, 1915-23, who enact a frozen dance of frustrated desire. The wings and furls of leather which flutter behind Greenwood's figure recall the disrobing of Duchamp's virgin. But his figure has no sexual partners and frustration finds an outlet in the guilty exertions of auto-eroticism. A yo-yo rises and falls in rhythmic repetition; toes massage the bulbs of three horns which trumpet their orgasmic delight as they ejaculate globules of white jelly. Droplets of white liquid fly off the torso to accumulate on the floor in lifeless puddles, a metaphor for energy spent in sterile activity; seed spilled on fallow ground. The picture reads as an allegory of the shuddering eruption of orgasm. But in place of sexual release comes fearful tension. The explosive figure embodies the terror of disintegration identified by Freud as the 'mini death' that may accompany the tremor of ejaculation. Anxiety is indicated by the decapitation of three phallic forms and a saw that cuts the ground from beneath the orgasmic horns. Masturbation may be rewarded by castration or impotence; pleasure is poisoned by fear.

Sexuality is a recurrent them. One source of inspiration was *The Mating Game*, a television series in which David Attenborough explored sexual activity in the animal kingdom. Seeds, shells, crustacea and insect life are recognizable sources for many of the pseudo-mechanical parts and bloated, fleshy forms of Greenwood's perverse organisms. Other images are borrowed from Surrealist painters such as Yves Tanguy, Max Ernst and Salvador Dalí, still more are dredged from the artist's unconscious by means of doodles, which are then refined and clarified.

Greenwood has adopted the meticulous hyper-realism of Dalí so as to lend credibility to his phantoms and to distance himself from his often painful imagery. He paints what Dalí described as 'realistically according to irrational thought, according to the unknown imagination…super-pictorial, super-plastic, deceptive, hyper-normal and sickly images of concrete irrationality.' [2] But whereas Dalí was familiar with psycho-analytic theory and was happy to analyze his paintings accordingly, Greenwood is reluctant to discuss his imagery, insisting that ambiguity is crucial to the work's success; interpretation must be left to the viewer.

2 Dawn Ades, op. cit., p.83

How Many Doughnuts Have You Collected?, 1991 (p.141) draws parallels between the sexual antics of *Homo sapiens* and those of the insect kingdom. The painting, inspired by a party at the artist's house, is set in a room furnished with striped rectangles. The host, a curl of naked flesh, is slumped against the wall like a limp penis. The lonely voyeur studies his navel through snail-like eyes and the painting portrays the scene revealed there.

The guests – bizarre assemblages of elements culled from botanical illustrations and books on insect life, machinery and plumbing – seem bent on mutual seduction and impregnation. One creature docks onto another by means of a long tube, like an aircraft refuelling in flight. Red beads, suspended in a necklace of white jelly, are propelled into the female, whose poppy-like head inclines toward a heart that dangles through a hole in the ceiling. The heart radiates flames, as though mimicking the agony of Our Lady of Sorrows, while a fish-hook warns of the dangers of romantic attachment.

This display of sexual urgency and romantic longing is watched by the snail-like eyes of the host, who observes his flamboyant guests through the ceiling. André Breton described Surrealism as 'a cry of the mind turning back on itself'. [3] The circular narrative of this painting is like a manifesto in which Greenwood declares himself to be the generator of phantoms which enact the anguished psycho-dramas of his inner being.

3 André Breton, *What is Surrealism?* (ed. Franklin Rosemont), Pluto Press, 1978, p.317

It would be easy to dismiss Greenwood's paintings for following so closely in Surrealist footsteps. Yet they have an undeniable authenticity and candour. 'It is perhaps, with Dalí,' Breton wrote, 'the first time that the mental windows have opened wide.' [4] John Greenwood is not merely imitating appearances. He opens windows to allow us a glimpse of the fears and inadequacies that preoccupy him.

4 André Breton quoted by Dawn Ades, op. cit., p.84

ALEX HARTLEY

Untitled, 1992 (p.145) is a perplexing object. A black and white photograph of an open door is encased in a frame of heavy glass. The glass – six millimetres thick with a green tint – is acid etched to a satin finish that gives it a foggy opacity. One sees through it with difficulty, as though it were a thick mist. The box is wedge-shaped – one side is wider than the other – so the front plane is at an angle to the picture that it protects.

To see the photograph you have to manoeuvre yourself in to a position where the frame is less obtrusive. The door then appears as a mysterious opening to a misty beyond with the quality of a memory, a dream or a still from a silent movie. But one's thoughts are not encouraged to stray far from one's immediate sur-roundings; the virtual space of the picture is contradicted by the physicality of the glass box. The thin side of the wedge is on the hinge side of the door, so the open door swings in the opposite plane to the projecting glass. The two movements, real and imaginary, both emphasize and counter one another, and suggest hesi-tancy or reluctance. There is ambivalence about crossing the threshhold.

The door belongs to the Grob Gallery, a prestigious West End venue specializ-ing in contemporary art. Artists are often castigated for making self-referential work, suitable only for a museum context. Alex Hartley employs gentle irony to address the limits (and limitations) of the art world and to demonstrate that, despite being part of it, art need not be bound by its parameters.

Invested, 1990 (NIC), a piece made while still a student in the sculpture depart-ment of the Royal College, mocks the power of the market to confer value on indifferent work. An amateur painting bought in Brick Lane market is packed in a case made with exaggerated care and craftsmanship so that it resembles a sculp-ture by the German artist, Reinhard Mucha. The promotion, packaging and mar-keting of artworks are recurring themes in Hartley's work. To what extent are perceptions of a work manipulated by the gallery that handles it? To what degree do museums influence public taste and condition responses?

Untitled (After Monet), 1991 (NIC) focuses on the presentation of paintings in a museum context. A horizontal strip of the National Gallery wall, including seg-ments of three Impressionist paintings, is photographed and presented as an installation. The pictures are represented by glazed aluminium boxes and the area of each canvas is indicated by a rectangle of satin etch on the glass.

The ensemble is deeply paradoxical. Hartley focuses on presentation rather than on pictures. Display, he points out, is not a neutral act; it guides perception. Gilded

frames indicate old master status, aluminium boxes connote contemporary art. Once radical, these paintings have long since been institutionalized. Installed in the National Gallery, they can no longer be experienced as controversial.

'Buildings', argues Hartley, 'are both physical and mental spaces'. Museums, town halls, libraries, court houses and prisons are fronted by edifices that proclaim the values upheld by the institution. A prestigious museum or gallery lends credibility to its works through its ambience, as well as through its name and reputation.

Untitled (Sackler), 1992 (p.144) is a coloured photograph of a spacious gallery, breathtaking in the pristine elegance of its white walls and wooden floor. These are the refurbished Sackler Galleries of London's Royal Academy. The space is empty save for a chair awaiting the guard who will watch over the exhibits. The subject is the gallery itself, an exquisite envelope designed to be self-effacing – to display artworks to perfection without declaring the architectural wizardry that makes this possible. To be effective the support structure must be invisible: behind these walls and ceilings are concealed complex lighting, air conditioning and alarm systems. Hartley has encased the photograph in a wedge-shaped frame of etched glass that inhibits our view and alerts us to the fact that what you see is substantially modified by the circumstances in which it is encountered.

Untitled (Miro), 1992 (p.144) turns its attention to a commercial gallery. A black and white photograph of an empty interior is housed in a wedge of etched glass. The room is recognizable as Victoria Miro's Gallery, a West End space designed by an architect to accommodate minimalist art. A studied simplicity identifies the gallery with the work it promotes; art and architecture espouse the same purist aesthetic. A declaration is made, an ethos created. The frosted glass distances the space and gives it the soft-focus romance of something desirable, but out of reach.

Within a year, though, Hartley's work was on show in the gallery; an indication of the appropriateness of his observations. He does not pretend to function outside the system. Galleries confer visibility; if you remain an outsider, your work cannot make an impression. But he is not a cynic. On the contrary, he believes that despite the obvious power exerted by galleries, art can transcend its context; it need not be compromized by commerce.

Untitled (Touched Out), 1993 (NIC) is a series of ironic cameos. Installation shots of influential galleries, such as Leo Castelli's in New York and Conrad Fischer's in Dusseldorf, have been enlarged from the pages of art magazines. In a flamboyant Oedipal gesture, the work on show – by father figures such as Bruce Nauman, Don Judd and Lawrence Weiner – has been airbrushed out. The older generation has been erased to make room for the younger. Power relations between artist and dealer have also been reversed; instead of waiting for an invitation, the artist has

appropriated the space. Instead of housing the art, the gallery becomes its subject; wishful thinking, of course. The humour and pathos of the challenge comes from the fact that this symbolic gesture tacitly acknowledges the status quo.

Art fairs reveal the power of naked commerce to reduce art to decorative merchandise. But when it was shown at the 1994 London art fair, *Untitled,* 1993 (NIC) attracted enormous attention. A frame of etched glass, measuring some ten feet by five, contains a black and white photograph of an empty gallery. Mounted on the wall, the structure is an awesome sculptural presence able, through its calm authority, to withstand the ethos of the marketplace. The work provided a contemplative space that proved immune to the bustle of the business surrounding it.

Untitled (Model), 1992 (p.143) was the first of a series of ideal galleries that appear spacious but, in reality, exist only as cardboard models. The artist creates the venue of his dreams and, metaphorically, asserts his independence of the exigencies of the art world. These are symbolic spaces, set apart from vulgar reality; places of promise into which one can project one's desires and aspirations.

Despite its ironies and ambiguities, Alex Hartley's work is fundamentally optimistic; romantic even. He seeks to demonstrate that God and Mammon can co-exist. Artists can retain their integrity and art can transcend commerce; not all human activities can be reduced to a function of the market place.

MARCUS HARVEY

An image of an erotic object is a negation of the object's essential character or humanity... The model thus becomes a token of nature, an objectified artifice that allows the viewer to handle her mentally and to fantasize about her; the human becomes a mannequin, a doll. Robert Sobieszek [1]

'I paint with my prick',[2] boasted Renoir and, according to myth, he liked to start his day by drawing a nude before breakfast. It is a truism that sexuality and creativity stem from the same source. Less readily acknowledged is the voyeurism that has provoked the myriad female nudes in Western art history. Humbug has prevailed to such an extent that in his book *Beauty and Other Forms of Value* the aesthetician Professor Alexander could declare: 'If the nude is so treated that it raises in the spectator ideas or desires appropriate to the material subject, it is false art, and bad morals.' [3]

Now that the veil of delusion has been lifted by feminist art historians and predatory impulses acknowledged by writers such as Robert Sobieszek, it is all but

1 Robert Sobieszek in *Nude Photographs*, ed. Constance Sullivan, New York, 1980, p.171

2 Jean Renoir, *Renoir, My Father*, Collins, 1962, p.185

3 Professor Alexander quoted by Kenneth Clark, *The Nude*, Penguin Books, 1985, p.6

impossible for a male painter to take on the nude without tackling the accompanying issues of exploitation and objectification.

Marcus Harvey manages to have his cake and eat it. On the one hand his paintings are an orgy of unrestrained sensuality, on the other, an indirect indictment of the illustrious history of the nude. His acceptance of the polymorphous perversity of infancy, in which all tactile impulses are equal – his work equates eating, excreting, art-making and love-making – provokes some basic questions. What, for instance, is the difference between Velasquez caressing, with a fine sable brush, the rosy buttocks of his *Rokeby Venus*, de Kooning ravaging the contours of his castrating nudes, Harvey's orgiastic gropings, and the masturbatory consumption of pornographic pictures? All these images stem from and invite sexual responses, the difference being the degree to which this is acknowledged. Pornography is blatant in its reduction of flesh to objecthood; high art is more circumspect. By creating a clash between the two cultures, Harvey equates art with pornography and, according to one's viewpoint, either damns or exonerates them both.

'In essence', writes Georges Bataille, 'the domain of eroticism is the domain of violence, of violation… What does physical eroticism signify if not a violation of the very being of its practitioners? – a violation bordering on death, bordering on murder?' [4] It takes Harvey half an hour to clean his hands after a painting session; 'It's like being a murderer,' he says. He speaks of the animalistic and cannibalistic aspects of sex and the loss of boundaries as bodies fuse. For him painting is a similarly orgiastic experience, an abandonment of control. He psyches himself up to complete a painting in one session since, as in sex, the materials must be wet. Freud characterized painting as a sublimation of the infantile desire to smear the walls with excrement. Harvey smears colour onto canvas with his fingers, in an orgiastic wallowing.

4 Georges Bataille quoted by Robert Sobieszek, op. cit., p.171

The results are gorgeous; because of his deft control, the colours don't merge into a fecal ooze but remain bright, clear, distinct and fresh. Oranges, yellows, pinks, magenta, blue and white are applied with a spontaneity that energizes the canvas. It is impossible not to relish the sensuous tangle of succulent marks that criss-cross these sumptuous surfaces. Cleaving their way through the juicy paint, like runnels or gouges, are hard black or grey lines. From a distance they meld into crisp line drawings of body parts. Schematized images delineate a crotch, an anus, a pair of tight knickers, suspenders, stocking tops, labia and pubic hair. These are the crotch shots of soft porn magazines and the naughty knickers worn by Reader's Wives in the DIY porn sent in for publication from the suburbs.

The lines are stamped onto the colour like a template: insensitive, reductive, crass, generic. The harsh simplicity of these cartoon-like cyphers is a graphic equivalent of the reduction of a person to body parts; a debased public language that makes inadequate reference to the private domain of desire. It outlines the shapes

with an authoritarian rigidity that reminds one of the repressive lash of a whip or the choking restraint of guilt.

Without the lines the paintings would be formless. They delineate areas within which the splurging can be indulged; Harvey describes it as 'giving oneself boundaries, within which to dive in in an orgiastic state, like a chocoholic.' The work stands at the intersection of the public and private, the adult and infantile, the unbounded and the circumscribed, the intuitive and the conceptual. Tension is created by the separation of the two languages – the one premeditated and inert, the other indulgently expressive – into a dialogue of confrontation between high art and pornography and between the Apollonian need for order and the Dionysian propensity for excess.

At Goldsmiths' in the early 1980s Harvey was taught by Harry Thubron, Bert Irwin and Basil Beattie – painters committed to the expressive possibilities of their medium – but also by Michael Craig-Martin, in whose work objects are defined by sharp black outlines. Harvey has fused these disparate influences – luscious painterly abstraction and rigorous conceptualism. While on one level rude and crude, on another, Harvey's paintings are as deftly orchestrated as a Roger Hilton abstraction. Rigorous formal constraints contain the outpouring of sexual energy. Square canvases are framed by broad white borders that mimic the format of the polaroid prints which are their source. The device simultaneously elevates the pictures with its formal elegance, and lowers the tone by referring to suburban smut.

The line drawings energize the whole canvas. There are no slack areas; figure and ground interact in a dialogue of open and closed forms. Balance, tension, nuance, measure and scale are brought into play. Only the subjectmatter subverts the politesse of the design. A vagina or anus draws the eye inexorably to it as a point of entry, a piercing of the picture plane, a disruption of the homogeneity of the surface. Harvey capitalizes on the fact, pointed out by Kenneth Clark, that 'one of the difficulties of the nude as a subject for art is that these (sexual) instincts cannot lie hidden...but are dragged into the foreground, where they risk upsetting the unity of responses from which a work of art derives its independent life.' [5] Confrontation with such sexually explicit imagery destroys one's 'unity of responses', but without it there would be no tension and the paintings would be merely chic.

Yet the articulation of the paint is as important an issue as the subject-matter. The lines are masked over so that, during the finger painting, they are not visible. The smearing relates to the canvas – to the arena of art-making – rather than to the nude. Harvey's dialogue is with art history, with the expressive potential of paint and the source of the creative urge, as much as with sexuality itself.

In paintings where a hand print is embedded in the pigment, one has a different awareness of scale. The woman's body becomes enormous and the hand as

5 Kenneth Clark, op. cit., p.6

small as a child's groping for its mother's body. Art-making is equated with infantile sensuality as well as adult sexuality.

Harvey is a pop artist, pillaging the high street for imagery, invigorating his art with an injection of gutter energy. And in the tradition of Warhol or Lichtenstein, he redesigns his sources. *Half Way Up*,1993 (p.146), shows the twin peaks of a pair of knees traversed by the spotted line of a pair of knickers half way down the legs – 'important knickers, heavy knickers, stretched knickers', intones Harvey. In *My Arse is Yours*, 1993 (p.148), the anus is translated into a neat black asterisk, the vagina into an ovoid form hung with labial curtains.

Once the shock has worn off, Harvey's nudes will look as elegant as Roy Lichtenstein's swooning blondes. They will be seen as a strategy for continuing to make beautiful, juicy, erotic paintings at a time when painterly painting is an exhausted genre and the nude, by and large, an unacceptable subject. By being unrepentant as a painter and a sexual predator, Marcus Harvey transforms an untenable position into a revitalizing challenge.

DAMIEN HIRST

I sometimes feel I have nothing to say, I often want to communicate this.[1]

1 'Damien Hirst and Sophie Calle' in *Damien Hirst*, Institute of Contemporary Arts, 1991

A photograph of Damien Hirst, taken when he was a student, shows him in a morgue, his grinning face cheek by jowl with the head of a corpse. If it weren't for the dead man's expression, this would be a grisly image. His crumpled features seem to be smiling – as though he were sharing the joke with his live companion. Witnessing this antic, distaste gradually gives way to relief. By looking death in the face, its terror is diminished.

Hirst is fond of quoting Brancusi: 'When we are no longer children, we are already dead.' He asks questions the way children do, without prevarication: 'Why do I feel I'm so important, when I know I'm not?' He makes statements that encompass the ambiguity of human experience: 'Nothing is important; everything is… I don't know why I'm here, but I'm glad I am – I'd rather be here than not… I am going to die and I want to live for ever. I can't escape the fact, and I can't let go of the desire.'[2]

2 This last remark comes from 'Damien Hirst and Sophie Calle,' op. cit.

He works with a similar going-for-broke courage. *Gambler* was the title given to an exhibition that he curated. 'Playing to lose' was his ironic assessment of his position. Invariably, he wins. He wants to know where he fits in; where we all do. Key memories: once he said to his grandmother, 'I still feel as confused as when I

was seven.' She replied, 'So do I.' He felt alienated in the supermarket and told his mother, 'I don't really feel like I'm part of all this.' 'Neither do I,' she admitted. He realized that no one did.[3]

3 From 'Damien Hirst and Sophie Calle,' op. cit.

Hirst lives on a council estate in Brixton, built in the shape of a vast wall punctured by windows – a shit-coloured cell block where lifts are broken, landings are strewn with rubble and plants are dead. No one could feel at home there. *In and Out of Love*, 1991 (NIC) was an installation in a space off Oxford Street, London. Malaysian butterflies hatched from pupae attached to white canvases. Their brief lives were spent in the confines of the gallery – sipping sugar water, mating, laying eggs and dying in the simulated climate of a tropical rain forest. Downstairs, specimens were embedded in the gloss paint of monochrome canvases; beautiful but dead. Two ways of viewing the same thing – as living organisms or as aesthetic objects. Two ways of viewing art – as a creative process that mirrors life, or as a collection of masterpieces.

Hirst espouses the former approach. His work takes numerous forms and functions as a series of propositions. He seduces one into considering the big issues – death, life, living death, meaningful living, belonging, alienation – without getting mired in maudlin expressionism. The brief existence of the butterflies, trapped in an urban environment remote from their natural habitat, provoked contemplation of the quality and purpose of life, of one's own brief span, and of survival in general; ours and that of other species. In all his work life's processes are rigorously framed and contained within minimalist geometry. 'Art is about life,' says Hirst. 'It has to be – there's nothing else. Through the formalism you can make people think about things they don't want to.'

In and Out of Love was beautiful, languid and melancholic. *A Thousand Years*, 1990 (p.153), which also features the life cycle of an insect, is busy and repellent. Two glass cubes, the size of museum display cabinets, enclose a white cube containing thousands of maggots. The blue bottles hatch, fly next door, feed on a rotting cow's head, mate, lay eggs, buzz about, stumble into an insect-o-cutor and die. This dismal spectacle, of sordid circumstance and elegantly framed putrefaction, engenders confusion. The formal and conceptual clarity of the sculpture makes it admirable and monstrous in equal measure. Can one feel sympathy for a fly? Most people kill them without compunction; they even hang insect-o-cutors in vegetarian restaurants. But to give the insects life, then watch them die randomly is too much like bread and circuses. Yet the life cycle of a fly is irrevocably bound up with death; they spread disease and maggots hasten decay. The sculpture merely reiterates this stark fact.

One of Hirst's most dramatic works to date, *The Physical Impossibility of Death in the Mind of Someone Living*, 1991 (p.152), is a fourteen-foot tiger shark preserved in a tank of formaldehyde, a colourless liquid that resembles water so that,

at first glance, the creature appears alive. The dark, silent shape – small eyes, powerful, streamlined body and razor-sharp teeth –. embodies ruthless, destructive efficiency. We link sharks with death, while the film *Jaws* transformed the creature into a metaphor for the unknown, the fearful and the repressed – an embodiment of evil whose swift, underwater invisibility engenders visceral paranoia.

'I access people's worst fears,' says Hirst. 'I like the idea of a thing to describe a feeling.' [4] The sculpture brings hunter and hunted face to face. Why are we so fascinated by animals that kill and eat us? They play havoc with our value systems; they make us aware that we are meat, part of the food chain. They puncture our monstrous arrogance and the belief, enshrined in our religion, that we have the right to exploit other species: 'and the dread of you shall be upon every beast of the Earth, and upon every fowl of the air; with all wherewith the ground teemeth, and all the fishes of the sea, into your hands are they delivered. Every moving thing that liveth shall be food for you.' [5]

4 From 'Damien Hirst' in *Frieze*, pilot issue, 1991

5 *Genesis*, chapter 9 verse 2

The shark tank – three cubes bolted together – was built by the company that made the aquaria for Brighton's 'Sea World'. The preservation of animals in zoos and aquaria is a vexed issue – what does their captivity achieve? The sculpture acts as a gateway to the moral maze of conservation. The great white shark, which Hirst planned to use, was declared a protected species three days before he placed his order in Australia. The extraordinary tension of the piece comes from its neutrality; from raising issues, yet refusing argument. The work offers drama without catharsis, confrontation without resolution, and provocation without redress. Responsibility is returned to the viewer.

Since nature is not benign, is moral living possible? Life is sustained by death; in order to eat something we kill it. Hirst is not callous; he simply points out the irony of the situation. For the 1993 Venice Biennale, he sliced in half a cow and calf, preserved them in two tanks of formaldehyde and presented them as walk-through sculptures entitled *Mother and Child Divided* (NIC). Flattened against the glass walls, the landscape of each animal's interior was revealed as a delicate convolution of channels and ducts; fascinating rather than repellent. The butchery of the mother and child had been a commonplace event. Confrontation with the complex inner workings of their bodies, on the other hand, provoked unaccustomed feelings of empathy and identification. In *The Lovers (Spontaneous, Committed, Detached, Compromising)*, 1991 (p.160) the brains and entrails of two cows have been removed from their separate bodies to share the same preserving jars. One's response to this inventory of vital organs is dismay. As Helen Chadwick has pointed out, we generally treat internal organs as the 'hidden profane'. 'Meat reveals the links between what we eat and what we are – the human as animal', I wrote about her work. 'Attention shifts from external form, (the body as object of desire and aesthetic contemplation), to the inner workings (the body as process,

6 Sarah Kent, 'Border Territory' in *Lifelines*, Tate Gallery Liverpool, 1989, p.24

flesh governed by appetites oral, sexual and intellectual).' [6] Death and its relationship to life – the deaths that we unthinkingly inflict to sustain ourselves – is a recurrent theme.

Hirst enjoys paradox. That which cures can also kill. As a child, his stomach had to be pumped after he mistook pills for sweets. The drugs in his wall cabinets offer a model of the body – those at the top are for the head, those at the bottom for ailments of the feet, and so on. 'I use pills as metaphors for people, like cigarettes', he says. 'Ashtrays are like graveyards.' We cling to the notion that drugs can save us from sickness and decline. But Hirst's cabinets contain drugs that have (or soon will have) degenerated and crossed the divide between panacea and poison.

Isolated Elements Swimming in the Same Direction For the Purpose of Understanding, 1991 (pp.154-5) consists of thirty-eight different species of fish, bought at Billingsgate Market and preserved in formaldehyde. The separate tanks are arranged on shelves like laboratory specimens – parodying our obsession with ordering and classification. Watching fish swim is said to soothe anxiety, but Hirst's pallid shoal frustrates expectations – the fish simulate swimming in a poisonous medium and are inedible as well as lifeless.

Irony, absurdity, incredulity, parody; these are some of the weapons used by Hirst to pose the questions of childhood. The directness of his approach makes a mockery of adult attempts at explanation and their tendency to accumulate information but destroy wonder. The delight of Damien Hirst's work arises from his acceptance of the inexplicable. Alongside irony comes awe.

GARY HUME

I don't ask what painting is, the question has no relevance to me. I like its absolute basicness. Its a very human activity; we've been doing it for thousands of years. I'm an ancient Egyptian with caveman ancestry. Gary Hume

Gary Hume calls his early canvases 'pictures', because they are faithful representations; yet they appear completely abstract. The surface texture alerts you to the fact that these are not tasteful essays in minimalism. The canvases are choked with creamy layers of inert household gloss. Brushmarks are evident, but they have as much significance as a decorator's drips.

The colours, magnolia and mint white, evoke the impersonal cleanliness of a kitchen, clinic or canteen. Buried within the thick skins are geometric shapes – circles, squares and rectangles – their forms built up by even greater thicknesses

of paint. The shapes repeat in perfect symmetry around a central vertical. The sparsest configuration – two circles above two vertical rectangles – has strong anthropomorphic overtones but these are frequently diluted by the addition of two large, horizontal rectangles across the bottom.

Recognition suddenly takes hold. They are doors; the heavy swing doors found in institutions like hospitals, which open both ways, have windows so you can see someone coming and large kick plates to accommodate metal trolleys, beds, wheelchairs and people with their hands full. The life-sized images are based on doors in Bart's Hospital. 'I didn't want them to have class references: grand versus council flat,' says Hume, 'or to show aspiration and design consciousness. So I chose the kind of doors that we all go through at one time or another.'

Neither quite pictures *of* doors, nor pictures *as* doors, the paintings raise curious ontological questions. Each set of doors is perpetually united on a single canvas: an image rather than an object. But the thick paint is not a grunge imitation. Rather than faking the look of a door's age and usage, the layers record the history of the picture: the application of a thick coat of paint, sanding it down, applying another, until the canvas weave is obliterated, choked and muffled. Later versions painted on MDF board or honeycomb aluminium panels are more like doors and less like pictures – non-functioning architecture that frustrates the user, rather than paintings offering escape to the dreamer.

Hospital doors swing back and forth with an oppressive thud, but the paintings are seductive, silent and insistently shut; emblems of our comings and goings, our entrances and exits. On one level they are utterly banal, on another, profound. 'I wanted to make pictures that are classic; absolutely simple and highly sophisticated, a common sign,' says Hume; 'metaphors for the decisions taken in life and for the anxiety of all those questions such as what? where? how? and when?'

Generic signs are turned into symbols representing the span of a human life which, in our society, is monitored and circumscribed from hospital birth right through to institutionalized death. Minimalist idealism is subverted to become its dystopian opposite: a jaundiced emblem of subjecthood. A later door, painted red, green, white, blue, black and cream so that it resembles a flag, is titled in mock pomposity *Symbolic Representation of the Journey from the Cradle to the Grave and Beyond*, 1991 (NIC). But Hume does not labour significance. The paintings skid past rather than pin down meaning.

The introduction of colour shoves one's reading in the direction of abstraction. *Dream*, 1991 (NIC), for instance, is painted in pale and dark blue, cream and grey. Irony has melted away to be replaced by questions of taste. 'I started to become an aesthete,' recalls Hume, 'putting a beautiful green next to a beautiful pink, so I asked other people, not artists, to do the paintings for me.'

The *Dolphin Series* are multi-panel pieces, based on a variety of Bart's doors,

butted together and aligned along the top to provide a ragged lower edge. Hume gave his collaborators cut-outs of the shapes to be painted and a thousand colours to choose from, but restricted them to two per door. The four panels of *Dolphin Painting IV*, 1991 (NIC) are green and red, pink and grey, black and two yellows; the four panels of *Dolphin Painting I*, 1990-91 (pp.162-3) are black, dark blue and two shades of pink. The MDF support creates surfaces so glossy that they reflect their surroundings; it is as though Hume is determined to destroy any idea of the picture as a self-contained entity or a meditative space. Relentlessly superficial, the paintings deny both depth and profundity. 'The surface is all you get of me,' Hume once said.[1]

He continued to paint his own versions of doors. *Incubus*, 1991 (NIC) is a triptych in shades of pink, *More Fucking Values*, 1991 (NIC) a diptych in black, white and grey, whose title indicates a growing frustration with the niceties of painterly decision-making. In 1989 Hume described the doors as 'a potentially endless series'; the break came when he cut door configurations out of green tarpaulins and hung them as an installation of putative exits and entrances.

Once the switch to new imagery had been made, ideas began to pour out in perplexing variety. *Man, Woman, Jealousy and Passion*, 1993 (p.166) consists of the yellow silhouette of a standing nude on a soft grey ground. A smiling female mouth has been attached to an otherwise featureless face, but the head is divided by a vertical line to create a dual image: one person striding away from you, another turning towards you.

This is one of a series of ambiguous figures inspired by the marble athletes carved for Mussolini's Olympic stadium in Rome. Flanked by the green flower of envy and the earth-red flower of passion, this homo-erotic presence is reminiscent of Richard Hamilton's *Adonis in Y- fronts*, 1962, a painting and collage of a bodybuilder working a chest expander. But whereas the pop painter handled his materials with the fastidious refinement of a craftsman, Hume lays his canvases on the floor and puddles on a single layer of glutinous gloss to dry into a syrupy skin that is without movement or vitality. The outlines of earlier forms are often buried within its contours, the only indication that the paintings have a history and that the images do not arrive ready-made.

Patsy Kensit, 1994 (NIC), the actress, is painted mat pink on a gloss apricot ground; a blank face sucking its thumb. Her mouth is outlined in green, but other features are buried within the paint, like shapes vacuum-formed in plastic, so the face reads as a mask held up by an arm. A descendant of Warhol's silkscreened celebrities, her identity has been obliterated even more emphatically than theirs. Warhol's images seem almost euphoric when compared with this degree of erasure. 'The images are pop, because this is part of our culture,' says Hume. 'But there's no romance or idealism, you can't be celebratory any more.' *Tony*

1 Quoted by Adrian Searle in 'Shut that Door', *Frieze*, Summer 1993, p.48

Blackburn, 1994 (p.165) is a black, three-leaf clover haloed in a dome of black hair on a pink and yellow ground. Both icons represent a peculiarly British form of failure: the disc jockey because he was sacked from BBC Radio for pouring out his troubles on air, the actress because her success was limited by her island context.

If anything, the recent paintings are about loss; making do and getting by after one's hopes and dreams have died. *Two Three Leaf Clovers*, 1994 (p.164) is an emblem of pragmatism; making do with the possible, rather than harbouring unrealizable goals and ambitions. Both Patsy Kensit and the clover are painted in matt, pastel colours with a large admixture of white that robs them of vitality, to create a sense of enervation and melancholy.

Yet a wayward optimism persists. *Bear*, 1994 (NIC) is a bright blue teddy with black gloss dots for eyes. He is flanked by two three-leafed clovers suggesting resilience and, buried within the form, is a hand giving the thumbs-up sign. Things may not be good, it suggests, but that is okay. These dumb emblems have an endearing, full-frontal naivety. But one shouldn't be misled by their apparent stupidity. Buried within the thick skins are dark observations about our one-dimensional culture. Like the doors, they are a lot wiser than they let on.

ALEX LANDRUM

In the West we went from painting of presence to painting as presence; I mean that painting ceased to represent this thing or that – gods, ideas, naked young women, mountains, or bottles – in order simply to present itself: painting does not seek to be representation but presence. Baudelaire was the first to note this change and also the first to note the contradiction. Colour, he said, thinks for itself. Now if colour really thinks, it destroys itself as presence; it transforms itself into sign. Language, signs, are not presence but what points to presence, what signifies it. Modern painting lives within this contradiction between language and presence; more exactly, it lives thanks to it. Octavio Paz [1]

1 Octavio Paz, *Convergences*, Bloomsbury, 1987, p.250

Alex Landrum studied sculpture and he regards his paintings primarily as objects: 'images of sculpture'. The proportions of his canvases are derived from old masters so as to affirm, subliminally, their status as artworks; 'certain rectangles lend themselves to being seen as paintings,' he says. The measurements of *Ecstacy*, 1990, are based, for instance, on Poussin's *Adoration of the Golden Calf*. The geometry that lent clarity to the original composition and emphasized its moral dimension now determines the proportions of an abstract canvas.

Ecstasy is painted the deep pink of raspberry cordial, the colour that an advertising company might employ to suggest an after-glow of satisfaction. Its synthetic charm reminds one that utopian dreamers are accused of viewing the world through rose-tinted spectacles. Idealism no longer seems an option. Landrum's paintings are not 'pure' minimalist statements, but an acknowledgement of loss of belief or, rather, its corruption into sentimentality and the replacement, in our consumer society, of hope by desire and artificially stimulated appetite; 'I am more interested in the material, the quotidian, than in metaphysical utopianism.'

To establish links with the everyday, Landrum uses household paints. Four layers of eggshell are brushed on uniformly and sanded down to a perfectly smooth finish: 'like something that a well-trained apprentice from a painting and decorating college would do.' The colours are chosen from the 1700 paints produced by Dulux in their 'Mix and Match' range and are selected as much for their names as their appearance, since these provide the paintings with their titles.

Paint manufacturers understand the power of words. They employ poets and advertising men to invent names which seduce buyers into thinking that household paint is as sexy as satin and as appetising as food. *Raven's Cry, Night Velvet, Secret Wood, Still Water* and *Dark Passion* propagate belief in the power of colour to ensure happiness and security or to stimulate romance and passion.

Landrum integrates name and pigment. He attaches the cut-out letters to the canvas before applying the paint, so that the name is embedded in the colour it refers to. The embossed words look as though they are carved in stone; they remind one of the names of the departed etched on tombstones. These melancholy paintings are like memorial plaques mourning the loss of the idealism once embodied in art.

Wassily Kandinsky, one of the pioneers of abstraction, believed that colour was a force for spiritual regeneration: 'colour directly influences the soul,' he wrote. 'The artist is the hand that plays, with colour as the keyboard and the soul as the piano.' [2] The philosopher Henri Bergson argued that 'direct communication can take place on a primary visual (pre-verbal) level.' [3] Convictions like these provided the foundation for abstraction, an art that would bypass language and affect the viewer directly. Abstraction seemed to offer mind to mind communication free, like Hugo Ball's phonetic poetry, of 'the language corrupted and rendered unusable by journalism'. [4]

But Kandinsky and Bergson were unaware of the degree to which experience is governed by language. The physiology of the eye is constant the world over, but the perception of colour varies widely from one culture to another. Language, the way colours are described and accorded significance, modifies vision. Ernst Cassirer neatly phrased it: 'Man not only thinks of the world by means of language. His vision of the world is predetermined by his language.' [5]

2 Wassily Kandinsky, *Concerning the Spiritual in Art*, Wittenborn, 1947

3 Henri Bergson, *Essai Sur Les Données Immédiates de la Conscience*, Paris, 1904

4 Hugo Ball quoted by Octavio Paz, op. cit., p.3

5 Ernst Cassirer quoted by Octavio Paz, op. cit., p.28

Big Brother understood the power of language to control thought. In *Nineteen Eighty-Four* George Orwell had him banning words that allowed the formulation of deviant ideas and inventing new ones to enforce correct thinking. Orwell implies that every part of our being is subject to control; there are no sacred recesses; the onlooker who can step outside his or her culture is a myth. Jean-François Lyotard described the self as an entity permeated by language: 'a post through which various kinds of messages pass'. 'A self does not amount to much,' he wrote; 'each exists in a fabric of relations…a person is always located at "nodal points" of specific communications circuits.' [6]

6 Jean-François Lyotard, *The Postmodern Condition: A Report on Knowledge*, Manchester University Press, 1984, p.15

Landrum's paintings demonstrate the discrepancy between the modernist belief in pure sensation and the postmodern realization that even colour is contaminated by language. But the paintings are highly paradoxical, since they accommodate both sets of ideas. Saturated in often beautiful colour, the canvases seem to confirm Kandinsky's vision of an art unpolluted by worldliness. The letters, on the other hand, demonstrate the invasive power of the word.

Wrestling for dominance, the two sets of information exemplify 'the contradiction between language and presence' referred to by Octavio Paz. The fields of colour emphasize presence, the letters vitiate the integrity of the surfaces that support them by triggering a rush of trashy associations. The colour refers to itself, the letters direct attention elsewhere. 'By its very nature', remarks Paz, 'writing always goes beyond itself; what we are looking for is not in the writing, except as a pointer or an indication: the writing cancels itself out and tells us that what we are searching for lies *further on*.' [7]

7 Octavio Paz, op. cit., p.252

The paintings are therefore a battleground of conflicting concepts; of the modernist view of the subject as a sovereign entity and art as an autonomous realm versus the postmodern realization that no borders are inviolable.

Landrum pairs the paintings to imply a narrative connection and further to pollute the 'purity' of the colour. The deep green of *Secret Wood* addresses the plum magenta of *Dark Passion* to suggest the melodrama of a Gothic novel or a Mills and Boon romance. The crisp yellow of *Desert Dawn* and the fresh blue of *Cool Oasis* conjure the clear light and broad horizons of a Hollywood film like *The Sheltering Sky*. The soft green and beige of *Valley Slope* and *Weathered Stone* evoke twin sets in the Lake District; the scene of an Agatha Christie murder?

One fights to keep the fields of colour free from trivial associations, but the insidious nonsense seeps in. Foolish screenplays rattle round one's head alongside images of pretentious living-rooms and Kentish Town kitchens which mimic Provençal farmhouses; as unwelcome as junk mail. The landscape of art collides and colludes with that of advertizing; abstract canvases invite inane projections.

By making the words almost invisible, though, Landrum delays the process and makes it possible to experience the mechanism through which ideas are planted

and associations activated. His deceptively simple paintings exemplify the way that 'pure sensation' is corrupted by ideas and associations that, once planted, are impossible to weed out. Advertizers now join with journalists in exploiting language to feed us myths and fables that lodge themselves in the collective psyche. By exposing the process, Landrum's paintings perform the function demanded of intellectuals by Michel Foucault: 'to lay bare the mechanisms of power. …to provide instruments of analysis…in other words, a topological and geological survey of the battlefield.' [8]

8 Michel Foucault quoted by Jeffrey Weeks in 'Uses and Abuses of Michel Foucault' in *Ideas from France*, ed. Lisa Appignanesi, Institute of Contemporary Arts, 1985, p.23

If Orwell was correct, conformism would be assured and rebellious thought and action denied. Since this is not the case, resistance to the colonization of thought and perception must still be possible. 'I still believe in the possibility of subjective expression,' insists Alex Landrum. 'Consciousness has not been totally invaded by forces outside our control. I still have dreams – and that is evidence of an inner world.' But it requires vigilance, and his work testifies to the struggle.

ABIGAIL LANE

Abigail Lane's *Ink Pads*, 1991-2 (pp.171 & 176) are beautiful but highly paradoxical objects. The humble ink pad has been transformed into a secular icon. Four shallow aluminium boxes, eight feet tall, hang on the wall, their lids folded back like the doors of an altarpiece. Each contains a felt pad impregnated with black ink to resemble a large abstract painting. As the ink dries, it is replenished with a sponge so that the surfaces remain saturated, moist and extremely sensuous. The sponge leaves traces which parody gesture, but the marks are random and procedural, rather than aesthetic, and are continually remade. The imagery is never completed; it does not reach a conclusion.

Jackson Pollock described his paintings as 'energy and motion made visible – memories arrested in space' [1], so portraying the canvas as a record of the creative moment which allows the viewer access to the artist's thoughts and actions. In her work Lane explores and frequently severs this primary link, which is crucial to traditional notions of authenticity and meaning.

1 Quoted by Ellen G. Landau, *Jackson Pollock*, Thames & Hudson, 1989, p.182

Ink pads are normally the source rather than the site of mark making, objects to be used rather than looked at: potential rather than product. Lane's ink pads therefore play havoc with the idea of a painting as the trace or distillation of prior actions or, in Harold Rosenberg's words, a 'gesturing with materials'. [2] Unlike paintings, they seem to speak in the future tense. The retrospection implicit in the

2 Harold Rosenberg, 'The American Action Painters' in Herschel B. Chipp, *Theories of Modern Art*, University of California Press, 1968, p.570

notion of 'memories arrested in space' is replaced with a sense of imminence, the anticipation of gestures yet to come.

Jean Baudrillard described the traditional relationship between artist and artwork in terms of a scene and its mirror. But today, he writes, 'the scene and mirror no longer exist; instead, there is a screen and a network. In place of the reflexive transcendence of mirror and scene, there is a nonreflecting surface, an immanent surface where operations unfold – the smooth operational surface of communication.' [3] Although there is no connection between his words and her work, Baudrillard's description of a surface 'where operations unfold' provides a remarkably apt description of Lane's ink pads.

3 Jean Baudrillard, 'The Ecstacy of Communication' in Hal Foster, *The Anti-Aesthetic: Essays on Postmodern Culture*, Bay Press, 1983, p.126

In a new series the pads are impregnated with blue ink, a colour strongly associated with Christian imagery. Lane's use of saturated blue echoes Yves Klein's sublime canvases and reminds one of Anish Kapoor's use of raw pigment to lend vibrance to his sculptures. The work of all three artists has an aura of spirituality and a heightened emotional intensity, despite the fact that it seems essentially impersonal; devoid of mark-making.

The impulse to leave one's mark on the world is strong; traces left by artists, especially their signatures, tend to be treated with exaggerated reverence. The cave painters left their handprints on the rock faces of Lascaux and Altamira as indelible signs of presence. Richard Long has stamped his hand and foot prints on numerous gallery walls and floors as a sign of solidarity with the primitive impulse and as a symbol of his own artistic journey. Photographers often isolate an artist's hands, as if they were the embodiment as well as the instrument of genius.

In *Evidence*, 1989 (NIC) two rubber stamps engraved with the outline of the artist's hands are exhibited in vitrines, as though they were holy relics. *Making History,* 1992 (NIC) consists of a pair of simple clogs whose rubber soles have been engraved with footprints. When they are inked up, the wearer leaves a trail of footprints that may or may not be their own. Divorced from the host body, the imprint no longer provides reliable evidence. The almost sacred identification of the body with its traces is severed; the cult of authorship is ridiculed.

The shoes provide a contrast between the barefoot and the shod, the 'primitive' and the civilized, the low-tech past and the computerized present. To Robinson Crusoe the footprint in the sand provided indisputable evidence of a native presence, but technology has long since complicated this simple relationship. As ways of creating and duplicating images rapidly advance, traces detach themselves from authors. Theoretically, at least, a trail can be laid that has no human source. 'Technologies', writes Kim Sawchuk, 'make possible the doubling of life, giving a new force to the power of the imaginary and the memory trace to dominate and completely substitute the real.' [4]

4 Kim Sawchuk, 'A Tale of Inscription/Fashion Statements' in Arthur & Marilousie Kroker, *Body Invaders*, Macmillan, 1988, p.72

Conspiracy, 1992 (NIC) is a game for two players, each provided with a set of

stamps that replicates the artist's fingerprints. It is the job of the participants to implicate her in a crime that they have staged, and her responsibility to undermine the evidence with a conflicting set of data.

If you sit on the chair of *Reference Point*, 1992 (NIC) you are faced with a print resembling a Rorschach blot. The realization quickly dawns that it is the print of a bottom, that the chair seat has been replaced by an ink pad and that, inadvertently, you are in the process of creating the next, clothed image. Past, present and future confront one another in a circular dialogue enlivened by an ironic, in-your-face confrontation with naked buttocks.

Printed onto wallpaper, buttocks rain down the gallery walls, like the bowler-hatted men in Magritte's painting *Golconde* (1953). Floating freely in defiance of gravity, the blue prints evoke angelic hosts as much as blue movies. Details of skin texture induce thoughts of intimacy, but the seduction of proximity is denied by the impersonality of emotional distance. The images are erotic yet passionless, actual yet elusive. Ardour is numbed by repetition; Yves Klein meets Andy Warhol. The bottom prints are facsimiles that imitate mass-production; yet each one is unique, the result of direct contact with the model's body. Concepts of authorship and originality are queried once again.

House & Occupants I and *II*, 1991 (p.173) explore the allied issues of categorization and status. The sculpture gallery at the Victoria and Albert Museum includes a mélange of objects from different times and places; original carvings rub shoulders with copies and plaster casts. Lane's photographs of the gallery further complicate the issue by making no distinction between visitors, guards, exhibits and their reflections. Objects and people are seen through or mirrored in the glass display cases, and all are accorded equal status. The relative importance of a person and their reflection, of an original, a copy and a cast becomes irrelevant; all are reduced to images that can be infinitely replicated. Once circulated as a set of signs, all things are equal; 'there is nothing', writes Hilary Lawson, 'beyond the play of differences of the signifiers.' [5]

Mounted behind blocks of thick glass the prints require one to consider the influence of display and presentation on judgement and understanding. Meanings are not fixed or static. Objects are perceived variously in different contexts and by successive generations. 'People continually try to make sense of things by categorizing and contextualizing them', remarks Lane. 'Objects in museums are treated as relics, but history is a shifting story, its coherence is apparent rather than real; tentative and fragile. All the labels in the V&A were changed to make them more politically correct. They should have left up the old ones; they are as much a part of history as the exhibits. Each time you add another page, it alters all those that have gone before. But the process is not futile; it doesn't matter that the results are imperfect, there's pleasure to be had at every stage. I'm not a nihilist.'

5 Hilary Lawson, *Reflexivity*, Hutchinson, 1985, p.106

Lane sees art as a way of forging a coherent thread out of disparate moments, of leaving traces from which others can piece together a history. 'The process is like knitting. A thread builds up to a block, which looks like an object. The last stitch holds the key; if you drop it, all the rest may unravel and disintegrate.'

When Harold Rosenberg claimed Abstract Expressionist outpourings as primary traces, 'expressions of a pure state', Clement Greenberg denounced him for reducing art to 'the record of solipsistic "gestures" that could have no meaning whatsoever as art – gestures that belonged to the same reality that breathing and thumbprints, love affairs and wars, but not works of art, belonged to.' [6]

6 Clement Greenberg, 'How Art Writing Earns its Bad Name' reprinted in Herschel B. Chipp, op. cit., p.569

Abigail Lane's work can be seen as a series of ironic meditations on the nature and importance of the trace or sign. She produces foot, thumb and bottom prints as art, then distances them from their source by replicating them. Does the act of severance save them from the solipsism that Greenberg complained of, or does divorce from their author deny them the immediacy and authenticity claimed by Pollock and Rosenberg? Does it matter? Lane's actions make the argument look singularly dated and irrelevant.

Lane continues her bid to confuse the categories and codes. Two recent sculptures consist of waxworks. On a scale from original to copy, what status would one accord these three-dimensional replicas? A grisly future project blurs even further the boundaries between meaningful and involuntary gesture. Lane plans to make wallpaper printed with facsimiles of the bloodstains splattered by murder victims at the very moment of death. These final traces, 'expressions of a pure state', of being or of ending, would make unbearably poignant artworks. Doubtless, the marks would bear an uncanny resemblance to Jackson Pollock's splatters of paint. Would they be meaningful signs, though, or arbitrary gestures?

LANGLANDS & BELL

Let us ask...how things work at the level of on-going subjugation, at the level of those continuous and uninterrupted processes which subject our bodies, govern our gestures, dictate our behaviours etc. In other words, rather than ask ourselves how the sovereign appears to us in his lofty isolation, we should try to discover how it is that the subjects are gradually, progressively, really and materially constituted through a multiplicity of organisms, forces, energies, materials, desires, thoughts etc. We should try to grasp subjection in its material instance as a constitution of subjects. Michel Foucault [1]

1 Michel Foucault quoted by Ian Hacking in *Foucault; A Critical Reader* (ed. David Couzens Hoy), Basil Blackwell, 1986, pp.35-6

One tends to think of the façade as the important aspect of a building's presence, the face with which it impresses, admonishes, terrifies, cajoles or reassures the populace. Victorian musuems and town halls were built in city centres, their imposing neoclassical frontages the embodiment of civic pride. The museum emphasized cultural supremacy and dominion, while the town hall was a statement of power and stability. But those splendid Victorian palaces have been turned into banks and arts centres. Local government has moved to the periphery and the new town halls are located in anonymous office blocks, the embodiment of faceless bureaucracy.

The change mirrors Michel Foucault's argument that power is no longer invested in a single office or person, but is spread throughout the social organism in a multiplicity of forms of management – medical, judicial, economic, political, moral and so on. 'Power is not like two adversaries confronting each other; it is comparable to "government" in a broad sense, where to govern means "to structure the field of eventual actions of others."' [2]

2 David Couzens Hoy (ed.), *Foucault; A Critical Reader*, op. cit., pp.134-5

In order to understand the dispersal of power throughout the social body, Foucault analyzed institutions such as schools, libraries, hospitals, prisons and barracks. Ben Langlands and Nikki Bell concentrate more on the structures of international organizations, but their approach is essentially similar: 'The history of architecture', they say, 'is the history of structures of power. We choose buildings because of what they represent, rather than because of their architectural interest; because of the way that they embody their purpose, rather than the quality of their design.'

They ignore the façade, or elevation, and focus on the plan. 'The plan', said Le Corbusier, 'is the generator.' [3] It reveals the hidden geometry that structures the relations of those housed within. 'Every plan is an agenda,' argue Langlands & Bell, 'a metaphor for the social organization that the building embodies. We are not interested in physical presence, in public demonstrations of power – as in churches, town halls and palaces. These have been replaced by less visible and much more pervasive forms of power.'

3 Le Corbusier quoted by Adrian Dannatt, Langlands & Bell, vis Campagna, Langlands & Bell, Valentina Moncarda, Paley Wright, 1991, p.6

'We shape our buildings and, thereafter, they shape us,' [4] say Langlands & Bell, but they make no judgements as to whether this interaction is repressive or benign. Their work retains an impartiality as impeccable as a judicial hearing. They slice through the chosen buildings and present, in low relief, a bird's eye view of their inner workings. Lacquered pure white, their models transform the architecture into a ghostly fossil or skeleton, as though the flesh had been stripped away in order to reveal the structure that articulates it. Their cool appraisal is comparable to the method of an archaeologist, anthropologist or geologist; the buildings are perceived as specimens.

4 Langlands & Bell interviewed by Adrian Dannatt in *Flash Art*, November 1991, p.110

Germany is home to numerous multinational corporations whose headquarters

are an expression of the company's identity. The plans of their office blocks are frequently based on simple geometric forms; Unilever, Hamburg is triangular; Rank Xerox, Düsseldorf consists of three hexagons forming a triangle; Messeturm, Frankfurt is a hexagon inscribed in a square and BMW, München consists of a circle surrounded by four others. So clear are the images that, subliminally, they function almost as logos. 'The people who work for the company and those who visit the company are imprinted with the agenda of the company, through the plan of the building', argue Langlands & Bell.[5] They present the plans on coloured mounts so that the shapes float like delicate emblems, as iconic as badges.

5 Langlands & Bell, op. cit.

Many of the chosen buildings – the UN Security Council, New York; The European Foundation for the Improvement of Living and Working Conditions, Dublin; the European Court of Human Rights, Strasbourg and the International Court of Justice, The Hague – reflect the growing importance of an international network of organizations, which operates over and above local and national controls. Langlands & Bell's model of the Council of Europe, Strasbourg demonstrates how the architecture and seating plan focus attention on the President and Secretary beneath whose gaze stands the podium for the speaker. Structural and decorative elements converge in a glorious, organic crescendo; a declaration of the authority vested in the President. The press survey this arena of self-aggrandizement from behind. The debating chamber of the UN Security Council, New York, on the other hand, is laid out democratically, as the segment of a circle in which no one has pride of place. The delegates face the press benches, so that the sessions are like performances staged for the media.

People understand the symbolic significance of spatial relations. *Negotiating Table*, 1991 (NIC) is an oval table whose shape and proportions are based on those of the negotiating table of the International Monetary Fund's headquarters in Paris, chosen by Langlands & Bell because 'economic exchange is the key expression of international communication'.[6] While they were working on the sculpture, a newspaper headline asking 'What Shape Peace Table?' announced that the Geneva peace talks between James Baker and Tariq Aziz had been held up by arguments over the furniture. Options included a round table, a triangular table and two sofas facing one another.

6 Langlands & Bell, op. cit., p.108

Langlands & Bell frequently place their architectural models inside furniture so that presentation is dramatized as metaphor. Glass-topped tables or glass-seated chairs become display cabinets embodying the interplay between architecture, furniture and the human presence. *Maisons de Force*, 1991 (p.181) consists of a set of seven chairs containing models of seven different prisons. The incarceration of the models within the seats amplifies the restrictive function of the buildings.

The artists also make furniture, 'architecture for the body', that functions as sculpture rather than as display units. Whereas their architectural models seem

neutral, their furniture is relatively expressive. *Project for a Museum of Furniture*, 1989 (NIC) consists of a table and chair, whose slender frames and glass infill make them too fragile to use. The chair back penetrates the table top so that it is immobilized and access is denied. Locked in stasis, the two units provide a potent metaphor of negative potential. 'In the same way that the chair is the companion to the body and at the same time to the building,' say Langlands & Bell, 'so the table to us indicates society.' [7]

Furniture mediates between people and architecture and, in their work, is used to comment on the effects of buildings on their users. In *Interlocking Chairs*, 1989 (NIC) two glass-seated chairs are joined at one corner like Siamese twins. Although not completely incapacitated by their symbiosis, the elements are severely compromised by a union which impairs mobility. Social relations, on both a large and an intimate scale, the work suggests, are fraught with difficulty.

The wall reliefs are often mounted behind a passe-partout, so that the spaces appear recessed, like subterranean cells. Sheets of thick glass imprison the models within airless chambers. Their elegant entombment implies that life is being stifled by the structures that manage and direct it: 'subjugation', writes David Couzens Hoy, 'increasingly permeates and characterizes all aspects of society. Foucault is concerned to chart what he calls the process of "normalization" – the increasing rationalization, organization, and homogenization of society in modern times.' [8]

The triptych *Museums in Motion*, 1989 (NIC) includes a model of the Panopticon, designed by Jeremy Bentham in 1797 for use in the design of factories, schools, hospitals and prisons. The building is circular: a drum surmounted by a dome. The cells are placed around the drum so that a single gaoler in the central viewing tower can observe everyone. 'The object of power is everywhere penetrated by the benevolently sadistic gaze of a diffuse and anonymous power,' writes Martin Jay of the design, 'whose actual existence soon becomes superfluous to the process of discipline (since)…the external look, becomes an internalized and self-regulating mechanism.' [9]

Foucault cited the Panopticon as a metaphor for the shift from physical restraint to a more intrusive network of social control that now orders our lives. 'The shift from "atrocious" torture to humane "correction"', writes Hoy, 'may look like increased humanitarianism and progressive recognition of the autonomy of the individual. However, Foucault argues that what looks like a new respect for humanity is, rather, a more finely tuned mechanism of control of the social body, a more effective spinning of the web of power over everyday life… The whole society has become "carceral", and there is no outside.' [10] Open-plan offices and factories owe their origins to the realization that an observed workforce is obliged to function efficiently: 'our society is not one of spectacle, but of surveillance. We are neither in the amphitheatre, nor on the stage, but in the panopticon.' [11]

7 Langlands & Bell, op. cit., p.110

8 David Couzens Hoy, op. cit., p.131

9 Martin Jay in *Foucault; A Critical Reader*, op. cit., p.190

10 David Couzens Hoy, op. cit., pp.136, 138

11 Michel Foucault quoted by Martin Jay, op. cit., p.192

Langlands & Bell juxtapose the circular Panopticon with Palladio's Villa Rotunda, whose square plan offers unrestricted views of the Tuscan countryside in all directions, thereby encapsulating the Renaissance model of man as the centre of the Universe, in control of the gaze rather than subject to it. The third primary shape, the triangle, is represented by Hans Hollein's New Museum of Modern Art in Frankfurt which embodies, on its centrally located site, the idea of the city as a dynamic organism.

The artists are also interested in benign social organization. Ivrea was built outside Turin by Olivetti, as a modernist utopia. The company headquarters is shaped like three propeller blades. Sharing the site are an office block and research and development buildings, plus housing for company employees, a social welfare centre, an art gallery, theatre, cafeteria and restaurant: enlightened paternalism.

The empty cells of Langlands & Bell's models remind one of the neutron bomb, designed to leave buildings intact while destroying their inhabitants, and of utopian ideals that flourish on the drawing board but fail as social engineering. You may see the whiteness, silence and perfection of these vacant shells as memorials to broken dreams; the ghosts of modernist ambitions to enhance the quality of life by creating pleasant and ordered environments. Or you may read them as sinister traces of the creeping 'normalization' observed by Foucault, their colourless uniformity representing the ruthless supression of difference, the unremitting quest for conformity. Both interpretations are valid. The strength of the work lies in its ambiguity.

DAVID LEAPMAN

David Leapman's paintings speak with several different voices. The synthetic cheeriness of the hard-edged grounds is like acid house music at full volume. Dozens of coats of fluorescent day-glo are rolled on to build up a uniformly textured surface, like a plastic version of fancy plasterwork or fine pebble-dash. Sometimes the day-glo is mixed with ground glass to give it even greater luminosity and, in recent paintings such as *Fugitive's Fuel*, 1993 (p.185), bands of night-glo or ultraviolet, which require black light and conjure the ambience of a disco, are interspersed with the day-glo.

Across this impersonal and highly structured terrain meanders a line that seems to unravel like thought, shortly before one falls asleep. Following its wanderings is like listening to a private monologue: words spoken softly in conversation with the

self. The line is painted in interference gold and blue, a paint with mica-coated particles whose soft, pearlescent sheen reminds one of the inside of a shell; a hidden place associated, in childhood, with the murmurings of the sea.

In earlier work these ruminations journeyed across canvases that were either left raw or were stained with limpid colour that seemed to belong to the same realm of the imagination as the lines. Following the imagery is like listening to a story; one is aware of the narrative unfolding and senses that the outcome remains uncertain. In these paintings, line and ground are in accord with one another. They create an integrated world; an expression of the internal monologue that accompanies one through life.

Thin Skin, 1992 (p.184) is the first painting in which bands of hard-edged colour create a ground in raucous opposition to the whispered phrases overlaying it. Concentrating on the line is like trying to read a subtle poem against a full-volume blast of disco music that blots out thought and numbs feeling. At every moment, the flamboyant ground with its dumbly emphatic certainties threatens to drown the discursive murmurings of the upper layer. The disjunction is a telling analogue of our times; people's internal voices are being swamped by the brutal incursions of urban noise. If the bright ground belongs to the impersonal, plastic present, the fine overlay has an archaic flavour. It is as though one layer addressed contemporary experience, while the other delved into the arcane depths of species memory, and located archetypes that resonate like distant echoes of the once familiar.

Leapman's imagery is often situated on the edge of recognition and legibility. The marks could be letters of a lost alphabet or runes that are no longer decipherable. Notations resembling signs, ciphers, hieroglyphs and Arabic or Hebrew script merge with repeating patterns or the lines of a maze, encouraging one to read the pictures as conceptual rather than figurative spaces. In paintings such as *Thin Skin* and *Slowburn Escort*, 1992 (p.184), a perspective grid maps out a three-dimensional ground occupied by architectural elements and a figure. But even here the space remains ambiguous, shifting from representation to writing to a range of autonomous marks that decline to be limited to a single reading. And with no indications of scale, the cluster of geometric forms could be a box, a building or a mediaeval city.

In *Thin Skin* one can identify a staircase, a bridge, a city skyline and various architectural elements, but other marks are abstract and free-floating, as though they had yet to be pinned down, physically or linguistically. These inconsistencies demand piecemeal interpretation; as in a dream or fable, the elements do not conform to a coherent set of physical laws, but follow an internal logic that is symbolic, metonymic or metaphoric.

The linear elements look improvised, but are worked out on paper before being carefully transferred to the canvas. During the past ten years or so, the artist has

filled dozens of sketchbooks with gold and silver ink drawings for use as source material. Over that time the imagery has gradually evolved, but the theme has remained constant; the paintings chart a search or a metaphoric journey toward self-knowledge. Earlier paintings are like parables, strongly reminiscent of John Bunyan's *The Pilgrim's Progress* in their synthesis of actuality and metaphor. Titles such as *Christian Scaling the Hill of Difficulty*, 1988 (NIC) acknowledge a link with Bunyan's hero and in many paintings an ideal city, comparable to Bunyan's Paradise, can be glimpsed on the horizon.

Wary of simplistic narrative interpretations, Leapman is moving towards a greater degree of ambiguity and abstraction. Elements that featured in earlier work – winged figures, the tree of knowledge, a horn-blowing herald, walls, bridges, staircases, wells, pits, boxes, gateways, fences, mazes, mountains, churches and citadels – are now abstracted into basic forms – cubes, ovals, circles, lozenges and geometric clusters – more like archetypes than the idiosyncratic furniture of the artist's mind.

Pilot Schemer, 1992 (p.182) represents a transitional phase. The line, clearly visible on the black ground, is fairly easy to interpret. The central figure is a 'casing': a four-legged creature whose fist-like shell combines the soft curves of a padded leather glove with the angularity of brickwork. This strange hybrid has evolved from earlier figures. He appears, in a previous incarnation, as a young man sheltering within an egg-shaped aura. In later paintings the womb-like enclave has developed into an angular web in which he becomes enmeshed.

The 'casing' unites figure and envelope into a creature that carries its emotional and physical baggage on its back like a tortoise, whose shell is both protective and inhibiting. A mixture of the organic and architectural, the carapace represents the physical, mental and emotional environment in which we have our being – the various forms of entrapment and support (both hostile and benign) that accompany us through life.

Pilot Schemer is furnished with evidence of wrong turnings, false promises and misinformation, as well as with indications of hope and solace. The casing struggles toward a refuge, but is surrounded by a maze and swamped by screeds of illegible script. In the same way that Bunyan's hero Christian wanders into Doubting Castle and becomes mired in the Slow of Dispond, the casing is distracted by various entanglements, orthodoxies and forms of false knowledge.

Recent paintings are still more abstract; narrative incident gives way to the mapping and charting of roads and pathways. The markings of *Channel*, 1992 (p.183), traverse day-glo bands of red, green, yellow and deep blue. A bending figure, wooden post, box and casing are legible only with prior knowledge. All else is hieroglyph, pattern or invented script, as if the artist wanted to test the distance he could travel from legibility without falling into an abyss of the meaningless.

Leapman employs Paul Klee's technique of 'taking a line for a walk', but whereas Klee drew back from abstraction, preferring to remain in the realm of figuration, Leapman is inclined to cross the border. 'I want to break new ground formally and emotionally,' he says, 'but there's a watershed between the drawing working, in the conventional sense, and failing completely. I want to cross that boundary yet to remain sensical and meaningful.' The balance is a delicate one. The artist dips his brush into incoherence, then returns to legibility.

The fascination of his work comes from the fact that the journey he charts is twofold: it embraces his progress toward understanding and self-knowledge, and the development of a language in which to articulate this endeavour. The duality or even plurality of the recent paintings acknowledges the complexity of contemporary experience. On the one hand, there's the inner voice of the individual and, on the other, the collective noise of our media-saturated society. Klee believed that artists are able to tap into the collective unconscious. David Leapman warns us against becoming so distracted by the noise of modern technology that we are unable to hear either our internal monologue or the arcane whisperings of ancestral lore.

BRAD LOCHORE

Each of the arts is removed by its own 'primary illusion'. In painting this is virtual space – this exists as an appearance only and has no relation to the space of common sense or of science… A picture is made by deploying pigment on a piece of canvas, but the picture is not a pigment and canvas structure – the paint and ground disappear. Suzanne Langer [1]

A painting has traditionally been thought of as a window opening onto a fictive world that, although given form on the picture plane, appears to reside in a virtual space behind it. For the illusion to hold, asserts the American philosopher Suzanne Langer, the surface of the painting must not distract tbe eye from its journey into this imaginary realm. 'In artistic production,' she writes, 'the composer's materials must be completely swallowed up in the illusion they create.' [2]

When they were written, her words were already out of date. Photography had long since revealed the inadequacy of paintings as a reproduction of external reality. It was clear that painting offered a view not of nature, but of a cultural and ideological space: a projection of the artist's mind. The picture plane became more and more evident as artists deliberately clotted their canvases with paint to draw

1 Suzanne Langer quoted in Louis Arnaud Reid, *Meaning in the Arts*, Allen & Unwin, 1969, p.82

2 Langer, op. cit., p.82

attention to the surface and to the act of reading it.

Subjectivity – the quality most clearly distinguishing painting from photography – became a virtue, and painting was associated with expression rather than with verisimilitude. Emphatic paint handling became equated with emotional intensity, the laden brush with the loaded soul; marks and gestures were studied as though they produced a map of the psyche.

Recently, though, photography has lost its innocence. The camera's bias has become evident and computer manipulation now allows a photograph to present fictions as convincingly as facts. According to statistics, ten per cent of published photographs are digitally manipulated, a figure that doubtless will increase as technology improves.

Painting and photography are now on a similar footing; each presents what its maker wishes the viewer to see. 'As the truth value of photographs breaks down, it opens up an interesting space for painting,' argues Brad Lochore. 'Now painting can compete with cinema and photography.' His paintings are a meditation on these issues. They portray shadows; transitory phenomena without material substance, manifestations of the effect of light – apt metaphors for the illusory realm beyond the picture plane. The shadows are of windows, a further reference to the notion of a painting as a window.

The windows cast the pattern of a grid, a form adopted by American minimalists in the 1960s. In reaction to Abstract Expressionism they were keen to limit the personal and subjective aspects of painting in favour of the rational and universal. Artists such as Sol Lewitt argued for an art based on philosophical constructs rather than expressive outpourings or perceptual data – on the mind rather than the heart or the eye; on reason rather than feeling or the senses.

Lochore plays ironic games with minimalist tenets. His grids are shown in perspective, as though based on things seen; on perception rather than conception. The integrity of the grid and of the painting as a self-referential object are thoroughly subverted.

Lochore studied at film and television school, and for five years designed and made film sets. The business of dissembling, of creating a fiction that on film will pass for reality, made him 'very conscious of the relationship between the fictive and the real'. Langer's analysis of painting 'as a virtual rather than an actual object...nothing but a vision' [3] is more apt as a description of film, whose projected image has no material substance other than light. Lochore's paintings seem to aspire to the condition of film; his subject is light and shade, the very stuff of film images, and his canvases have a uniform sheen akin to celluloid. He uses paint thinned to a fluid gloss with linseed and clove oil so that the images seem suspended behind the surface. One cannot relate them to actual substance; there are no brushmarks or dabs of pigment to anchor them on the canvas.

3 Langer, op. cit., p.82

And like film sets, Lochore's shadows are fictions. They are computer-generated simulations made into transparencies, then projected onto the canvas to be painted. Initially he drew the images, but the results were too realistic to promote the idea of painting as a screen bearing images whose relationship to reality is ambiguous. Painting is equated with film and advertizing – realms of desire and longing.

Artworks operate on a fictive and metaphoric level, but they also exist as material objects in the here and now. Film, on the other hand, offers a dramatized version of events that is, by definition, out of reach, and advertizing portrays a mythic world available only to those magically transformed by some product. 'The publicity image', writes John Berger, 'uses only the future tense. With this you *will* become desirable. In these surroundings all your relationships *will* become happy and radiant.' [4]

4 John Berger, *Ways of Seeing*, Penguin, 1972, p.144

Lochore's paintings deny these distinctions. Seamless, hallucinatory images, slightly out of focus as though suffused in filmy evanescence, are the embodiment of romantic daydreams. This is the vertiginous terrain of spectacle and visual seduction. But it is also the terrain of frustration, disappointment and passivity in which the viewer/consumer is offered simulated experience in place of real action and palliatives instead of genuine satisfaction. 'The work is about seduction and betrayal,' says Lochore; 'the point at which the imaginary dissolves and is denied.' It is also the point at which language breaks down and the image slides off-key so that we are unable to locate it or to situate ourselves in relation to it.

In this paradoxical space painting becomes virtual reality, filled with electronically generated signs that have no signifiers; the negation of the need for an external frame of reference. 'It is representation on the verge of collapse,' says Lochore, 'at an almost Zen point where it stops speaking about anything except the act of looking.' This 'iconoclastic impulse' is a denial of painting as a mirror, a window or a space that offers confirmation and assurance. It also a denial of the transcendent potential of art; a critique of the sublime. 'The sublime is now an orgy of information on optical highways,' says Lochore, 'a cyberspace net, an absolute collapse of the real.'

In *The Human Province* Canetti describes 'a painful idea: that beyond a certain precise point in time, history was no longer real. Without being aware of it, the totality of the human race would have suddenly quit reality… Our task and our duty would now be to discover this point.' Quoting Canetti, Jean Baudrillard argues that we have already reached the point at which 'that sort of condensation, of significant crystallization of events that we call history' has ceased. 'Each event becomes inconsequential,' he argues, 'because it goes too fast – it is too quickly diffused, too far, it is seized by the circuits - it will never return to testify to itself… Moreover each cultural and factual set must be fragmented, disarticulated,

in order to enter the circuits, each language must be resolved into 0/1, into binary terms, in order to circulate no longer in our memory, but in the memories, electronic and luminous, of computers. No human language can resist the speed of light. No historical event can resist its planetary diffusion. No meaning can resist its acceleration.' [5]

By denying the physicality of paint on canvas, Brad Lochore's paintings embrace the loss of the reality principle described by Baudrillard; a state of disengagement from events which are experienced as though they were only spectacle. Perhaps he is warning us that soon we will arrive at a point of dislocation where engagement is no longer possible, because most happenings will reach us already transformed into electronic images – programmes to be absorbed sitting down, rather than events to be encountered on our feet.

5 Jean Baudrillard, 'The Year 2000 Has Already Happened' in Arthur and Marielouise Kroker, *Body Invaders*, Macmillan, 1988, pp.35-6

SARAH LUCAS

The female nude is not simply one subject among a whole range of subjects that artists have chosen to depict within the history of art; rather, it should be recognized as a particularly significant motif…(that) symbolizes the transformation of the base matter of nature into the elevated forms of culture and the spirit. The female nude can thus be understood as a means of containing femininity and female sexuality. Lynda Nead [1]

1 Lynda Nead, *The Female Nude*, Routledge, 1992, p.2

Of all the images that daily bombard our senses, the female body outnumbers other subjects by an enormous margin. We are visible everywhere – in perfume, confectionary and underwear ads, on calendars, in pornography and as Page 3 pin-ups. Yet despite this visibility, we are strangely mute; the subject of conversation rather than participants in the debate. The majority of these images are made by men for one another, evocations of the 'other' that confirm their cultural and sexual identities.

Women are infiltrating the media, but most networks are still male precincts, vehicles for masculine perceptions and opinions. The Page 3 nude is not merely an innocent amusement, as editors claim. She confirms the male right to control public discourse by affirming that women belong primarily in the private sphere – the sexual and domestic – outside the public domain of masculine action and debate. Women's issues are seen as personal problems; men's concerns are matters of universal significance. Female readers are given the women's page; men are honoured with the rest. Women's sport gets almost no coverage, men's games are

considered to be of national and international interest. The fantasy of male supremacy is hard to sustain now that the majority of women work and many are the breadwinners; but this only makes it more imperative to promote the myth.

Sarah Lucas operates as an aesthetic terrorist, pillaging mainstream culture. In so doing she acts as a mirror, monitoring the sexism and misogyny routinely found there. Her main topic is the female body as a subject in fine art and popular culture, especially the tabloid press.

Most women find Allen Jones' *Table*, 1969, gratuitously offensive. The glass top of a coffee table is screwed to the back of a female figure, scantily clad and kneeling in a submissive position so as to invite sexual abuse. Sarah Lucas likes the work because its message is unequivocal. 'I use sexist attitudes, because they are there to *be* used. I get strength from them,' she explains.

Magritte's famous painting *Rape*, 1934, in which a woman's facial features have been replaced by those of her body, so that she is denied any identity beyond the sexual, is a source of inspiration for Lucas's sculpture *Two Fried Eggs and a Kebab*, 1992 (p.192). The title is a perversion of the slang denomination of a woman as 'two fried eggs and a kipper'.

The equation of women with food is commonplace. Both as providers and as tasty morsels, one of their prime functions is seen as the gratification of masculine appetites. A second-hand table forms the support for two fried eggs and a doner kebab – slices of meat served in a vaginal envelope of pitta bread. A photograph of this configuration is propped up at the head of the table in lieu of a face. Together the elements form a putative reclining nude, an ironic antedote to the traditional model portrayed swooning in languid sensuality, the epitome of being rather than doing, of passive availability.

As a readymade, the table establishes a link betwen art and life: it acts as a pedestal for the humorous staging of the art event and refers to the arena in which the warfare of sexual politics is waged. It acts as an emblem for the missing ingredient in the story as it is traditionally portrayed: the reality of women's working lives where they function as subjects rather than as objects. The table was chosen for evidence of use and for its aura of place – kitchen, office or canteen – so as to invoke domestic and office work.

Lucas refers to the piece as 'a conversation between the ideal and the actual'; woman as beautiful seductress versus woman as domestic drudge. Her description is also an apt summary of her work. The selection of the table demonstrates her pragmatism, being content with 'the adequate rather than the great, the table I found on the day I was looking'. Such making-do demonstrates a lack of pretension which makes masculine self-aggrandisement seem ludicrously narcissistic.

'My work is about one person doing what they can. I like the handmade aspect of the work. I'm not keen to refine it: I enjoy the crappy bits round the back. When

something's good enough, it's perfect.' Thus speaks the voice of necessity, of someone who has turned her marginalization into a position of strength, a tactic advocated ten years ago by feminist artists such as Susan Hiller: 'to the extent that the artist speaks about herself as sexed, specific and particular, the work is located oppositionally… I'm a marginalized person, because as a woman in this culture I do not have a female language. I am excluded from culture and from cultural traditions.' [2]

Lucas uses her work as an offensive weapon, a way of saying 'Up Yours' to the masculine mainstream. *Receptacle of Lurid Things*, 1991 (p.191) is a plaster cast of her middle finger raised in what would, on the streets, be a gesture of abuse. Sitting atop its pedestal this tiny pink monument, a diminutive version of César's gigantic thumb, seems ludicrously small yet fiercely defiant. Directed at the art world, the gesture mocks the equation between creativity and virility. This may be only a finger, but it too can stand erect.

Figleaf in the Ointment, 1991 (p.191), consists of wax casts of the artist's armpits: cousins to Duchamp's *Wedge of Chastity*, 1951, a paradoxical object resembling a genital plug. They are like miniature Henry Moores, but the master's abstract forms, in which sexuality is sublimated as a diffused sensuality, have been defiled by the imprint of underarm hair; an acknowledgement of the smells and secretions of the body. 'I could have chosen any part of the body and achieved the same shape,' says Lucas, 'but I wanted something provocative; the strongly sexual aspect of fetishized hair – that tension between disgust and desire.'

The artist appears herself in *Great Dates*, 1992 (p.194), photographed in a leather jacket with cropped hair that makes her look like a streetwise boy. She is eating a banana, a soft porn cliché that she transforms into an assertion of female sexuality on its own terms. 'With only minor adjustments, a provocative image can become confrontational,' she says, 'converted from an offer of sexual service into a castration image.' Pages from the *Sunday Sport* newspaper, collaged onto board, form the backdrop to this act of reclamation. Gleaned from the newsstand, these pages of naked flesh show how the idea of woman-as-sexual-toy is confirmed each day for thousands of men. 'I don't take pornography as my subject, I take the acceptable stuff available at 25p: common currency, rather than the deviant or marginal,' says Lucas.

Works such as *Sod You Gits*, 1990 (p.193), were made in homage to Tom Wesselman's *Great American Nudes*, a series of pop art assemblages that reduce women to lascivious curves and inviting orifices. The *Sunday Sport* centrefold is enlarged in A5 photocopies to create a giant spread measuring seven feet by ten. The titles come from the headlines. *Sod You Gits* shows a topless, midget kiss-o-gram with a whip and leather gear, declaring, 'I'm fairly damn sexy for my size.' The *Sunday Sport* is revealing of men's attitudes. Women are sexual servants

2 Susan Hiller, 'Anthroplogy into Art' in Sarah Kent and Jacqueline Morreau, *Women's Images of Men*, Writers & Readers, 1985, p.149

and items of property. In Sharon's case 'Hubby's the minder'.

Fat, Forty and Flabulous, 1990 (p.190) tells how Reg Morris was 'so naffed off with his marsh-mallow-mound-missus' that he put his 25-stone wife up for sale with his house. She appears wearing only fishnet stockings. The 'old bat' is insatiable, says Reg, who is advertizing her as 'an old-fashioned façade in need of redecorating: like a trowel of make-up'.

Lucas treats the images as readymades and in the spirit of 'truth to materials', alters them as little as possible. 'I'm dipping into the culture, pointing a finger; directing attention to what's there. I'm not making a didactic point.' Comment is redundant; the articles damn themselves with their breathtaking misogyny. The spreads demonstrate a pathological mixture of love and loathing, of fear and desire, and the need to limit women's demands and control their appetites. Apologists would argue that they are fairy stories. Yet daily repetition, with minor variations, suggests that they satisfy needs by reflecting deep-seated antipathies.

How can women redress the psychological battering delivered by these images? Lucas sees them as 'the quicksand you have to negotiate every day', the backdrop that inhibits perception of the self as an active, autonomous being. Her work is an act of embattled defiance. The billboards are the backdrop, the amplified public noise that she must compete with to make heard her small, private voice. The casts of her armpits and finger work like talismans, warding off the evil eye of ubiquitous sexism. A pair of Doc Martins that used to be worn by the artist have had razor blades set into the toe caps to turn them into weaponry. These are not fashion items; they are sculptures as offensive footwear.

STEPHEN MURPHY

It was the family photographs, particularly those taken during June and Hilda Thompson's primary-school days, that became some of the most painful things to examine in the history of this family...the children in them not only looked perfectly normal, they could have been me or my friends at that age... Alexandra Artley [1]

In 1988 the Thompson sisters murdered their father after a lifetime of abuse. Yet their family album is filled with pictures of the smiling girls, taken by the abuser. They enact on film the fiction of a happy family, as though the celluloid myth might erase the reality. To a certain extent, all family albums are fictions: icons of happiness and security staged for the benefit of each other and forthcoming

1 Alexandra Artley quoted in Val Williams, *Who's Looking at the Family?*, Barbican Art Gallery, 1994 p.30

generations, with the pain and failure edited out. 'Snapshots', writes Val Williams, 'mirrored life as it ought to be, or as what we would wish it to be. Carefully coded, they acted as a talisman against the real.' [2] The historian Timm Starl noted that after the Second World War, German families began taking pictures only once they had something to celebrate – 'the new furniture and fittings, the new car, moving into a new house, the first television set'.[3] The humiliation of defeat and the labour of reconstruction were not deemed worthy of record.

2 Val Williams, op. cit., p.13

3 Timm Starl quoted by Val Williams, op. cit., p.19

Steven Murphy's *Untitled*, 1993, consists of fifteen photographs gleaned from his family album. By means of a computer, all the people have been removed and the holes left by their deletion knitted over as though they had never been. All traces have been erased of the individuals that differentiated these from other snapshots, leaving empty views: photographs of absence.

A lawn is littered with toys, a hosepipe snakes across the grass, an odd corner of a landscape is framed. One's eye roves around the inconsequential images, struck by odd viewpoints chosen because the subject was a child, and by awkward cropping and idiosyncratic framing; searching for a point of focus, trying to identify a motive for immortalizing this particular subject or moment.

In *Camera Lucida*, Roland Barthes names the element that triggers emotional engagement with a photograph as the 'punctum': usually an incidental detail inadvertently recorded, rather than a considered aspect of the composition. 'Certain details may "prick" me. If they do not, it is doubtless because the photographer has put them there intentionally,' he writes. 'The detail which interests me is not, or at least is not strictly, intentional, and probably must not be so; it occurs in the field of the photographed thing like a supplement that is at once inevitable and delightful.' [4]

4 Roland Barthes, *Camera Lucida*, Jonathan Cape, 1982, p.47

By erasing the elements that were knowingly framed, Murphy directs attention to the incidental details, the results of happenstance and unconscious selection. It is as though he were searching for Barthes's 'punctum', the key that would unlock the emotional field of the photographs, once their clichéd subjectmatter – the couple leaning on a stile, the children playing on a lawn – was removed.

Autobiography is not the issue. To a certain extent all snapshots are the same; we recognize potential selves in other people's pictures. 'Anonymous family photography,' writes Val Williams, 'divorced from its private context, becomes part of a universalized fiction and a national narrative.' [5] Murphy is currently working on the album of the Dutch curator Masha Roesink. The differences are negligible; the removal of her family reveals a background similar to that of all our childhoods.

5 Val Williams, op. cit., p.19

Murphy's iconoclasm parallels the Soviet Union's notorious practice of deleting from all official photographs public figures who have fallen out of favour. His decision to work with pictures of private people rather than public figures encourages consideration of the relationship between personal and collective history. To what

degree is one's sense of self governed by individual experience – by family, school, friends and so on – and to what extent by a shared understanding of history?

Memory is a crucial aspect of identity. 'We have, each of us,' writes Oliver Sacks, 'a life-story, an inner narrative – whose continuity, whose sense is our lives. It might be said that each of us constructs, and lives, a 'narrative', and that this narrative *is* us, our identities… A man needs such a narrative, a continuous inner narrative, to maintain his identity, his self.' [6] Without the context and the continuum of memory, he argues, we face the 'ever-opening abyss of amnesia' [7], the nightmare of an endless flow of happenings that are without anchorage or meaning. An amnesiac, observes Sacks, must 'make meaning, in a desperate way, continually inventing, throwing bridges over abysses of meaninglessness, the chaos that yawns continually beneath him.' [8]

The narrative that we extend day by day, like a spider letting out a gossamer thread, is a lifeline between past and present and a vital link between individual and collective experience. How do citizens of totalitarian states, where information is censored and history rewritten, construct a comparable sense of reality? Does enforced amnesia induce the disorientation observed by Oliver Sacks? Can their state of mind be likened to collective psychosis?

As computer technology advances, image manipulation becomes easier to achieve and harder to detect. Murphy questions the implications of this burgeoning potential to manipulate information and construct false histories. How can we guard against the sacrifice of truth to expediency? If veracity were to become nothing more than a relative term, what would that do to our sense of ourselves?

A padded cell that prevents contact with the external world is an apt metaphor for the denial of access to information needed to establish the truth of one's situation. *Cell*, 1994 (p.197), a computer simulation of the interior of a padded cell, warns of the impact on individual and collective psyches of the destruction of verifiable, shared experience.

Self-portrait as a Rabbit, 1992 (p.195), a freak-show hybrid of an animal's face with human teeth and eyes, evokes a crazed, B-movie scientist who has become the victim of his own experiments in genetic engineering. Knowing eyes fix us with an intense stare, the mouth opens as though to speak, but words are impossible. This bizarre mutation – of a human brain trapped inside an animal body – is as chilling an evocation of imprisonment and censorship as the padded cell. In each case, incarceration prevents communication. Surrounded by a vibrant white aura, as though it were irradiated, and floating on a magenta ground the shape of a billboard, this emblem of folly and miscalculation advertizes a corrupted future.

In *Untitled*, 1993 (p.196), a series of landscape photographs, the reassuring splendour of the natural world is underscored by the fine detail of gorgeous close-ups. But invidious messages infiltrate the field, like subliminal warnings. Gaps in

6 Oliver Sacks, *The Man Who Mistook His Wife for a Hat*, Picador, 1985, pp.105-6

7 Oliver Sacks, op. cit., p.109

8 Oliver Sacks, op. cit., p.106

the foliage of the tree canopy organize themselves into the word 'Hell'; the fungi growing on a treetrunk spell out 'Inferno'; 'Swarm' writes itself on a rockface and a skull and crossbones materialize amid scrubby vegetation. Murphy fed archive photographs into a computer; then, with meticulous care, rearranged the pond weed, reshuffled the leaves, plucked the daisy heads and knitted the backgrounds into a seemless perfection that hides the interface between host image and intruding word or symbol. Premonitions of Dystopia infect pastoral idylls.

William Burroughs described language as a virus; the bug in the machine is given a similar name, as though computers were biological organisms vulnerable to disease. Linking the two concepts, Murphy infects his landscapes with dis-ease concerning the potential for computer-generated information to infiltrate our perceptions and corrupt our mental landscapes.

Erasure, mutation, infiltration; Murphy's images are witty embodiments of the potential implicit in information control. While fearful of its misuse, he is obviously seduced by its subtle, invasive power. The Soviets believed that they could control both the past and the present. Murphy is fascinated by the science fiction fantasy that reshaping the past modifies the future. His work explores how our sense of self is embedded in time. Thirty years ago the psychologist Benjamin Libet discovered that it takes us half a second to register and analyze sensory data. Consciousness comprises retrospection and anticipation; the present is an amalgam of the past and the future.[9]

Murphy toys with the science fiction fantasy of opting out of time; of casting himself adrift from his origins, reprogramming his genetic code and launching himself into the free-fall of virtual reality. He describes a padded cell as a 'comfortable enclosure created to protect you and others from yourself'. If computers are allowed to rewrite the past and reshape the present, so that there is nothing solid against which to measure virtual reality, maybe the padded cell will become a model of sanity.

9 Benjamin Libet, *Neurophysiology of Consciousness*, Birkhauser, 1994

RENATO NIEMIS

The epoch which is now drawing to a close, is characterized by a belief in the Book. In this Book is held a description of our world. It is a true and accurate description of how things are, and of how things were. The Book is in the process of being completed; at present we have only fragments. Fragments to which others are being added – painstakingly determined through research and analysis…

The Book and the fragments are however mythical… We must now abandon this belief, but in doing so we must be careful not to initiate a belief in a new Book…for there is never a single unified story, but a plenitude of stories that play and jostle with the other stories of our time. Hilary Lawson [1]

1 Hilary Lawson, *Reflexivity*, Hutchinson, 1985, p.90

Hilary Lawson uses a capital letter to designate the Book, implying that it is a religious text. But his mention of analysis and research indicates that the Book is still being written, by academics and scientists rather than by theologians. He blurs the distinction between information gleaned from empirical research and truths thought to be dictated by God. Belief in either, he implies, requires an act of faith; both are stories that we tell each other to explain things we don't fully understand.

Science has been dubbed the religion of the twentieth century. Lawson gives voice to the postmodern realization that faith in human knowledge has no surer foundation than belief in God. Informed guesswork provides useful models of how things are, but we have come to accept that our understanding is limited by our conceptual powers and by the language in which we couch our questions and analyze the answers.

Renato Niemis's actions are inspired by similar realizations. He was brought up a Catholic, but his belief did not survive his scientific education. 'Darwinism and the Big Bang theory make it difficult to sustain belief in a God,' he says. 'Maybe one could think of the unified laws of physics as a guiding principle or an external force, but not as a sentient being.' He was employed by British Aerospace as an electrical engineer working on Nimrod and the assembly of satellites. But he was not convinced by the project and his belief in scientific progress withered. Having lost his faith for a second time, he turned to art.

While still a student he made a sculpture that brought together his two former belief systems: faith in God and in technology. An electronic keyboard was juxtaposed with a church pew; to play one you had to kneel on the other. But the piece was too literal and lacked pathos. He made a series of empty pedestals; paradoxical objects that designated a symbolic space, but left it empty to suggest absence and uncertainty.

Blind Faith, 1992 (pp.198-9) also frames empty space. Two rooms built from wood and plasterboard and measuring eight feet by twelve simulate the ambience of an office and a gallery – the two environments that have framed the artist's adult life. The 'office' space has white walls and a skirting board, is carpeted with speckled, grey-blue tiles and lit with ambient light filtering through transparent ceiling panels. Its dimensions are nominally related to minimum standards, so that it is possible to envisage someone spending their working life in such a space. The gallery has white walls and a sanded wooden floor and is lit by four spots, let into

the ceiling to create the focused illumination needed for display.

The hand-built sturdiness of these structures makes them fundamentally ambiguous. Their independence from the larger envelope – they are free-standing and float on their own platforms – situates them somewhere between architecture and sculpture, objects and environments. The décor of the rooms is familiar, but their function is obscure. They are too solid to be exhibition stands, too quirky to be off-the-peg units, too small to be mobile homes and too large to be items of furniture: cupboards or confessionals.

They have no doors and offer scant privacy, while the sparseness of their interiors creates a focused intensity – as though they were ritualistic rather than ordinary spaces. It requires courage to cross either threshold and take possession of the space. But once inside, the rooms claim you; the coded interiors exert a suggestive power. The décor indicates the behaviour expected of you. The concentrated brightness of the gallery is daunting. Display is on the agenda, but with nothing on the walls, you are thrown back on your own resources, like a monk in his cell or an artist in the studio.

In art schools flimsy partitions create temporary enclaves where students try to develop creativity but, for many, this semblance of privacy is not enough. The space is too public for such a private activity; working there is like performing in a lavatory with no door. What circumstances enable one to access the imaginary and the symbolic? The presence of other people can either stimulate collective euphoria or shackle one's thoughts to mundane reality. Cathedrals are uplifting, but religious services are often prosaic. Whereas the abstract cadences of the Gregorian chant are inspirational, the specifics of the litany can limit reverie and the spiritual dimension.

Museums and galleries are often described as the new cathedrals. Niemis is interested in Norwegian Stave Kirks, modest wooden churches built, like his rooms, as self-contained units without foundations. He plans to build a pair of church sculptures of similar dimensions to *Blind Faith*, to discover whether the transcendent ambience of a church can be recreated in small, secular spaces.

The title of *Eat Me, Drink Me*, 1993, small versions of the larger rooms, refers to Alice's experiences through the looking glass and to the ease with which children enter the realms of the imaginary. The sculptures refer to the models that the artist built in childhood: to the magical transformation of balsa wood and card into recognizable structures. All details are rendered in miniature; the floorboards are from doll's houses, the carpet is a segment of waistcoat material.

Exhibited on plinths as though they were museum displays, and bathed in dramatic pools of light, they acquire the solemnity of ancient temples. The rooms establish their own frames of reference, but the models are dependent on the context in which they are shown. The crypt-like basement of the Atlantis Gallery

in East London gave them a funerary grandeur. 'I've always thought of them as tombs,' Niemis says, refering to ancient Egyptian tombs: small niches cut into the cliff and fronted with fake façades, etched in the rock. His models similarly deal with make-believe and the power of projection.

The large and small sculptures work in opposite ways. By keeping you out, paradoxically the models empower you. You lay claim to them mentally; longing and desire find a focus. The rooms, on the other hand, both stimulate and frustrate desire. Their emptiness is a challenge rather than a resource. If his gallery were filled with pictures, its metaphoric role – as a temple to lost belief – would evaporate. It would merely become a neutral envelope lacking the tension and anxiety generated by loss.

Renato Niemis does not see loss of faith as an occasion for melancholy. Liberation from Catholic dogma allows him to embark on a new search for meaning. *Blind Faith* offers a model of creative thought that, in its DIY denial of orthodoxy, makes a bid for the individual to establish his or her own physical and conceptual structures. The artist provides a framework free from ideology; a vessel for viewers to fill with their own hopes, longings and dreams.

HADRIAN PIGGOTT

We neglect the human privilege of understanding individual events and objects as reflections of the meaning of life. When we break bread or wash our hands, we are only concerned with nutrition and hygiene. Our waking life is no longer symbolic. Rudolph Arnheim [1]

1 Rudolph Arnheim, *Towards a Psychology of Art*, Faber, 1966, p.12

So when Pilate saw that he prevailed nothing, but rather that a tumult was arising, he took water, and washed his hands before the multitude, saying, I am innocent of the blood of this righteous man: see ye to it. Matthew 27 v.24

Wash (1) (Self - position 1 - London 23 March 1994), 1994 (p.202) consists of eighteen bars of white soap on plaster dishes, each imprinted with the name of a body part: armpits, chest, belly, prick, balls, arse, back, hands, forehead, nose, cheeks, chin, ears, neck, shoulders, arms, legs, feet. Reading the list seems an almost indecent act of voyeurism, like peeping through the keyhole at someone bathing. The piece is autobiographical; it refers to the washing order adopted by Hadrian Piggott in his twentieth-floor flat in south London. The water pressure is too low to allow a shower and rarely is there enough hot water for a bath. This means squatting in the tub for a hand wash.

Two other versions record his shower and bath rituals. Asking others to make comparable lists revealed a variety of washing practices – the inclusion of between eleven and twenty-six body parts in different orders and wide differences in the terms used to name them.

Hitchcock's film *Psycho* exploits our unique vulnerability and self-absorption in the bathroom, a place where we indulge our (dis)pleasure in our bodies; their shape, texture and smell. *Wash (1)* similarly engenders the frisson of forbidden territory. This narrative portrait of the artist's body also encourages consideration of bathing in general.

Washing can be seen variously as a routine necessity, a comfort and solace, a means of seduction or a religious ritual; it can be a private and intimate occasion or a public affair, just as the bathroom can be a retreat or a meeting place. In the Third World bathing may take place in a communal bathhouse, a lake or a river while, in contrast, some Western families spend thousands on the latest fittings.

In remarking that daily life has been stripped of symbolic significance, Rudolph Arnheim overlooks the fact that new forms of symbolism have replaced the old. Drinking Coca Cola, smoking Marlborough Lights or wallowing in a jacuzzi are not just a matter of quenching one's thirst, inhaling nicotine or bathing; they are as much symbolic statements – about class, aspiration, belief and belonging – as a religious ceremony or a public declaration.

Cleanliness is one of the pillars of Western civilization. Personal hygiene enlists you into the company of the blessed – the healthy, wealthy and aromatic. Multinationals spend as much money advertizing soap in the Third World as they do Coca Cola. The acquisition of what the French philosopher Edgar Morin called a 'filth complex' is a first step in the construction of a cleanliness threshold that fuels the need for toiletries and household cleansers and sets the individual's foot firmly on the rungs of the consumer ladder. It opens the door to desire.

The desire for modern conveniences, argues Morin, propelled the French peasantry into the towns during the 1960s. In her book *Roses à Credit* Elsa Triolet charts one such journey. 'When Martine saw the bathtub for the first time and Cecile told her to to soak herself in all that water, she was overcome by an emotion that had something sacred about it, as though she were about to be baptized.' [2]

The euphoria of being released from filth and drudgery has since been tempered by the awareness, as our rivers and lakes die, that the environment pays a heavy price for our pleasure. Hadrian Piggott's other sculptures embody both delight in bathing and dismay at the destruction that it causes.

Untitled,1993 (NIC), a smooth, pumpkin-shaped vessel made of white plaster and snowcrete, is both magical and perverse. In place of the stem is a waste outlet and plug. This sensuous object is like a bridge between nature and culture. It

2 Elsa Triolet, *Roses à Credit,* Gallimard, 1959, pp.39-40, trs Kristin Ross

exemplifies ripeness and plenitude; but it is also a man-made vessel in which waste accumulates and festers. Both seductive and obscene, it is the embodiment of a closed system, like the globe, that is forced to accommodate waste.

Untitled is also an apt metaphor for anguish, for poisoning one's body with the juices of one's own despair. At the time, the artist was suffering a domestic crisis which led to separation and divorce. He developed an allergy to water, yet continued to resort to the bathroom as a place of retreat and restoration. The sculpture is the perfect embodiment both of frustration and ambivalence.

In the next work the shape has multiplied into three similar forms made of plaster and snowcrete, each endowed with a single fitting – tap, plug and soap dish – but fulfilling none of the associated functions. Then came an egg-shape, endowed with all three accoutrements, like the negative of a washbasin; as though empty space had become solid substance or water and basin had combined into a single abstract form encompassing the sensual experience of washing.

The artist next made a three-piece bathroom suite in plaster and snowcrete. *Tap Tap Soap Chain Plug Waste*, 1993 (p.200), is a white egg fitted with taps, a waste, plug and soap dish and resting on a pedestal. *Hinge*, 1993 (p.200), is a single solid in the form of a lavatory bowl and *Tap Tap Chain Plug Handle Waste*,1993 (p.200), is a streamlined slab resembling a surf board, which would sink like a stone. The interior space of a bath seems to have crystallized out into solid form, but the fittings and the cold, white porcelain purity bring to mind a mortuary slab, rather than the luxuriance of a hot bath. Without legs to lift it off the floor, the slab seems inert and impotent, like a mummified corpse. Together the three elements are beautiful, comic and surreal; like bathroom fittings beached on an alien shore, objects whose poetic mutation prevents them from fulfilling their initial function.

Dysfunction, 1994 (p.202) is also a triptych. One piece is furnished with taps, waste, plug and soap dish but, carved out of soap, the object would dissolve if used. A cross between a basin and a bar of soap, the piece involves a paradoxical conflation of container and contained, permanent and temporary fitting, and a confusion of form and function. Its companion has a soap dish and waste, plus holes for absent taps. Divested of all fittings, the third object has holes to accommodate them, but they have wandered out of place to become little more than decorative indents. The naked form assumes the status of an abstract sculpture, but smells strongly of soap which, in large quantities, is a nauseating irritant. Beauty and beastliness combine.

Submersive I and *II*, 1994 (p.201) evoke the jacuzzi set. Based on fixtures designed for two so that bathing becomes a social/sexual occasion, these svelte, undulating slabs are six feet long, the length and shape of a bulky, wrapped body. Made of pink and blue soap respectively, they are drilled with plumbing orifices,

but are without chrome fittings. As the link with bathroom fixtures becomes tenuous, the objects are nudged further in the direction of abstract sculpture to become stranded on a far shore somewhere between functionalism and abstraction. We seem to be witnessing the pollution of Barbara Hepworth purism by an inappropriate material, a nauseating aroma and synthetic, his-and-hers colouring.

Streamlined like underwater creatures, these perverse, poisonous objects are like beached wales – out of their element. Shrink-wrapped in glistening polythene, they could have slithered off the supermarket shelves to lie here, awaiting the addition of water to pollute the planet.

Water is the missing ingredient in all these works; that unruly element that is normally carefully contained by pipes, taps and drainage systems. It offers a soothing embrace that relaxes the strains and washes away the stains of daily life; but here it would cause havoc – flooding the floor or dissolving the sculpture. Piggott's sculptures are like votive offerings, cult objects that pay homage to the goddess, but also keep her threatening presence at bay with offers of appeasement.

Resurrection (after Richard H.), 1994 (p.201) is a bar of soap measuring eighteen inches across, imprinted with the words 'Slip it to me' borrowed from a Richard Hamilton painting. Taken from a badge, the phrase was originally a sexual come-on. In its new incarnation it refers to the sensuality of soap and its status both as a luxury and necessity. 'To substitute SLIP IT TO ME for a soap bar brand name seems to work on a number of levels,' Piggott wrote to Hamilton. 'In our advanced state of soap addiction and dependency, we the consumer need it, and the manufacturers sell it to us. The transaction is smooth, effortless – they make it, we buy it, use it… One can't refuse to read/recognize a brand name – it's there, loaded into RAM [computer memory] for instant recall. How did the associations get set up? Who slipped them in when we weren't looking?' [3]

Like Piggott's other pieces, *Resurrection*… refers to desire and disgust, to our inability to resist the seductions of the bathroom and the slippery persuasions of the ad men promoting the latest toiletries as the passport to a fragrant future. Awareness that soaps and detergents are seriously polluting our planet is beginning to seep into consciousness; but we are addicts hooked on hygiene, suffering from a washing disorder.

Pilate's symbolic act of washing parallels our refusal to take responsibility for the suds we swill down the plug hole; washing our hands of the problems caused by washing our hands. With their poisonous purity, Hadrian Piggott's sculptures embody the paradox of the hygiene that has become a health hazard.

3 Hadrian Piggott in a letter to Richard Hamilton, 1994

JOANNA PRICE

Marxism privileges the characteristically masculine activity of production as the definitively human activity (Marx: men 'begin to distinguish themselves from animals as soon as they begin to produce their means of subsistence') ; *women, historically consigned to the spheres of nonproductive or reproductive labor, are thereby situated outside the society of male producers, in a state of nature.*
Craig Owens [1]

1 Craig Owens, 'The Discourse of Others: Femininists and Postmodernism' in *The Anti-Aesthetic,* ed. Hal Foster, Bay Press, 1983, p.63

In 1988 Joanna Price began trawling through newspapers looking for images on which to base her paintings. Female activities are mainly relegated to the women's pages so, apart from pin-ups, most newspaper photographs are of men. Price was attracted to pictures of civil disturbances – fights and fracas – and to tragedies such as the Hillsborough disaster, in which hundreds of fans were hurt when the stands collapsed at a football stadium.

Recently she dressed some friends in suits, posed them in fighting groups and took photographs of the tableaux to use as additional source material. Groups of men, painted a vibrant blue, cluster together on shapes resembling clouds or small islands, as though they were porcelain figurines. Each group is vividly portrayed but, isolated on a cream-coloured ground, is restricted to its own frame of reference. The lack of a coherent, Renaissance-style space prevents communication from one cluster to another. They could be floating on clouds or adrift on the open sea.

Each incident happens simultaneously and remains distinct; the happenings do not cohere into a story. 'Events are only given dramatic form in the telling of them,' says Price. 'People on the spot are often unaware of what is going on. When Jack Ruby shot Lee Harvey Oswald, most onlookers were oblivious to what was happening; they were immersed in their own frame of reference and, in effect, were part of a different story.'

At the centre of *Small Blue Executive World*, 1993 (p.204) are three business rivals. One man holds the central character in an arm lock, the other trips him up. A man in the right-hand group is also under attack. A large brute twists his arm while another tries to pull him off his perch. But cooporation is also evident. A well-dressed pair pat each other on the back; one is based on a photograph of George Bush, the other is reminiscent of the artist's father. Below them three men struggle to keep aloft a shape resembling the baguette clouds that float across Magritte's painting *The Golden Legend*, 1958.

An element of the surreal or inexplicable infects the paintings. Masculine bond-

ing and camaraderie, rivalry and double-dealing is meticulously observed, but the familiar becomes strange. Price resembles an anthropologist studying an exotic tribe, recording its activities faithfully without having the faintest idea of their individual or collective meaning. Despite an accumulation of detail, the overall picture remains elusive.

This innocent act of voyeurism is profoundly radical. The masculine world of work and public affairs has lost its privileged position as the place from which observations and judgements are made. Under scrutiny, masculine behaviour is revealed as a set of strange rituals governed by alien codes of conduct. No longer accepted as the norm against which everything else is measured, it is demoted in status from a universal standard to a parochial set of practices.

In *Thus Spake Zarathustra*, Nietzsche queried our belief in the supremacy of Western values. 'Many lands saw Zarathustra, and many peoples: thus he discovered the good and the bad of many peoples… Much that passed for good with one people was regarded with scorn and contempt by another: thus I found it. Much I found here called bad, which was there decked with purple honours.' [2] The traveller introduces the notion of relativity; the outsider similarly brings to bear a fresh perspective, in this case a female one.

In Price's paintings the action is as carefully choreographed as a dance; violence is ritualized and restrained to the point of elegance; gestures and poses are canonized, removed from the everyday and transformed from anecdote into metaphor. The blue invokes religious art and many of the poses remind one of depictions of saints and martyrs. 'All the paintings I admire are religious,' she says. 'I lift the structure, and the flavour comes too.' 'Pieta' and 'deposition' groups are apparent in several paintings. *Blue Pieta*, 1992 (p.205), features two depositions – two men carrying an unconscious companion – and a pieta, a man kneeling over a wounded friend. Their poses owe as much to Bellini, Raphael and Titian as they do to newspaper photographs.

But Price does not elevate contemporary events to the level of epic tragedy; she is not competing with Géricault, whose *Raft of the Medusa*, 1819, portrays a contemporary shipwreck as a history painting. She neither heroises her characters nor empathizes with them, but maintains an unnerving emotional distance that transforms the familiar into the exotic or deviant.

Two men walk out of the frame in *Blue Pieta* to give the impression that this is an arbitrarily chosen segment of a larger scene. Two dogs watching the action introduce a chilling note of disinterested curiosity. 'The dogs are benign spectators,' explains Price; 'members of another species.' They also function as the alter ego of the artist who observes the activities of another sex, if not another species.

Blue Painting, 1992 features deposition and pieta clusters and, sitting beneath a tree, a woman suckling an infant. The group is reminiscent of paintings of the

2 Friedrich Nietzsche, *Thus Spake Zarathustra*, trs Thomas Common, 1909, pp.65-6

Holy Family resting on their way to Egypt, and of Sebastiao Salgado's photographs of Ethiopian refugees.

The groups are dispersed across the picture with scant regard for the conventions of Renaissance perspective. Leafy fronds arc across the space, creating a rhythmic accent similar to repeating patterns on wallpaper. Price's approach to storytelling is inspired by popular prints and political cartoons, her sense of space by Romanesque relief carvings and mediaeval book illuminations.

On the left an observer bears witness to the events, a scenario reminiscent of Gauguin's *Vision After the Sermon*, 1888, in which Breton women witness Jacob wrestling with the Angel. Inspired by local calvaries – in the form of Romanesque carvings – Gauguin adopted a flattened space imbued with a mood of mystical unreality. Price uses unreal colours and ambiguous spaces to similar effect. 'I am trying to reclaim the sort of space and the spinning together of things/narratives which was second nature to Romanesque artists, until the Renaissance dazzled that sort of popular image out of the mainstream,' she writes. 'I need this cool, ordered space to contain all the confusion with which I animate the pictures: rage, commerce, tragedy and chicanery.'[3]

3 Joanna Price in a letter to the author, June 1994

The spatial ambiguity destroys any notion of there being an underlying rationale to the actions portrayed. Heroes are replaced by anonymous strangers, stereotypes whose actions are arbitrary and insignificant. Western systems of representation, argues the American critic Craig Owens, 'admit only one vision – that of the constitutive male subject – or, rather, they posit the subject of representation as absolutely centred, unitary, masculine.'[4] Price replaces this centred, unitary and masculine view with a multiplicity of unrelated observations that introduce the concept of relativity to the field of vision – the notion of numerous accounts that each reflect the mental and physical vantage point of the witness.

4 Craig Owens, op. cit., p.58

All kinds of nastiness are perpetrated in *Circle with Green Cuttings*, 1993. The colours, brown on gold, lend the painting an iconic glow that encourages religious interpretation. The foreground figure accosted by two men might be a contemporary Christ at the moment of betrayal, the brutal surrounding scenes modern equivalents of the tortures that Christ suffered at the hands of the soldiers. The arcs containing the action remind one of the arabesques framing Andrea Pisano's reliefs on the doors of the Baptistery, Florence. But a series of green circles painted over the surface anchors the painting in the twentieth century and undermines the validity of the iconic narrative.

The references to religious art are like an ironic aside concerning men's desire to glorify their every action. Titles which contain phrases such as 'Abrasive Sales', 'Mutual Screw' and 'General Bludgeon' offer a comical summary of contemporary business practices. But the folly and vices of the characters in Price's Comedy of Errors are observed without comment, other than 'a kind of chill'.[5]

5 Joanna Price interviewed for *CV Guide*, 1992, p.4

MARC QUINN

Most human action can be seen to involve not only an adjustment and adaption to the external environment, but also to an internal perceptual scheme or self concept. One integral component of a person's self concept is the perceptual structuring of his physical body, the 'body image' or schema of himself as an objective entity. This image of the boundaries of one's body provides the basis for a sense of identity: it permits the distinction between self and the world 'out there' to be maintained. Susan Postal [1]

1 Susan Postal, 'Body Image and Identity: a comparison of Kwakiutl and Hopi' in *Social Aspects of the Human Body*, ed. Ted Polhemus, Penguin Books, 1978, p.122

Two men in dark coats arrive carrying a heavy, black box. They don white gloves, then lift out the frozen head and place it with infinite care under the perspex lid of a refrigeration cabinet. It rests at head height to allow maximum eye contact and, although the exhibit is covered in a thin film of ice, one can see that the features belong to a man in his late twenties. He looks at peace. The eyes are closed as though in deep contemplation and a beatific smile plays across the frozen lips giving the lifeless form a surprising degree of animation. The men check the temperature on the diode panel – minus 6 – then one of them poses for photographs. There is an uncanny resemblence between his face and the frozen features.

Self, 1991 (p.206) is a self-portrait in blood. Nine pints of plasma, the amount contained in the human body, were taken from the artist's veins over a period of five months. Poured into a cast made with dental plaster from his features, it was then frozen solid. The sculpture is serene, beautiful, but highly paradoxical. Form and content are indivisible, fused in an almost demonic bond. The piece is fundamentally unstable, dependent on a life-support system: unplug the refrigeration unit and the sculpture would melt into a formless pool. Rather than conferring immortality on its maker – as, by proxy, stone or marble would – it emphasizes the fragility and transience of life.

Being made of the same substance as the artist, the sculpture blurs the margins between art and life. With the advent of AIDS, it has become common to store a supply of one's blood for future transfusion. In its hi-tech refrigeration unit, *Self* refers to state-of-the-art medicine: to plasma banks. But the head also has an arcane, ritualistic quality, as though it were a talisman or fetish to ward off the evil eye. And its resemblance to a Buddha creates a religious aura that introduces the issue of the spiritual.

Self is no ordinary likeness. It is a *doppelgänger*, a sublime alter ego that begs numerous questions. Can a sculpture made of living substance be said to be alive? If the sculpture were defrosted, the blood allowed to die and the potential lost for

reciprocity, for its return, how would that alter its link with the parent body? Artist and likeness would no longer share the same vital substance. The object's duality as sculpture and plasma bank would be lost; its status would be less ambiguous.

Blood is the stuff of life, but since the advent of AIDS, it can be an agent of death. If *Self* were made of polluted plasma, its meaning would change radically, but its appearance would remain constant. If no correspondence can be guaranteed between appearance and meaning, how then does an artwork communicate? Quinn's sculptures raise fundamental questions concerning the issues of meaning and definition, in art and in life.

Western aesthetics owe their origins to the Platonic view of the visible world as an imperfect echo of ideal forms that lie beyond the grasp of the senses. Verisimilitude is therefore despised and art making is seen as a quest for meaningful form. But Quinn plays havoc with this concept and throws doubt on the potential of form to embody authentic expression. *Louis XV1* and *Marie Antoinette*, 1989 (p.210) are bronze busts made with baroque flamboyance. But they are strangely incoherent, as though they were the work of an autistic child not fully in command of his faculties.

Instead of using clay, Quinn made the heads from bread dough and baked them. Dough rises in unpredictable ways, so the results could neither be anticipated nor fully controlled. *Character Head*, 1989, a person of indeterminate sex, has the directness of 'outsider' art and reminds one, in its lascivious vitality, of Dubuffet's cartoon-like personages inspired by the work of children and the untutored. *Dr Pangloss*, 1990 (p.210) is based on a character from Voltaire's *Candide* who assures everyone that the world is as it should be; all mishaps have rational explanations. The identification is ironic, of course, since the sculpture implies that attribution of meaning, whether in art or life, is more or less arbitrary.

The busts were inspired by the character heads of Franz Xaver Messerschmidt, an eighteenth-century portraitist. After a period of mental illness, Messerschmidt made an extraordinary series of grimacing heads whose facial contortions seem devoid of emotional substance; no intelligible link can be made between internal feeling and external form. Their features parody facial expression, much as Quinn's busts parody aesthetic expression.

The face is thought of as a mirror of the soul. 'Physiognomics', writes Patrizia Magli, 'is based on the assumption of a solidarity between body and soul, between inner and outer dimensions… According to Aristotle, the soul is "figure" and "form". The body is "matter". The passions are forms immersed in matter.' [2] Aristotle's definition of the relationship between body and soul is an apt model of artistic expression in which the artwork is seen as an embodiment of the artist's inner world – feeling or idea expressed in matter.

In life, a discordance between feeling and expression is regarded as a sign of

2 Patrizia Magli, 'The Face and the Soul' in *Fragments for a History of the Human Body: Part Two*, ed. Michel Feher, Zone, 1989, p.87

madness; in art, as evidence of inauthenticity. Quinn loosens these indissoluble links. By demonstrating that appearances are unreliable and form need not be a vehicle for expression, his sculptures beg the question of how matter is invested with meaning or vitality. Can expressive form be said to have independent existence or is meaning largely dependent on the viewer? Does authenticity therefore become a redundant concept?

If one applies Quinn's thinking to people rather than to products, the issue becomes one of identity: what constitutes an individual? The busts are like portraits deprived of their souls. When previously exhibited, *Self* was accompanied by an installation of hands, made one-a-day over the period of the blood-letting: a ritualized means of marking existence. The lines of the artist's palm, emblems of destiny, were traced onto the dough. As the bread rose, the hands acquired a look of bloated putrefaction, but the lifelines remained clear. Quinn's installation asked one to consider whether fate is predetermined or negotiable, genetically programmed or influenced by social factors.

Susan Postal, the American anthropologist, identifies the body's surface as the crucial boundary which differentiates self from other. When it courses through one's veins, blood is integral to one's being. When it leaves the envelope of the flesh, it becomes alien. *Self* can be seen as an attempt to reclaim the lost substance. *You Take My Breath Away*, 1992 (p.208), a thin skin of latex imprinted with the artist's form, marks the slender boundary between inner and outer: between the self experienced as subject and seen as object. It hangs limply in space like a used condom: a melancholy residue of being and of the euphoria of creativity. In 'The Man with the Blue Guitar' Wallace Stevens asks:

…where
Do I begin and end? And where,
As I strum the thing, do I pick up
That which momentously declares
Itself not to be I and yet
Must be. It could be nothing else.[3]

3 Quoted by Yehuda Safran in 'The Condition of Gravity is Grace' in *Gravity & Grace*, The South Bank Centre, London, 1993, p.41

To what degree does an artwork have an autonomous life? Once it is finished and the connection with the artist severed, does it become a relic, a sloughed-off skin?

I Need an Axe to Break the Ice, 1992 (p.209) is a latex balloon, imprinted with the artist's features and protected within a glass dome. A cork blocking the neck of the vessel prevents loss of air, but also imprisons the embryonic wraith; the personification, perhaps, of the elusive spirit that the artist seeks.

Quinn is like the high priest of a cargo cult, making vessels and luring spirits to inhabit them. His work can be seen as a quest for the life force, the entity that in gothic novels like Mary Wollstonecraft-Shelley's *Frankenstein* imbues man-made creations with life. But it eludes him. Doubt has been cast on the existence of the

soul by scientists and philosophers such as Jean-François Lyotard, who describes the self as little more than a web of connections embedded in a matrix of political, cultural and historical influences.

'Does subjectivity exist,' asks Quinn, 'or is it only a function of the outer?' The tension in his work comes from the co-existence of belief and doubt. Its humour and melancholy come from his attempt to reconcile this duality. The disembodied being trapped in the glass dome may represent the lost spirit, but it may also be an emblem of isolation, alienation and emptiness: the void that marks the spot where the soul ought to reside; a paranoid vision of the self under threat. Inspired by the photograph of a foetus in the womb, it seems reluctant to quit the maternal body. It is safer inside. There one can escape the issues of separation and of boundaries; of distinguishing oneself from the world and from one's work. One can escape the issue of identity.

FIONA RAE

The pressure is on to develop an individual voice; to have something original to say. Yet a glance through the history books creates the overwhelming impression that everything has already been said, and every gesture already made. And you have only to pick up a newspaper or switch on the radio or TV to encounter the babble of contemporary communication. How can an archaic form like painting compete with film, television, virtual reality or even with its own illustrious past?

This is one of the questions that Fiona Rae addresses in her work. 'Painting is an unsolicited activity,' she says. 'It's superfluous, and you have to come to terms with that. It would be dishonest to pretend that this is not a problem; acknowledging it is necessary. But it can be positive; it forces you to ask what painting is about and whom it speaks to. Why paint? What kind of painting? I worry at these issues like a dog gnawing a bone, and nervously work them out on canvas.'

Her paintings are the visual equivalent of station-hopping on the radio; snippets of voices speaking French, German, Spanish and other half-familiar languages are briefly heard as one turns the dial. In music they call it sampling; taking a phrase from here, a snippet from there, a snatch from somewhere else. The nearest process in art is collage or assemblage, but both involve the physical manipulation of found elements. Rae's method of juxtaposing painted elements allows her the freedom to direct and modify her ingredients at will and to set in motion a fast-moving frenzy of interactive fragments.

On a table in her studio are catalogues on seminal figures in twentieth-century art – Miró, Picasso, Guston, Klee, Dubuffet, Motherwell, Picabia, Basquiat, Cy Twombly – and books on an assortment of subjects: the Mexican Day of the Dead, Mickey Mouse, 3D alphabets, shorthand, Pinocchio, signs and symbols, Assyrian sculpture. This is source material, to be dipped into and plundered at will.

If you trawled diligently through you might locate some of the sources, except that by the time they reach her paintings they have frequently undergone strange marriages and metamorphoses. Identifying the elements is not the point; its enough to recognize that items culled from high and low art – Miró to Micky Mouse, Kandinsky to Krazy Kat – are given equal billing.

Simultaneity reigns. An amazing plethora of found marks and gestures are brought together to jive and shimmy, shout and sing, make love and wage war in a joyous cacophony of barely controlled chaos. Scribbles, dribbles, splurges, splats, dots, bursts, waves and tangles prance and cavort with the hectic energy of a cartoon. Rainbow brushmarks tangle with knots of colour, high-speed shapes skid across hard-edged pools, blots lurk and dawdle, drips descend, rain falls, ellipses float, ears flap, a hand gestures.

'Language is the theme of the work,' says Rae, 'but I don't subscribe to the idea that the dictionary is as meaningful as Shakespeare. Language only works through the combination and juxtaposition of words.' In her paintings the collision of dissonant voices becomes anecdotal. Shapes behave like characters in a children's storybook; they limber up, show off, run away, glide past, trip over or stop dead. 'Zap', 'splat', 'ouch' and 'crunch' might accompany their high-voltage antics.

Rae describes the process as 'having an argument, a dialogue, in the painting. I tell myself a story about why things are there; a furry, bushy, feathery thing comes out from something which it doesn't match. A crude, rough shape on the left balances an elegant, clean one on the right. Something spindly and weedy supports a shape that looks substantial.' Given the literary flavour of her work, it comes as no surprise to discover that before going to art school, she embarked on a degree in English.

Occasionally an identifiable object – a pair of tongs, a table, a corkscrew, a piece of flex or an ironing board – anchors the action in reality; but if the elements are too specific, they define and fix the space around them, slow down the action and kill the ambiguity on which the story relies for its restless vitality. Without ambiguity, the paintings become propositions offering solutions rather than games in play. 'The appeal of painting', says Rae, 'is that there is no solution. It always eludes you, you can't solve it or quantify it. It's a process with no possibility of arrival, a long and engaging attempt to conquer something unconquerable.' The same can be said for the process of deciphering the paintings; hence their enduring fascination.

A juggling act of this kind, which relies on the ability to keep dozens of plates in the air, takes courage and concentration. Lose your nerve and the whole shebang collapses. If you are feeling jaded, it is impossible to sparkle; the spirit is lost, the humour dies. Consequently failures are frequent, but they are also instructive.

An abandoned painting, consisting of a series of interlocking abstract shapes, leans against the wall. Because most of the elements have the same frame of reference – hard-edged abstraction – they co-exist comfortably, without dissonance or absurdity. They also occupy the same plane, so that no depth or ambiguity is created and their interlocking achieves stasis, deadlock. The element of time is also missing. In successful paintings nothing has come to rest. The action is circular; the story continues, there is no resolution.

Comparison with Roy Lichtenstein's paintings based on comic strips is also instructive. Lichtenstein enlarges a whole frame, modifies the image until it becomes elegant, then reproduces it on canvas in dots that mimic mechanical reproduction. His images – cool, detached, elegant, static and predetermined – rely on the tension between their point of origin (the comic book) and their point of display (the museum). The change of status creates numerous ironies concerning the relationship between high and low art, personal expression and mass communication.

Fiona Rae, on the other hand, deals with the marks and signs that constitute an image, rather than with images per se. Instead of retaining her source material intact, she lets loose her adopted fragments in a war zone governed by its own logic. To avoid creating systems or establishing habits, she frequently changes the rules. Earlier paintings are more ordered and systematic. Elements resembling signs or letters are arranged in a grid on a neutral ground, or are clustered like symbols on a playing card. Their similarity to letter forms gives the enduring impression that, with effort, one could decipher them.

This duality, of legibility and nonsense, raises issues concerning the meaning of painting in general, and abstraction in particular. If painting is a language, why is it so resistant to interpretation? Wassily Kandinsky, a pioneer of abstraction, was convinced of the existence of a universal language of pure form; it only required cataloguing and analysis. At the Institute of Art Culture, which he helped to found in Moscow in 1920, he proposed the study of shape, colour, structure, movement and gesture so as to produce a 'dictionary' of abstract form, a first step toward establishing the grammar and syntax of the language.[1] Within less than thirty years, Abstract Expressionism had given rise to an almost religious belief in the ability of marks and gestures to act as conduits for pure thoughts and feelings.

By ripping them from their original context, Rae deprives her elements of heroic associations and 'pokes fun at serious-looking language'. Like Miró's sculptures of 'personages' – comic assemblages of junk – her paintings thumb their nose at

1 For Kandinsky's plan of studies see *In Memory of Wassily Kandinsky*, Solomon R. Guggenheim Museum, March 1945

pomposity and the rhetoric of self-aggrandisement.

Does her flirtation with nonsense and chaos propose that painting is an absurdist game played with arbitrary rules amd a meaningless set of signs? Is it 'a tale told by an idiot, full of sound and fury, signifying nothing'? [2] Is her work, as some have argued, a cynical *End-Game* that savours the demise of the very language and form which it employs?

Comparisons with Samuel Beckett are irresistible, except that in place of pessimism and ennui, Rae's paintings burst with vitality and optimism. Rather than the nihilism demonstrated by the Irishman, they display the ambitions of a rebel, eager to storm the citadel and to throw the gates open to a marauding hoard of anarchists. This is the mayhem perpetrated with abandon in her paintings.

2 William Shakespeare, *Macbeth*, Act 5, Scene v, line 26

EMMA RUSHTON

Now you dress in violet; a jewelled crucifix swings on your breast; now your shoulders are covered with lace; now furred with ermine; now slung with many linked chains set with precious stones. Now you wear wigs on your heads; rows of graduated curls descend to your necks. Virginia Woolf [1]

1 Virginia Woolf, *Three Guineas*, Penguin Books, 1977, p.23

Popular mythology has it that clothing is more important for women than for men. But Virginia Woolf marvelled at the peacockery of ceremonial dress and its flamboyant declaration of status and authority. Generally speaking, dress functions differently for the two sexes. Traditionally women's clothing enhances beauty and stresses individuality, hence the embarrassment of meeting someone at a party wearing the same garment. For men, dress signals sameness and belonging, which explains the desire for uniformity and the prevalence of uniforms. Difference is restricted to details which are often standardized and symbolic. 'Not only are whole bodies of men dressed alike summer and winter,' Woolf observes, 'but every button, rosette and stripe seems to have some symbolical meaning. Some have the right to wear plain buttons only; others rosettes; some may wear a single stripe; others three, four, five or six.' Ceremonial dress is usually worn on occasions governed by ritual, so that behaviour as well as appearance is encoded with meaning.

Nowadays, in their private lives at least, men are encouraged to demonstrate greater individualism, but the long tradition of cloning has given them little experience of expressive clothing. Behaviour and dress codes still seem subject to rules that women, well practised in the arts of seduction and display, find endearingly

inept. Emma Rushton employs gentle mockery in her exploration of the vanities and foibles of the opposite sex. Attention is focused on subtle forms of self-expression, rather than on flamboyant excess.

While the sexual inuendo and fetishism of much women's clothing is widely acknowledged, this aspect of men's dress is often overlooked. *Glove Compartment Nos. 2,3,4*, 1993 (p.216) is a series of photographs of car enthusiasts standing in front of their vehicles. Their hands, clasped protectively over their groins, are clad in driving gloves. Isolating the section between thigh and waist, Rushton prints the images life-size and hangs them at groin height to dramatize their sexuality.

Several drivers were photographed at a rally in Hayward's Heath, where their gleaming sports cars were lined up in a field. Most would never drive at full throttle, but ownership of the potential of power seemed to offer adequate satisfaction. The display of potency was more important than its realization.

The accompanying set of photographs, framed in leather to emphasize their tactility, features gear sticks, glove compartments and door handles: parts within the driver's caress. Similarities between creases in a trouser leg, the scrotum hidden beneath the crotch and the leather envelope surrounding the gear lever underline the eroticism of the contact. In this context, the gloved hands appear distinctly fetishistic.

If Rushton's drivers demonstrate a need to seem potent and commanding, her sculptures of *English Clergy 92*, 1992 (pp.214-5) embody loss of authority and prestige. They follow in the tradition of ecclestiastical portraiture – bronze busts of bishops, popes and cardinals clad in finery that confirms their authority on earth and their place in Heaven – but instead of imposing presences, Rushton has created small wax dolls of diffident churchmen dressed in shabby, everyday clothes.

On their tall pedestals, the diminutive figures look lost and inconsequential. Every detail of posture, gesture and clothing suggests impotence and uncertainty. Ill-fitting suits and jumpers cover sloping shoulders while inclined heads, clasped hands and ingratiating smiles indicate the befuddlement of those without conviction; a mirror of the moral and spiritual vacuum in which we languish. While, for many, belief has become as threadbare as a vicar's jumper, the church is able to offer little consolation beyond parish teas and pious platitudes.

Rushton wrote her thesis on early religions in which female deities were served by priestesses, and their suppression in favour of a masculine god served by a male priesthood. Some two thousand years after their initial exclusion, women are again discovering the degree of animosity towards them harboured by the large number of churchmen determined to oppose their ordination.

The poignancy of Rushton's sculptures comes from the fact that they bear witness to the erosion of authority not just of the church fathers, but of patriarchs in

general. Men can no longer take for granted the power, admiration and prestige traditionally considered their birthright. Increasingly, respect has to be earned; humbug and pomposity no longer suffice.

Myth has it that an Englishman's home is his castle: the place where unbridled sovereignty allows him to demonstrate his taste and affluence. Rushton's sharp eye perceives another story. *Raphe and Chris, Simon and John*, 1992, is a work in two parts. Colour photographs show the four men holding model houses. Dressed in suits and smiling affably to camera, they could be architects cradling their designs. In fact, they are employees of a soap company holding models of their own homes.

Displayed on plinths, these flimsy models of stereotypical houses seem totally inadequate as status symbols: the fulfilment of a dream. Raphe's house looks like a shoddy speculative development; Chris's flat is in the kind of terrace painted by Edward Hopper as a scenario for urban loneliness and despair.

Rushton is fascinated by Beatties, a model shop in High Holborn where city gents buy model kits to assemble at home. Out of office hours, it seems that many revert to childhood, leaving their wives to fulfill the parental role. The domestic edifice therefore embodies a profound irony. It symbolizes the family's social standing, based on the breadwinner's professional status, yet, within its walls, the head of the household is often indulged as though he were a child. As more and more women become breadwinners, will their husbands be further infantilized? The models invoke the spectre of those for whom enforced idleness means increased dependency.

My Ideal Man, 1992 (NIC) is a series of photographs showing five women dandling on their knees dolls made by Rushton to embody descriptions of their dream lovers. The men are heroic archetypes – good-looking and athletic chaps – but their diminutive proportions make their macho posturing appear ridiculous. Their small scale turns them into pets, dependent on the women whose fantasies gave them form.

Is this a truer picture of the power relations between the sexes than the usual versions fed us by television and film? There could be no clearer statement of the degree to which dominance requires the complicity of those it terrorizes. When machismo no longer has the power to impress, women will cease to be in its thrall. But the unease caused by these photographs indicates our reluctance to relinquish the myths on which the edifice of masculinity has been constructed. The all-powerful female seems so terrifying that these perfectly ordinary women assume the monstrous proportions of harridans.

Social and economic factors are forcing a substantive reappraisal of men's and women's roles. In particular, masculine identity is in crisis. As their economic advantage dwindles, men are having to find new ways either to establish their

authority or to relinqush it gracefully. Emma Rushton holds up an ironic mirror to this painful process of growth and transformation. She does not gloat over the fall of the mighty; she observes their predicament with humour rather than cruelty. Her sympathy makes their downfall the more poignant.

JENNY SAVILLE

Patriarchal discourse depends upon the construction of woman as object, as that term within language that is always spoken about, but never achieves the status of full speaking subject. This means that actual women are rendered invisible, an absence, within the dominant culture. Lynda Nead [1]

1 Lynda Nead, *The Female Nude*, Routledge, 1992, p.68

Rubens's painting *The Fall of the Damned*, 1621, portrays a tangle of naked figures falling headlong to their doom, pulled inexorably down to Hell by winged devils. The tumbling bodies are fat; puffy cheeks blend with flabby necks, rotund bellies sag over dimpled thighs. A heavy woman is carried, like a prize captive (a grotesque absolute) on the back of a serpent-tailed tormentor. Two demons sink their teeth into the flab of a corpulent male as though fat were an indelible sign of depravity. Excess flesh is equated with excessive behaviour. These are debauchers who deserve their fate; we are invited to applaud their downfall.

Nearly four hundred years later obesity and transgression are still linked, and the association has been cemented by changing standards of beauty. In paintings like *The Three Graces* Rubens celebrates the beauty of full-bodied femininity. But a preference for youthful figures now makes these nudes seem bulky and too mature; they are women rather than girls.

Rubens would have been dismayed by the amenorrhoeaic bodies of our supermodels. In a society which valued women as childbearers, their adolescent frames would have seemed distressingly inadequate. Standards have changed so radically that even a sex symbol as recent as Marilyn Monroe now seems too fleshy.

The sexually mature female body has become a pariah. It reminds us of long-standing enslavement to the reproductive role; to succeed in the job market, women must overcome a tradition seeking to define us in terms of our biology. And as we gain success, we have to hide our fertility and masquerade as adolescent girls in order not to seem too potent. 'How ironic', observed a one-time anorectic, 'that feminism is running side by side with a school of thought that haunts our every waking hour with visual and mental images of frailty, denial and unimportance.' [2]

2 Quoted by Rita Freedman in *Beauty Bound*, Columbus Books, 1988, p.168

Rubens associated corpulence with luxury. In present-day Britain obesity is more often a sign of poverty and malnourishment; of a diet of white bread, chips, sweets and pop. And it has links with heart disease. Jenny Saville lives in Glasgow, the city with the highest rate of heart disease in Britain, targeted for a Healthy City Programme in an attempt to raise consciousness and alter diet. Given this context and our culture's obsession with the body – especially with the health, fitness and ageing of female flesh – Saville's paintings of gargantuan women embody a complex range of meanings.

Working from drawings and photographs of up to five models, she creates larger-than-life amalgams, powerful presences that are utterly convincing. *Branded*, 1992 (p.218) is a vast nude whose small head peers down imperiously from its perch atop a mountainous form. The discrepancy implies a discordance between mind and body; a light spirit trapped within a heavy frame. 'Imprisoned in every fat man', wrote Cyril Connolly, 'a thin one is wildly signalling to be let out.'[3]

Her stare is defiant, confrontational. But the nature of the challenge is unclear. Manet's *Olympia*, 1863, had to be protected by armed guards when it was first shown in the Salon of 1865. The crowd was outraged at the brazen immodesty of the model who returned the viewer's gaze with a cool appraisal. Her stare was an unwelcome challenge to their prurience. *Branded* offers similar discomfort. The body is occupied by an intelligence that makes us ashamed of our responses, and dismayed at our shame.

Has she undressed in a bid to alter perceptions; is she mocking our adherence to norms broadcast by fashion plates and beauty magazines? Or does she personify the distorted body image that plagues anorectics who perceive unwanted flesh in grotesque enlargement? Like Rubens's devils tearing at their victim's flesh, she pinches a fold of stomach fat. Is this is an act of defiance or of self-loathing; does she provoke rejection or seek sympathy?

The painting is deliberately ambiguous. Saville neither invites scorn nor begs forbearance; we cannot take refuge in pity, disdain or ridicule. She portrays the huge body with loving concern for detail. The density, texture, heaviness and elasticity of flesh are brilliantly evoked. Every nuance of skin tone is faithfully rendered. White highlights shade into pink mid-tones against mottled blue shadows. But Saville is not conducting a love affair; her position is different from that of the male artist celebrating a female body. Velazquez caressed into unblemished perfection the creamy skin of the Rokeby Venus, but Saville examines this mottled flesh with dispassion. She is addressing another issue: what it is like to occupy a body that deviates from the norm.

The model's bulk is matched by density of pigment. One skin stands in for another; paint becomes a metaphor for flesh. Various words are etched into the

3 Quoted by Hillel Schwartz in *The Three-Body Problem* in Michel Feher 'Fragments for a History of the Human Body: Part Two', Zone, 1989, p.407

paint. 'Supportive' is incised across the right breast, 'irrational' across the left; 'decorative' is scored into the upper chest, 'precious' is strung round the neck like a scar. Description becomes prescription and the figure, branded with words that emphasize the unorthodoxy of her form, reads as an embodiment of failure.

Women persecute themselves with a desire to retain adolescent figures. 'Nearly everyone I know', says Saville, 'is obsessed with dieting – from anorectics who end up in hospital to friends who take hundreds of laxatives a day. It's like an epidemic. Some companies write the provision of body management into employee's contracts; you can have liposuction so as to conform to company image. Plastic surgeons use computers to create the perfect face, but it will achieve such blandness. What would beauty be, if everyone were the same?'

Propped, 1992 (p.217), shows a huge woman incongruously perched on a tiny pedestal. Her hands claw at enormous thighs as though wishing to tear the meat from the bone. Her expression is ambiguous – part flirtatious, part defiant, part self-loathing. Scratched into the paint is a quotation from the French feminist, Luce Irigaray, that acts like a veil. 'If we continue to speak in this sameness', reads the mirror writing, 'speak as men have spoken for centuries, we will fail each other again.' We have allowed our vision to be conditioned by male observations, argues Irigaray. Few men would put this woman on a pedestal. But as we evaluate her, she meets our eye with arrogance, challenging the standards by which we assess her. The painting hangs opposite a mirror that reverses the text and reflects the viewer, forcing us to acknowledge our entrapment in the ideological web. From privileged observers (the masculine role) we are reduced to images (the female position), objects rather than subjects. Saville invites us to share the insult of rejection.

Plan, 1993 (p.222) has contour lines drawn on her body to indicate desired weight loss. Her cheek rests on her shoulder in a caress; her hand clutches her upper arm in a gesture of longing – a desire to be loveable. Most nudes invite sexual reverie. Saville's model thrusts her flesh in our faces, but the gesture is not seductive. Positioned at knee height we gaze up at this vast pyramid of flesh, too small to scale these flanks let alone to seduce their owner. She reminds one of the Dog Woman in Jeanette Winterson's novel *Sexing the Cherry*, 'too huge for love. No one, male or female, has ever dared to approach me. They are afraid to scale mountains.' [4]

4 Jeanette Winterson, *Sexing the Cherry*, Vintage, 1990, p.34

Prop, 1993 (p.223) sits on a stool, one leg folded beneath her so that a huge knee projects toward the viewer. The foreshortening of her billowing thigh, knee and bulging calf presents the artist with a formidable task which she handles brilliantly in complex passages of subtle colour. Dense areas of white on the inside of the thigh shade into pinkish-browns across the knee, then round to bruised purplish-greens and mauve shadows on the outer thigh. A scumble of frothy paint

delineates the pubic area, thick white paint contours the heavy stomach: a *tour de force* of painting.

Many women consider painting an inappropriate medium, because of its illustrious history in the masculine mainstream. Manipulating this sensuous material, Saville experiences the same pangs of guilt engendered by eating forbidden foods. She does not simply trespass on the tradition. By addressing the female nude as a subject as well as an object, she forces consideration of the prejudices that enslave us. In her hands the female nude is no longer the currency of conversations between men. Saville has claimed her for her own sex, able to address women's experiences of their bodies from within as well as from without.

JANE SIMPSON

In between freezing and melting. In between love and despair. In between fear and sex, passion is. Jeanette Winterson [1]

This mystery of the female lips, the way they open to give birth to the universe, and touch together to permit the female individual to have a sense of her identity, would be the forgotten secret of perceiving and generating the world… Openness is not the opposite of closure. Closed lips remain open. And their touching allows movement from inside to outside, from outside to in, with no fastening nor opening mouth to stop exchange… But openness dwells in oblivion…because it cannot be represented, nor made into an object, nor reproduced in some position or proposition. Luce Irigaray [2]

1 Jeannette Winterson, *The Passion*, Penguin Books, 1988, p.76

2 Luce Irigaray, *Elemental Passions*, Athlone Press, 1992, p.63-45 and *Sexes and Genealogies*, trs Gillian Gill, Columbia University Press, 1993, p.101

The French psychoanalyst Luce Irigaray uses the image of lips and the notion of duality to symbolize the feminine; but the concept, she argues, remains invisible – 'dwells in oblivion' – because it cannot be represented.

Jane Simpson proves her wrong. *Between*, 1992 (p.227), resembles a broken heart or the glans of a penis. The two segments, made of plastic-coated plywood, stand on the floor some two inches apart. A hidden refrigeration unit creates a build-up of ice along the adjoining surfaces, at first forcing them apart, then binding them together. The sculpture divides and unites in a dialogue between openness and closure, movement and rigidity. This dual object which becomes singular can be seen as the embodiment of Irigaray's concept.

The sculpture encompasses feminine duality and phallic unity which, argues Irigaray, has dominated perception and shaped our notions of identity. 'The *one* of form, of the individual, of the (male) sexual organ, of the proper name, of the

proper meaning,' she writes, 'supplants, while separating and dividing, that contact of *at least two* (lips) which keeps woman in touch with herself.' [3] By uniting male and female, Simpson refuses the eclipse of the feminine and asserts the equality and interdependence of the two genders.

In Between, 1993 (p.225) is a tongue-shaped shelf projecting from the wall at breast height. The title was inspired by Jeanette Winterson's definition of passion as an in-between state containing equal measures of cold and heat, fear and exultation, terror and delight. A brass lip frames a large tongue of butter melting at the centre and freezing around the perimeter; this is achieved by a halogen lamp and a refrigeration unit, each located beneath the shelf. A pungent smell emanates from the butter which is white and crystalline along its frosted rim; curdling, rancid and greenish around the melted pool.

The sculpture holds in balance the two extremes of preservation and putrescence; it demonstrates that being is not a fixed state but a continual process of transformation, flux and change; that living involves both the acceptance and the denial of death. It infers that flexibility and volatility, those qualities often despised in women, are fundamental to existence. The American psychologist Abraham Maslow cites the willingness to endure uncertainty as a key aspect of creativity. With its refusal to foreclose and reach a conclusion, *In Between* encapsulates this ability to sustain open-endedness. Attractive and repellent in equal measure, this sensuous sculpture arouses mixed feelings. The embodiment of perversity and duality, it has moral implications. In demonstrating the existence of both purity and corruption within one body, it denies the neat categorizations that enable a woman to be designated a virgin or whore, a mother or lover, and insists that ambivalence and complexity are fundamental to experience.

Sacred, 1993 (p.226) is an ambiguous object shaped like a baroque cabinet, its front bulging like a cow's belly. Its white surface is marbled with a pattern resembling animal skin, as though it were both animal and mineral. A refrigeration unit makes the sculpture vibrate gently as though it were breathing and causes an uneven skin of ice to form on the top. The object responds to its context. Dry air produces less ice than a damp atmosphere. Draughts affect the build-up, and the body heat of viewers melts the accumulated layers so that the frozen landscape differs each time the work is shown.

'The female imaginary is mobile and fluid,' says Margaret Whitford, summarizing Luce Irigaray. 'It is never fixed in the possible identity-to-self of some form or other. It is always *fluid*.' [4] The refrigerated pieces are not fixed or finite; they change daily as the ice melts and builds up in response to local differences. Simpson's concern is more with process than with product and her relationship to the work is ongoing. 'I've watched them grow and develop so much that I'm aware when they're not behaving,' she says. 'I think about them all the time.

3 Luce Irigaray, *This Sex which is not One*, trs Catherine Porter and Carolyn Burke, Cornell University Press, 1985, p.26

4 Ibid., p.79

I can't sleep, it's like being a mother! I like the fact that they wee on the floor.'

Domestic references are crucial to Simpson's work. They establish a continuum between daily life and the world of art, which is fundamental to her outlook. Earlier sculptures included vast jellies, brioches and meringues encased in zinc, and trays of sweets, cast and made in butterscotch, chocolate, caramel or toffee as single edible units. Decay was not the issue, so preservation was a problem. Freezing was one solution, another was mummification.

This led to a series of sculptures, made in 1993, based on kitchen utensils. Cast in aluminium, a double ice cream scoop becomes a shiny penis and balls. Its female partner is a dish, cast from the negative. Inanimate objects are sexualized by our vocabulary; in the manufacturing industry cast objects are referred to as positive and male, hollow forms and moulds as negative and female.

This differentiation is inherited from the ancient Greeks who in 6 BC formulated the Pythagorean table of opposites in which, writes Genevieve Lloyd, 'femaleness was explicitly linked with the unbounded – the vague, the indeterminate – as against the bounded – the precise and clearly defined. The Pythagoreans saw the world as a mixture of principles associated with determinate form, seen as good, and others associated with formlessness – the unlimited, irregular or disorderly – which were seen as bad or inferior…"Male", like the other terms on its side of the table, was construed as superior to its opposite.'[5] Simpson chooses objects whose sexual identity is ambiguous – kitchen implements with phallic form. Most are shown embedded in their moulds, as though dead (mummified) or not yet born (foetal), and are presented side by side with their 'female' counterparts as though to give equal weighting to the twin poles of gender.

Fondant Fancy 2 (NIC) is an ice cream scoop cast in white silicone. The phallic form still nestles in its mould and is accompanied by its sister negative. In place of the heroic isolation and triumphant individualism normally accorded the male, it appears simply as one term of an equation, dependent on the maternal matrix. The feminine is accorded equality with the masculine and the maternal origins of both are acknowledged. At last the female principle is given proper visibility.

Other objects are rendered impotent. *Cameo*, a cheese slice, and *Tender*, a meat tenderizer, are cast in a thin film of pink rubber resembling a condom to become floppy and dysfunctional. Some utensils take on gynaecological references – instruments used to probe the interior of a woman's body; others become exotic – artefacts in an archaeological museum whose purpose is forgotten. Embedded in their womb-like moulds, all are humorous demonstrations of the sexualizing propensity of our perceptions.

'Everything I make is saturated with sex,' says Simpson, 'with sensuality, gratification and orality.' It is also saturated with a female view of the world. Instead of applauding autonomy and individuality, the work affirms connection and interde-

5 Genevieve Lloyd, *The Man of Reason: 'Male' and 'Female' in Western Philosophy*, Methuen, 1984, p.3

pendence. The masculine myth of human origins, encapsulated in Michelangelo's depiction in the Sistine Chapel of Adam's creation by the touch of a male finger, is countered by the acknowledgement that all life begins in the womb. The balance is redressed; God is accorded female gender.

'The female has yet to develop its own *morphology*,' argues Irigaray. 'Forced into the maternal role, reduced to being a womb or a seductive mask, the female has served only as the means of conception, growth, birth, and rebirth of *forms* for the other.' [6] Simpson's casts are the embodiment of this missing morphology; the maternal mould gives birth both to phallic and to female forms.

6 Luce Irigaray, *Sexes and Genealogies*, op. cit., p.180

In Simpson's other sculptures, clear, strong images give concrete expression to concepts such as duality, flux and ambiguity; proof that it is possible to figure the feminine; that alongside the phallic 'one of form', duality can achieve comparable symbolic resonance.

KERRY STEWART

A baffling lack of ego, character, personality or energy attends this representation. The self is portrayed as constructed from the outside in…as though, almost faithlessly, the self today can only be seen as a sociological other, a statistic, a consumer, an act of the social will which would clone individuals into units of safety and reduction. Bruce W. Ferguson [1]

1 Bruce W. Ferguson, *The Sculpture of Charles Ray*, Centre for Contemporary Art, Malmö, Sweden, 1994, p.19

'The Boy from the Chemist is Here to See You',1993 (p.229) proposes the absurd notion that a sculpture is on the move, acting of its own volition. The boy is a cripple, a fibreglass charity box of the kind once chained outside chemists' shops. His tousled head is visible through the Flemish glass of a door; the sculpture is marooned in a lobby between a real and a false wall; literally and metaphorically in no-man's-land.

The door remains resolutely shut; if it were opened one would have to deal with the issues provoked by the uninvited guest. The question is one of taste, both moral and aesthetic. The collecting boxes have been withdrawn from public view on the grounds that they offend the dignity of the disabled by casting them in the humiliating role of mendicants. The pitiful image is designed to provoke generosity, but having frailty thrust in one's face can generate hostility as much as compassion. The Caspar Hauser unworldliness of Stewart's boy makes him more pathetic but also more irritating, since the object that provokes mixed feelings is blameless.

The vernacular knocks at the portals of high art; driven from the high street on the grounds of poor taste, the collecting box seeks refuge in a gallery. The form of the sculpture is as debased as its function. The figure is made in plaster and painted in Umbrol hobby paints, normally used to colour model aircraft, so as to render ironic its bid for high art status. Though made by hand, the work displays the same level of generalization as the mass-produced stereotype on which it is based. The sculpture embodies the indignity of being treated as a problem rather than a person. Its humour arises out of the bathos of a representation so perfunctory as to be comical.

Stewart's *Untitled (Pregnant Schoolgirl)*,1993 (p.228) is portrayed with the same degree of banality. She stands stiffly to attention as though being interviewed by a superior. Having stepped out of line, she awaits judgement. A pregnant schoolgirl could be seen as a contradiction in terms, a co-existence of opposites. A child-parent disrupts the web of classifications in which we are ensnared and highlights bureaucracy's inability to accommodate deviance or unorthodoxy. Her transgression is an act of passive rebellion, a refusal to be pigeon-holed within an unsuitable category. Literally and metaphorically she has outgrown her uniform, and the status it confers of a child subject to rules and disciplines.

Given the illustrious history of portraiture, there's irony in making a likeness of someone in a disadvantaged position. 'Portraiture in its extreme form can be seen as the genre of property,' writes Bruce Ferguson, 'of the man who has everything commissioning the image of himself, his wife, his children, his house, his horses, in short – his possessions, as an image of the full control of property…as a rhetoric of authority and positions of power.' [2]

2 Bruce Ferguson, op. cit., p.21

While the rich and powerful are accorded individual attention, lowlier citizens have been portrayed as exotic types: waifs, smiling urchins, revellers and ancients. Stewart proposes a contemporary equivalent of the genre, but without its inherent sentimentality.

According to another tradition, portraits are seen as mirrors of the human psyche, as sources of insight and understanding. Portraiture, Ferguson continues, 'is the rhetoric of character and psychic disposition, with art in the privileged role of window to the soul…a pictorial method of finding and delivering the innermost man.' [3]

3 Bruce Ferguson, op. cit., p.21

Collecting boxes are, by their nature, empty shells. Stewart's inadequate likenesses offer no glimpse of an inner life; faces are reduced to a few poorly defined features that give no indication of character or personality. Posture is deliberately inexpressive, as though the inhabitants of the forms were inarticulate dummies, without intelligence or will.

Flying in the face of the humanist tradition, the sculptures propose a view of

people as things perceived from the outside, of the self 'seen as a sociological other, a statistic'. They counter the idea that any representation can do more than deal in fictions and clichés that offer a standardized view of humanity.

'Everybody looks alike and acts alike, and we're getting more and more that way,' remarked Andy Warhol, the key proponent of the portrait as a blank, a mask. 'Some day everybody will think just what they want to think, and then everybody will probably be thinking alike.' [4] Stewart's subjects are children; they are also outsiders, dependent on the forebearance of others. The lack of differentiation in her sculptures mirrors the lack of status accorded to deviants and minors.

4 Andy Warhol interviewed by G.R Swenson, 'What is Pop Art?' Part 1 in *ARTnews LXII*, November 1963, pp.26, 60-61

Conformism is rewarded. The question of identity, of being trapped within an inappropriate envelope, is a key issue for the artist. Her mother was an identical twin. A high street photograph of the young girls shows them in identical green dresses; treated as a phenomenon, a pair. Stewart's normative depictions act as an accusation against those who fail to recognize difference within sameness.

An obvious comparison is with the plebeian artifacts adopted by Jeff Koons in stainless steel sculptures such as *Two Kids*, 1986, and porcelain figurines such as *Popples*, 1988. Even when enlargement makes the subject comic or grotesque, the sentimentality of the original is retained. In Stewart's figures, the elegance and blandness of Koons is replaced by an awkwardness that arouses discomfort. 'There are snags in them,' says Stewart, 'as opposed to the smooth even surfaces of Koons, that catch you unawares emotionally. My sculptures are not knowing like his; they are more blundering.'

Closer comparison is with Charles Ray, whose self-portraits as shop window dummies deal with the anonymity of social stereotyping, the self voided of character and authentic experience. But whereas Ray proffers himself, no matter how sardonically, as a normal guy, a clone, Stewart's subjects are victims of Fate; people who, through no fault of their own, have become extraordinary. In childhood Stewart experienced the role of an outcast. When at thirteen she came to England, no one understood her Glaswegian accent. From being an integral part of village life, suddenly she was a stranger. When she returned three years later, she experienced the double dislocation of no longer belonging. Her mother's twin meanwhile had moved into her parent's home, displacing her further.

A proposal for the Yorkshire Sculpture Park includes the figure of a drowned dog lying beside the lake; a completely abject object. The problem is finding an appropriate form. 'If I don't use an existing form, like a collecting box, I don't know how to make the figure formally. I need a forerunner.' Artistically Stewart is an ingénue, but the dumbness and apparent lack of sophistication of her work should not be mistaken for lack of complexity. The issue is one of authenticity and sincerity. Her directness is her strength; it gives the work its disturbing emotional edge. The challenge lies in the confrontation with existing norms and standards.

MARCUS TAYLOR

Nothing prepares one for the opalescent beauty of Marcus Taylor's perspex sculptures; nor for the dry humour, which arises from the contrast between their mundane forms, derived from fridges and freezers, and a quality of meditative calm akin to religious art.

The fridge has become so commonplace in modern kitchens that it is all but invisible. Taylor chose the form of this banal appliance for various reasons. It is roughly the size of the human body – if you remove the shelves and lining, a person can be accommodated in the space made available – so the object implies the human presence.

Containers, and their relationship to the mind and body, are an abiding preoccupation in Taylor's work. *Sleep*, 1989 (NIC), an early sculpture, consists of a slightly rusted box of raw steel, large enough to contain a person. The box lies on the floor like a coffin, without any trimmings to soften the harsh reality of death. Next the artist stripped down to the metal a fridge freezer, a readymade equivalent of *Sleep*, took out the innards and laid the empty container on its side. Bereft of the finishings used to domesticate the raw material – the plastic lining and the industrial skin that gives the object its smooth uniformity – the steel box looks naked, crude and vulnerable; like a flayed carcass. The sterile cleanliness of the appliance has been destroyed along with its ability to preserve food, to slow down the depredations of death. The object seems to have succumbed to mortality; to have changed its status from a conserver of life to a keeper of death; to have switched from fridge to coffin.

Untitled (Upright Fridge), 1991 (p.233) was the first sculpture, based on the form of a fridge, to be made in colourless perspex. The sheets are glued together to maintain the visual integrity of the skin and to ensure that the sculpture reads as a single, recognizable form. The perspex is sanded to a milky opacity that resembles a dense fog. The clouding makes it difficult to see into the interior, which appears to be filled with misty light or icy breath. The envelope seems as flimsy and brittle as a film of ice, yet the inner chamber appears almost solid, so reversing the usual relationship between protective outer shell and enclosed inner space.

As a man-made resin, perspex has a uniform internal structure, so that light is dispersed evenly through the sheet to accumulate along its edges. The joins therefore become lines of concentrated brilliance, as though the sculpture were outlined by a halo or glowed with a frosty radiance. This magical aura and the work's

cloudy translucence make it seem weightless and immaterial – as though it were a ghostly emanation, rather than a solid object. The fridge form and the icy pallor lead one to imagine that the piece is frosted with cold.

Untitled (Quadruple Fridge), 1991 (p.230), is a row of four perspex fridges of different shapes and sizes, lined up like a display in a department store. The ensemble looks in the direction both of mass production and minimalism. The simple geometry and colourless austerity of the pieces give them the impersonal clarity of minimalism. But formally, the sculptures are readymades (dressed in borrowed clothes) rather than geometric abstractions. Donald Judd meets Marcel Duchamp in pieces whose shapes are generic and particular, rather than universal. Rather than employing the repetition of identical elements (minimalism), the work ironically espouses variety within standardization (marketing). Non-hierachical idealism meets its opposite: the semblance of difference within uniformity.

Untitled (Container), 1991 (NIC), based on a refrigerated container, is nearly twelve feet long by seven feet high – almost architectural in scale. The chamber is made in three parts. Two acrylic bands conceal internal walls that strengthen the work. They also lift the sculpture off the floor so that it appears to float weightlessly. The complex diffusion of light within the several parts makes it impossible to determine the structure of the piece, which resembles a giant block of ice. A smaller chamber, suspended within the block, seems as secluded as a shrine accessible only to initiates. Their chill, silent clarity gives these sculptures a timeless perfection that divorces them, physically and metaphorically, from the exigencies of daily life. It is difficult to find solitude in the city. Churches, museums and libraries offer temporary retreat, but opportunities for prolonged withdrawal are rare. Sustained release from the relentless pressure is available only to the old, the ill, the insane, the criminal, the wealthy or religious. Metaphorically, *Untitled (Container)* is like a sanctuary; a model of the contemplative state.

Whereas early sculptures like *Sleep* refer to death and decay, these icy crucibles emphasize preservation. Their frosty eloquence speaks of immortality, as though it were a metaphor for suspended states (between life and death, sleep and wakefulness): those half-waking moments of meditative consciousness that allow the imagination free reign. The sculptures are like a crystalline embodiment of creative thought.

Untitled (Abstract Elevation I), 1993 (NIC) is the first of a series of abstract pieces. A canopy of sanded perspex rests on a column that raises it three feet above the ground. With the fridge/freezer pieces, recognition is crucial to one's perception of the object as an entity. With no comparable *gestalt*, one sees the skin of this piece as a fragile membrane rather than a closed shell. Its milky translucence conjures biological associations with, for instance, the umbrella and fronds of a jelly fish.

Untitled (Abstract V), 1993 (NIC) is a vertical block divided horizontally by two sheets of clear perspex that slice through a sanded rectangle. But complex internal reflections make it impossible to discern the actual structure. The experience is like looking through water, trying to comprehend something seen in refracted light.

Taylor makes no distinction between the figurative and abstract pieces. The subject of both is the relationship between lightness and solidity, enclosure and containment, access and its denial. But the fridge/freezer sculptures have the added dimension of irony, arising from the discrepancy between their ethereal beauty and their banal origins. Then there is metaphor, created through associations between ice and frosted perspex, between a container that preserves food and a chamber that sustains hope and aspiration.

I first saw the perspex fridges in a disused warehouse. With their silent and brittle radiance, they seemed to have landed from another planet. A photograph comes to mind by Cristina Garcia Rodero, of a woman praying beside a portable confessional, placed against the wall of a cemetry in Saavedra, Spain. The piece of furniture designates a symbolic space where private activities (confession, contemplation and prayer) are sanctioned. Although priest and penitent are in full public view, an invisible screen seems to separate them from their surroundings.

Metaphorically, Marcus Taylor's sculptures function similarly. Icy envelopes frame symbolic spaces into which one can project the dreams, aspirations and longings that cannot be accommodated in the mundane spaces of daily life. Chambers have been created for what Taylor describes as the preservation 'of thought, of breath and of a state of mind'. That is why his sculptures seem so vital, as well as beautiful.

GAVIN TURK

It is language which speaks, not the author; to write is…to reach that point where only language acts, 'performs', and not 'me'…the writer can only imitate a gesture that is always anterior, never original. His only power is to mix writings, to counter the ones with the others, in such a way as never to rest on any one of them. Roland Barthes [1]

In his degree show at the Royal College, Gavin Turk exhibited a blue ceramic heritage plaque which read 'Borough of Kensington, Gavin Turk Sculptor Worked Here 1989-1991'. Turk's career began with its end, as though he were already dead and worthy of commemoration. The plaque looked down on an empty

1 Roland Barthes, 'The Death of the Author' in Barthes, *Image, Music, Text*, Fontana Paperbacks, 1977, pp.143, 146

room; a space of potential rather than of record, of anticipation rather than achievement.

'Life only acquires meaning and shape through death,' says Turk. 'The plaque is the end point that allows my life to unravel.' Now ensconced in a Beuys-like vitrine, the plaque has been named *Relic*, 1991-3 (NIC) in acknowledgement of artists, such as Joseph Beuys, who made their lives into myth and created their own epitaphs.

The plaque also refers to other deaths; to the end of art, which always seems to be approaching – 'art is stammering,' declares Turk; 'we are almost at the end point, the last work' – and to the end of the artist as an heroic individual, a cultural icon. Roland Barthes' essay 'The Death of the Author', which asserts that a text essentially writes itself, has had enormous influence on young artists. It cuts right across belief in individual subjectivity as the wellspring of creative thought and in the indissoluble link between author and product.

Of necessity, Turk's proclamation is rhetorical: 'The Artist is dead. Long live the artist!' Barthes' essay was not an injunction to stop writing, but a proposition suggesting the need for other ways to view the relationship between author, text, reader and the culture in general. Authors have not stopped producing, but they have had to accept less heroic models of their enterprise.

Turk's subsequent work is a deliberation on the nature of authorship and the need to create work that makes no claims for the sovereignty of the subject. He employs two strategies. On the one hand, he stages the (ironic) myth of 'Gavin Turk', as though heroism were still a credible option and, on the other, he plays with and parodies the means by which value is established, recognition accorded and status conferred.

The institution of the museum, symbolized by the display case, is a recurrent preoccupation. Spattered with paint, *Stool*, 1990 (NIC) obviously comes from an artist's studio. The slot in the seat has been glazed so that the stool becomes a vitrine framing the bottom that sits on it. Art gazes up its own arse in a witty indictment of narcissism and as a rejoinder to the accusation that contemporary art speaks only to itself.

pipe, 1991 (NIC), a liquorice pipe cast in bronze and painted to resemble the original confection, is an abject little thing displayed in a case much too large for it. Pipes play an interesting role in modern art. Van Gogh portrayed himself smoking a pipe, just after cutting off his ear in 1888, and also painted the pipe lying on the famous yellow chair in his studio in Arles. Chair and pipe have become emblems of their user, the mythic artist/hero. A pendant picture of Gauguin's chair has an upright candle on the seat; each artist is represented by a phallic object. Magritte enshrined the pipe in myth with his paradoxical painting of a pipe titled *Ceci n'est pas une pipe*, 1929. He also painted a man smoking his own

extremely phallic nose and another endowed with three noses and smoking three pipes.

pipe has a small 'p' because it is an insignificant addendum, a humble footnote to an illustrious history, which includes Jasper Johns' beer cans, cast in bronze and painted to resemble the originals. Adult men swig beer and smoke pipes, children suck liquorice in imitation of them. Most art functions as an Oedipal challenge to its forefathers; but Turk's pipe is an emblem of impotence and immaturity, of being and feeling small, of acknowledging that the basis for the fight is over; heroism is dead. This is the source of its palpable pathos. The placement of this sad little thing inside its vitrine is determined by the position of Van Gogh's pipe on the chair: a ritual which pretends that the world is watching, when Turk knows that it isn't.

Floater, 1993 (p.238) is a similarly ironic gesture of disaffection. A piece of chewing gum is stuck to the roof of a display case as though it were a relic, a cast of the artist's mouth. Turk had in mind the final scene of the film *Last Tango in Paris* when Marlon Brando is shot, staggers onto the balcony and, in farewell to the world, sticks his chewing gum to the balustrade. As with *Relic*, the subject is death and the traces we leave behind. Turk offers only the residue of a meaningless act.

An artist's signature is treated as a holy relic unless, that is, s/he is unknown. Then it is of dubious value. Turk features his signature in a series that explores its function and usage. 'It was like robbing a bank with a water pistol,' he says. 'I had no right to a signature, because I was unknown.' In *Title*, 1990 (p.234), the signature is painted flamboyantly across three canvases, accorded the space and attention of the main motif. In *Stencil*, 1992 (NIC) it is cut from a stencil, as though it were a forger's kit. *Frank*, 1992 (NIC) is a stamp, authenticated with another stamp. *Gav (Neon sign)*, 1992 (NIC) looks like the prototype for a shop sign. *Piero Manzoni*, 1992 (NIC) is a sheet covered with copies of Manzoni's signature. By signing the sheet, Turk has 'authenticated' his forgeries. *85 Trees*, 1992 (NIC) is a proposal for a large-scale project to plant his name in yew trees. Highlighting a seemingly irrelevant scrawl in these variously ambitious ways is inherently humorous; it also foregrounds the importance of attribution to both museums and collectors. *Epiphany*, May 1992 (p.236) is a signed surveillance mirror that, when hung in a mixed exhibition, lays claim by proxy to all the exhibits reflected in it.

Gavin Turk Right Hand and Forearm, 1992 (p.237) is a silkscreened photograph of the artist's hand apparently pickled in a glass jar; a gruesome variant on the casts taken of artist's hands in the belief that genius resides in body parts. Death is again postulated and denied. The stopper in the neck of the jar turns out to be a live arm, proof that this dead author is a living artist, after all. The relative scale of the puny upper arm and the 'relic', magnified by the glass, provides a witty

analogy for the process by which ordinary men are transformed into mythic heroes. Turk is fascinated by the section in the Tate's Clore Gallery devoted to 'Turner the Man', where the artist's brushes and palette are displayed as though they provided insight into his work.

Pop, 1993 (p.235) represents the ultimate accolade: to be made into a Madame Tussaud's waxwork. Turk is not a recognized icon, so he presents himself as Sid Vicious of the Sex Pistols, adopting the stance of Andy Warhol's portrait of Elvis: shooting from the hip with cowboy bravado. *Pop* refers to pop art and pop music, but also to the sound of a popgun, since Vicious is armed with a toy pistol. The pop star is an angry kid whose threat is impotent and whose rage implodes on itself.

Pop is a schizophrenic object; a waxwork displayed in a museum case, as though it cannot decide whether it is art or a tourist attraction. There is no way of knowing who made the piece; Turk the artist is replaced by Turk the icon.

All Gavin Turk's actions can be thought of as end-game strategies. But I see him as a romantic who, denied the opportunity to emulate and challenge his heroes, opts to identify with an anti-hero, a suicidal punk renegade. Having declared himself dead, Turk can safely assert the opposite. 'I'm alive, I'm here, and I can't help it. I make the work because I believe I *can* do something. It *is* romantic; it has to be.'

Roland Barthes' declaration of the Death of the Author is easily recast as the text for a postmodern melodrama. Whereas the modern artist, epitomized by Van Gogh, has entered mythology as a tortured hero who struggles to lay bare his soul, the postmodern artist is enmeshed in a different form of martyrdom: the attempt to overcome erasure.

Turk made life possible by declaring death from the outset, then working backwards. As a strategy, it is like R. D. Laing's description of the schizophrenic who declares himself dead to save himself from murder, or the impotent who avoids castration by failing to perform. Turk's challenge to heroic father-figures has so far been couched in the ironic language of the disaffected adolescent, who brandishes toy guns and sucks liquorice pipes. Does death allow growth? Or does the postmodern position inevitably result in thwarted potential?

MARK WALLINGER

For Mark Wallinger racing has been an abiding passion since childhood. He attended race meetings with his uncle, who created a family sweepstake. He describes the excitement of the race – the loss of self in a crescendo of noise, and the rush of adrenalin as the horses approach the finishing line – in almost orgasmic terms. But he has chosen to paint individual thoroughbreds, rather than the meeting.

His stallions demonstrate the exemplary beauty of the animal. They are painted life-size with a transparent clarity that details every nuance of lean musculature and shining flank, yet they lack animal presence. They are self-evidently two-dimensional images, whose source is photographic rather than actual – pure spectacle.

A study by George Stubbs, the famous eighteeenth-century horse painter, inspired Wallinger to silhouette the stallions against a blank ground, devoid of context, as though they were cut-outs or figments of the imagination, rather than realities of the flesh. These are not portraits so much as conceptualizations; symbols that invite consideration of what horses mean to us.

During the 1913 Derby the suffragette Emily Davison threw herself in front of the king's horse as a protest at parliament's refusal to grant women's rights. This self-sacrifice (she died in hospital) carried great symbolic resonance. The first race to be described in this country was between the stables of Richard II and the Earl of Arundel. Ever since, racing has continued to be 'the sport of kings', indulged in by those who enjoy privileges of birth, wealth and power. Racing is a manifestation of patriarchal authority and capitalism at their most naked. Davison gave literal expression to the position of the disenfranchized: trampled under establishment hooves.

Standing obediently at the end of a halter, Wallinger's horses appear docile, yet their powerful frames are an embodiment of phallic potency. Freudian psychoanalysis identifies the animal as a symbol of masculine sexuality. In *The Uses of Enchantment* the psychiatrist Bruno Bettelheim explains in sexual terms the passion that many girls have for horseriding: 'by controlling this powerful animal she can come to feel that she is controlling the male, or the sexually animalistic within herself'.[1]

He does not analyze the relationship of males to their mounts, but one can assume the bond to have a sexual component. According to Bettelheim the horseman who features so often in fairy stories in the guise of the hunter, symbolizes

1 Bruno Bettelheim, *The Uses of Enchantment*, Penguin Books, 1978, p.56

masculine authority, because 'hunting was an aristocratic privilege, which supplies a good reason to see the hunter as an exalted figure like a father. (He is) the symbol of protection…one who dominates, controls, and subdues wild, ferocious beasts. On a deeper level he represents the subjugation of the animal, asocial, violent tendencies in man.' [2]

2 Bruno Bettelheim, op. cit., p.205

This duality – of the animal as an expression of masculine potency and the equestrian pair as a symbol of the control of animal instincts – allows identification either with the horse or the rider who manages this free spirit. On a symbolic level, Wallinger's stallions are the sublime embodiment of tamed sexuality. On a realistic level, they represent the appropriation and exploitation of animal potency.

The patriarchy is obsessed with lineage, with establishing patrimony. The same is true of the racing world. Wallinger's paintings are based on photographs in the breeders' manual *Stallions of 1991*. The lineage of the four horses in *Race, Class, Sex*, 1992 (pp.242-3), owned by Sheikh Mohammed of Dubai, is traceable back eighteen or nineteen generations to 'Eclipse', born in 1770 and painted by Stubbs, and even to Darley, the first Arabian imported into the country.

A stallion may run as few as eight races before retiring to stud. He will then cover up to three mares a day, at six-hourly intervals, at £30,000 a go. (Artificial insemination is not acceptable, since theft or substitution would be too easy.) The mating lasts a few seconds, so the discrepancy is absolute between our identification with the animal as a symbol of free sexuality and its use as a machine for procreation.

The title *Race, Class, Sex* indicates Wallinger's perception of racing, from the Jockey Club (the governing body that regulates the sport) down to the silver ring (the cheapest stands), as a model of the class system and of the operations of capital. 'Bookies represent the purest form of capitalism,' he says. 'They buy and sell nothing and, like the money markets, react instantly to market forces.'

Parallels between the racing business and the art market are easily drawn. Breeders and dealers share an obsession with provenance; both identify with the wellsprings of creativity, but exploit them mercilessly. 'All artworks are trophies,' says Wallinger, 'there to demonstrate the wealth and good taste of the patron. Horses have a similar status.'

Wallinger is not only a painter. His work takes many different forms, each being used to interrogate the assumptions that the medium or genre embodies. Since painting this series, Wallinger has set up a consortium of dealers and collectors and has bought a two-year-old chestnut filly named A Real Work of Art. The horse is being trained at Newmarket and will race under the colours of the suffragette movement – white, green and violet – each race being recorded as an artwork. An edition of small, die-cast equestrian statues is on sale to help cover the costs. The artist has also made a series of paintings of the racing colours registered with the

Jockey Club by the forty-three owners who are named Brown.

Capital, 1990 (pp.239-41), a series of full-length portraits in oil, continues his investigation of traditional genres. The paintings have been darkened with varnish and framed in heavy wood to emphasize links with the tradition. The series was sparked off 'by the banal irony of seeing someone asleep under the porch of the Bank of England. It was a challenge to deal with that subject matter. No appropriate fine art language exists for representing the plight of the homeless, so the series is a debate about representation as well as homelessness. It was conceived as a 'public work', a comment on the Thatcher years, a portrait of the underclass painted in the aggrandising style of corporate portraiture.'

In front of heavy double doors emblazoned with lions rampant and eagle escutcheons – the portals of financial institutions – stand bedraggled individuals against whom the doors are firmly shut. 'Matthew' wears odd shoes, an old coat, a balaclava and a scarf knotted tightly round his neck against the cold. 'Pete' wears a tatty coat tied with string and boots without laces. 'Kate' smiles with the bemused vacancy of severe disorientation. With her dishevelled hair and torn tights, 'Jo' looks like a defiant runaway. But a studied theatricality subverts the images and alerts one to the fact that the paintings are faked; these are friends of the artist posing as derelicts. Their dissembling creates a rift, a reminder that all images are fictions. Social identity, argues Wallinger, is an act of display. 'Brecht understood that behaviour is a performance and any ideological system is founded on rhetoric.' A performance requires interpreters, and in Britain, where class origins were encoded in every detail of appearance, we became adept at reading the signs. But social mobility has recently led to a new artform: the jumbling of those codes. Parody and quotation deliberately lead down false trails and force others to query their assumptions and prejudices.

Wallinger is an Essex man, born in Chigwell. His father was a fishmonger who went into life assurance; he was upwardly mobile. Nowadays, movement is more often downward: 'I want to counter the Darwinian notion', says Wallinger, 'that the homeless are intrinsically different. I was almost homeless at the time and it's a slippery slope. The underclass are not exotic aliens.'

Margaret Thatcher maintained that society is nothing more than a collection of individuals. Wallinger argues the converse; that individual identity is constructed through a network of social relations. A recurrent theme in his work is the way that class, money, privilege, power and national identity interconnect in the construction of individual identity.

Traditonally, oil paintings confirmed or conferred status. Wallinger uses the medium to indicate that identity is a socially constructed artifice and to reveal the role played by painting in its fabrication. He also meditates on the status of paintings as commodities that, like thoroughbreds, are both revered and exploited.

CARINA WEIDLE

Once we have left the waters of the womb, we have to construct a space for ourselves in the air for the rest of our time on earth – air in which we can breathe and sing freely, in which we can perform and move at will. Once we were fishes. It seems that we are destined to become birds. None of this is possible unless the air opens up freely to our movements. To construct and inhabit our airy space is essential. It is the space of bodily autonomy, of free breath, free speech and song, of performing on the stage of life. Luce Irigaray [1]

1 Luce Irigaray, *Sexes and Genealogies*, Columbia University Press, 1993, p.66

Carina Weidle's work adopts numerous forms, many of them short-lived. Taking as their starting point the body and some aspect of being in the world, her subtle, humorous and poetic sculptures are often made with cheap consumer products such as sweets, bubble gum and pop corn.

Spine, 1993 (NIC) was created from pop corn wedged into an undulating spring to resemble vertebrae. *Baby Sausage*, 1993 (NIC) evokes aching jaws and the sound of chewing. Huge quantities of bubble gum were chewed and moulded into a sausage the width of the artist's head. Casts of her ears, attached to either end of the tube, suggest a work that listened to its own making. A wall of wax tiles, indented with a line cast from the crease at the back of the artist's knee, evokes intimacy and a 'mental mapping of the body and its functions'. [2]

2 Adrian Searle in *Time Out*, No.1146, p.48

Tongue, 1992 (NIC) is a cast of the artist's back made in vinamould: opaque, red casting rubber. Some two feet long, the curved form retains details of every pore, spot and mole so that even the texture resembles the tongue of an enormous animal. While conjuring sensual pleasure, its dense, wobbling opacity provokes revulsion as well as fascination.

Air and breathing are recurrent themes. *Water Rises*, 1992 (NIC) is a snorkel and mask cast from melted Blue Jelly Dolphin sweets. The sticky, sea-green translucence of the rubbery form suggests choking or drowning rather than a free flow of air. Weidle imagines 'the sky thick as a jelly': air conjealed to the point where it becomes visible and tangible.

'Air is invisible,' she writes, but 'it seems that we can isolate and emphasize the air through certain actions or experiments…(which) although they are also immersed in reality, work in our minds as revealing fictions about our chosen subject matter.' [3]

3 Carina Weidle, extracts from a written sculpture, 1993

Several pieces feature large white balloons – breath given physical form. Compressed by heavy metal sheets or sandwiched between metal grills, they are like lungs confined by the rib cage. Breath is a potent metaphor for strength and

its inhibition; for establishing or being denied one's place in the world. A lung full of air resists the pressure of the earth's atmosphere and empowers the body with oxygen. Anxiety and depression induce shallow breathing and increase lassitude. External restrictions, such as tight clothing, deprive the body and brain of oxygen and induce fainting fits.

Weidle's balloons are weighted down, unable to inflate fully or float free. They are like caged animals, the embodiment of repressed energy and supressed potential; but such buoyant elements won't suffer restraint for long. Compressed air, writes Weidle, is 'dangerously full of potential energy. If something unexpected happens, this potential energy might be released, transforming itself into kinetic energy and deforming the whole surrounding atmospherical space like waves of sound.' [4]

4 Carina Weidle, extracts from a written sculpture, 1993

Blank and Flat, 1992 (NIC) is deliciously evocative. A slab of white wax rests on a large, creamy pink balloon. A nipple-like projection likens the soft, malleable form to a breast, though associations are also with the belly and lung. Projecting through the wax, the mouth of the balloon resembles a navel. The pair are like bodies twinned in a mutually supportive embrace. The wax prevents the balloon deflating; the balloon provides a pillow for the slab. 'It is very seductive', muses Weidle, 'to think about the round and absorbing surface of reality.' [5]

5 Carina Weidle, extracts from a written sculpture, 1993

In *Olympic Chickens I-X*, 1993 (pp.244-5), a set of ten coloured photographs laminated onto aluminium panels, Weidle abandons poetry for parody which, writes Arthur Koestler, 'is the most aggressive form of impersonation, designed not only to deflate hollow pretence but also to destroy illusion in all its forms... The artist reverses this technique by conferring on trivial experiences a new dignity and wonder: Rembrandt painting the carcass of a flayed ox, Manet his skinny, insipid Olympia...the result will be either a comic or an aesthetic experience.' [6]

6 Arthur Koestler, *The Act of Creation*, Pan Books, 1970, p.70

The subject of the series is the Olympic Games, in which athletes pit their strength and skill against gravity, air and water and, through their actions, make manifest the elements. Headless supermarket chickens, made-up to look plump and healthy, swim, ride bicycles, do somersaults and leap over high bars. The fantasy is deliberately threadbare; the wires show. The bicycles they ride are made of aluminium foil, the water they swim through is green petroleum jelly. Yet their bodies are arranged convincingly to mimic rippling biceps and pumping thighs.

Weidle wrote her thesis at Goldsmiths' on humour and learned from Arthur Koestler that 'any two universes of discourse can be used to fabricate a joke...it is the clash of the two mutually incompatible codes, or associative contexts, which explodes the tension',[7] and causes laughter. She juxtaposes the dynamism of pumping muscle, the adrenalin rush of competition and the heroism of the struggle with the inertia of dead meat, the unhealthy ethos of factory farming and the blind stupidity of headless chickens.

7 Arthur Koestler, op. cit., pp.35, 67

The implication is that any attempt to overcome the limitations of the physical body is as unedifying as a scramble of naked corpses that once were able to fly, but have been decapitated, plucked and grounded. The message is Zen as well as blackly humorous: the incongruous creates the ridiculous.

RACHEL WHITEREAD

We joke and believe death to be far removed. It is hidden in the deepest secrets of our organs. For since the moment you came into this world, life and death go forward at the same pace. Thomas More [1]

Woe to you who put your hope in the flesh and the prison that will perish... Woe to you who are captives, for you are bound in caves. Thomas the Contender [2]

In 1993 Rachel Whiteread became the first woman to win the Tate Gallery's Turner Prize. At the same time her sculpture *House*, 1993 (NIC) was becoming a *cause célèbre*, attracting extensive coverage (both positive and negative) in the national press. The sculpture was in London's East End. The local council demolished a terrace of dilapidated Edwardian houses in Grove Road, Bow, to make way for a forlorn park. *House* was a concrete cast of the last dwelling.

Steps led up to what had been the front door; but doors, windows and other architectural details were visible only as negative imprints in the block. The dwelling had become a bunker rather than a home, a sealed container that denied access; a dramatic negation of its history and function.

The process was essentially similar to casting a sculpture in bronze. The wallpaper was stripped, the walls were made good and all fittings were removed. Wax and paraffin oil were applied as resisters before a thick layer of concrete was sprayed onto the interior surface of the walls. Steel mesh and heavy filling lent support to this outer skin, and steel piles, inserted between the floors, gave the building-within-a-building the strength to stand alone once the neighbouring houses had been torn down and the external brickwork stripped off to expose the concrete.

The flat top (the attic was not cast), the austere material and the shallow architectural details produced a form like a travesty of the Bauhaus modernism which supplanted traditional housing with utopian schemes to eradicate urban slums. *House* was a memorial to architectural idealism, and a monument commemorating the ambition of postwar governments to provide plentiful, cheap public housing. Although it was in place for only a few weeks before demolition, *House* was,

1 See A. Lerfoy, *Holbein*, Paris, 1943, p.85

2 'Book of Thomas the Contender', Nag Hammadi Corpus, 2.143.10-22; Bentley Layton, *The Gnostic Scriptures*, Doubleday, 1987, p.407

nevertheless, a major public sculpture that embodied (and confronted) the lack of vision and generosity characteristic of the last decade of the millenium.

Whereas *House* made a stark comment on social issues, its precursor, *Ghost*, 1990 (pp.246-7), is a personal work about childhood memory. Whiteread made a plaster cast of a room in a Victorian house in Archway Road, similar to the one she grew up in. Eased away from the walls in sections and reassembled, the plaster forms a magical white crucible imprinted with architectural details. The door, windows, mantelpiece, picture rail and skirting board are visible in the negative. Projections like the door handle become recesses, and hollows like the fireplace, projections. Reality has been inverted, the ordinary and familiar made strange. The piece has the same haunting beauty as a fossil or a photographic negative. Memories are sealed within a silent, colourless, inaccessible chamber – a mausoleum.

The vibrance of the white shell contrasts with the meagre actuality of the living space it records. This sepulchral chamber is an act of remembrance and of purification, a statement of loss and of longing: an idealization. The small dimensions of the piece testify to the cramped arena in which family life is often experienced. In her novel *Villette*, Charlotte Brontë employs the metaphor of small and inhospitable rooms to embody the loneliness and alienation of her heroine. 'Lucy Snowe's experience of the diminished social architectures she moves through has affected her model of the mind', writes Tony Tanner in his introduction. 'The house contains the unhappy consciousness of those inhabitants to whom it offers inadequate living space and thus, by extension, insufficient thinking space.' [3] *Ghost* can be seen as a monument to 'inadequate living space', but like Brontë's novel, it is also a tribute to the resourcefulness that enables people to survive cramped quarters.

Her sculptures seem to be retrospective, to speak in the past tense, as though they were the crystallization of memories whose intensity still lingers. The chalky whiteness and maudlin silence of the plaster reminds one of fossils: lives turned to stone; prevented from completing the cycle of decay and merging with the fabric of the world. This is one source of their imaginative power; the other is Whiteread's ability to use objects as ciphers for human experience; anthropomorphism is a key aspect of her work.

Shallow Breath, 1988 (NIC) is the cast of the underside of the bed on which, according to her mother, she was born. The spaces beneath beds are unsavoury places. The residue of daily life collects there, like fluff in a trouser turn-up or dirt under the finger nails. By giving form to this dusty corner of domestic life, Whiteread has created a potent icon, the physical equivalent of a bad conscience. This squat rectangle is unprepossessing, without elegance or formal poetry. Yet it seems to work directly on the unconscious, triggering myriad associations and

3 Tony Tanner, introduction to *Villette* by Charlotte Brontë, Penguin Classics, 1985, p.14

103

conjuring inexplicable embarassment, as though the implacable block of ossified space were the condensation of repressed desires. Contemplating the piece is like being confronted with echoes of childhood voyeurism: the urge to know what goes on in the parental bedroom. Everyone has their own store of memories. Mine include a brother who kept an opened can of condensed milk under his bed, an innocent crime except that in retrospect this sticky substance, furry with congealed fluff, seems disreputable, like a blanket soaked with semen.

When the plaster is removed from a broken limb it takes with it the tiny body hairs. Whiteread covered the underside of the bed with material so that when the plaster was eased away, it was covered with a fine fuzz. She wanted it to be repellent, like a tangle of hair gathering slime beneath the plug hole.

Many of life's key experiences happen in bed – being born, sleeping, dreaming, making love, giving birth, being ill and dying: 'times', says the artist, 'when we open up to others, or are most alone and vulnerable'. This extraordinary sculpture was made soon after the death of her father, an inspired memorial to him and to her own origins: to birth and to death. It is also a testament to human passions and bodily processes in general, a metaphor for the remorseless cycle of life.

Mattresses are the site of our most isolated moments as well as our most generous and intimate ones. Whiteread has made several sculptures from mattresses found abandoned in skips or dumped on waste land, their surfaces impregnated with the juices of illness or effort, of pain or passion. Cast off like aged relatives, they are reminders of our inevitable decline. Made in rubber as well as plaster, the sculptures lean slumped against the wall or lie rigidly on the floor as though rigor mortis has set in.

Whiteread is adept at transforming mundane objects into telling icons. *Untitled (Square Sink)*, 1990 (p.249) was cast from the underside of a wash basin. The bowl is raised on a stack of plaster blocks, as though the image were entombed in a minimalist sculpture; the pedestal becomes the meeting point between abstraction and figuration. The negative of the missing fixture is a dessicated echo of the original. Filled with plaster, the holes for the taps become projections, like stunted horns or bleached bones, as useless as a blocked outlet.

Washing is as much a ritual as a practical activity, a means toward spiritual as well as physical cleansing. 'Say with your mind that the garment of the soul is the body, and keep it pure, since it is sinless,' reads a Gnostic maxim.[4] The elevated height of Whiteread's bowl transforms it into a ritual vessel, a font whose waters welcome the newborn into the community. Those who have not been ritually blessed are outsiders, so are the unwashed. *Untitled (Square Sink)* is a monument to the centrality of washing in our society.

Valley (NIC), *Ether* (NIC) and *Untitled (Bath)* (p.248), all 1990, were cast from the underside of baths. Set into high blocks of plaster so that their rims are at rib

4 'Sentences of Sextus', Nag Hammadi Corpus, 12.30.11-14, Bentley Layton, op.cit., 1987

height, they have acquired the solemnity of marble sarcophagi. *Valley* and *Untitled (Bath)* have glass lids that mimic water and seal the internal spaces. They remind one of the lidded baths used by nuns in certain orders to avoid seeing their bodies, and of glass-lidded coffins that enable mourners to pay their last respects. Drowning and asphixiation come to mind, but *Untitled (Bath)* has two holes drilled where the taps should be to alleviate one's sense of claustrophobia.

In Christianity dirt and decay are both associated with sinfulness. According to myth, the body of the Blessed Virgin remained whole, untainted by sin or the corruption of the grave. But her special case serves only to highlight the processes which the rest of us suffer. Whiteread's baths acknowledge the association of cleanliness with purity, while accepting the inevitability of death and dissolution.

The artist once worked in Highgate cemetery fixing lids back onto crumbling coffins. The glass lids were prompted by a documentary about Christchurch, Spitalfields where plague victims were buried in the crypt. When a lead coffin was moved, its contents could be heard swilling about. Metaphorically, Whiteread's baths accommodate the liquids of decay as well as those of ablution.

Her earliest sculptures were plaster casts of her own body. Plaster is associated with broken limbs and with death masks: traces of a life caught at the moment of transition from being to object, from flesh inhabited by spirit to inanimate matter – empty vessel. Whiteread is preoccupied with the pain and vulnerability of living, and the blank insensibility of ending; with memory and commemoration and with bodily processes in life and after death. Her remark that 'we begin to die as soon as we are born' echoes the observations of Thomas More.

Her sculptures mainly take the form of vessels or plinths: containers or supports for the body. Her work is a meditation on the relationship between the body and the envelopes designed to house and protect it, and on the body as a vessel housing the soul or the self; between the body as a living organism and a lifeless shell – a sensible subject and an inert object. Whiteread does not renounce the body; she attempts an exorcism by making sculptures that celebrate the actuality of living, while acknowledging the inevitability of dying.

JOHN WILKINS

The avant-garde poet or artist tries in effect to imitate God by creating something valid solely on its own terms, in the way nature itself is valid, in the way a landscape – not its picture – is aesthetically valid, something given, increate, independent of meanings, similars or originals. Clement Greenberg [1]

In his depictions of brushstrokes, Roy Lichtenstein exposed the expressionist equation of formlessness and feeling and reflected upon the gesture as sign – a sign that does not present the real or register the self so much as it refers to other signs, other gestures. Hal Foster [2]

John Wilkins describes *Glistening*, 1993, as 'Roy Lichtenstein meets Caspar David Friedrich': American Pop meets German Romanticism. The painting is covered in circles, a reference to the dots used in printing that Roy Lichtenstein mimics in his paintings. Wilkins' circles are more complicated than the Pop painter's dots. They represent snowflakes as a cartoonist might draw them. A white circle surrounds a black circle in which is inscribed a line of scribble.

Snowflakes the size of saucers float across the twelve-foot canvas in a repeating pattern, like a fly's eye view of an Op Art design. The canvas is crossed by two vertical bands that could be slender tree trunks; they are indicated by a black outline, a white highlight (snow) and a line of scribbled cross-hatching (shadow). The washy grey ground was spread on with a broom after a bucket of paint had been sloshed across the canvas in an action that Wilkins describes as 'more Tony Hancock than Jackson Pollock', done in a spirit of self-deprecating irony rather than of heroic myth-making.

Wilkins retains a lively sense of the ridiculous. This polka dot fantasia is a cartoon deconstruction of the language of picture making; an exploration of the grammar and syntax of images as they might look if examined through a magnifying glass. The title of the work is gleaned from the song 'Walking in a Winter Wonderland'. Other titles are taken from Frank Sinatra's 'My Way'. Irony is again at work, since Wilkins' paintings are based on the conviction that objects and ideas always refer to their forerunners, so that 'my way' is always an amalgam of other people's ways: of conscious and unconscious influences. At worst, originality is a delusion, at best a restating or reshaping of that which already exists.

The time has long since gone when artists could, as in Clement Greenberg's model, imagine themselves to be acting like God, creating images that are 'valid, in the way a landscape – not its picture – is aesthetically valid'. Artists are well aware that their products are cultural artefacts related to their historical moment,

1 Clement Greenberg quoted by Ronald Jones in 'Even Picasso', *Artscribe International*, No. 72, p.50

2 Hal Foster, *Recodings*, Bay Press, 1985, p.63

and that ambitions to be natural, universal or timeless are misguided.

Wilkins refers to his paintings as still lives: representations of an already existing object; in the case of *Glistening*, an imagined landscape painting. He is the same generation as Sherry Levine, who caused tremors of dismay by purloining the work of famous male practitioners such as Egon Schiele, Walker Evans, Franz Marc and Willem de Kooning, and re-presenting their work under her own name. In a reverse action she also represented, as art, images from the cartoon Krazy Kat.

Wilkins goes in closer to examine and dissect the language of picture-making. The arcs of *Bend*, 1993, are extensions of the chippolata shape that appears in other paintings as the representation of a gesture; the curve of the sausage indicates the sweep of an arm. A stencil cut from card replicates a standardized version of an impromptu action that can then be repeated indefinitely. The movement of an arm is replaced by the outline of a form, which is without energy or direction and appears to hang or float weightlessly on the canvas. When repeated, the sausages or bands become anonymous elements in a decorative pattern; when used singly or in small groups they become like cartoon characters in an absurdist narrative.

The black lines, scribbles and white brushmarks represent the basic elements of drawing – outline, shading and highlights. But the white also functions illusionistically, as a cartoon rendering of thick oil paint; it represents the light reflected off juicy, impasto paintwork. It also refers to Robert Ryman's exploration of the language of painting, in particular to the white paintings made by pulling a loaded brush across the canvas until the paint is exhausted, then reloading the brush and repeating the action.

Wilkins' marks therefore signify two distinct uses of paint: as a medium with which to image other things (objects, people, landscapes and so on) by employing the convention whereby light and shade denote space and volume; and as a self-contained and self-referential activity. His arcs and sausages encompass the duality of a painting as both absence and presence; as an imaginary space that the viewer enters conceptually, and as a physical object that inhabits real space alongside the viewer. The two states appear to be mutually exclusive. By being self-effacing, the painting-as-window offers escape into an imaginary realm; the painting-as-object declares its presence and demands attention. Yet the two states frequently coexist, especially in the work of expressionists such as Van Gogh, Chaim Soutine and de Kooning, where a brushmark will stand for itself at the same time as representing something else, and tension is created through the contradictory demands that this imposes on the viewer's attention.

Wilkins' paintings require a similar duality of focus. In *Dancing in the Dark*, 1993 (p.250) a conversation is set up between the 'image' and the washy ground, which is alive with the marks left by the broom. The ground parodies the painterly

gestures of expressionism, while the arcs deconstruct the language of representation. Each functions as a commentary on and a representation of a painterly convention – both are paintings of painting.

In *Glistening* and *Winterwonderland*, 1993 (p.251), ghosts of the stretcher bars are imprinted in the ground, like traces on the Turin Shroud, reminders of the picture as a physical structure. The main source of tension in Wilkins' work, though, is the coexistence of meaning and mindlessness, of dry conceptualism and cartoon-like levity; of all the pictures he makes, only the most 'goofy' are selected for exhibition. The mixture of dispassion and hilarity reminds one of René Magritte's dry humour and of Wilkins' principal hero, Roy Lichtenstein.

The series of works known collectively as *Frank's Wild Years* was begun in 1988. All the paintings are based on the chippolata shape and its extensions into an arc or curve, and all the compositions extend to the edges of the canvas in such a way that the paintings appear to be details of larger pictures. Given the limited number of elements employed, the range and diversity of images is astonishing. Paintings such as *Dreams and Schemes* (NIC) and *Only Dreams* (NIC) are like enlarged doodles; the elements of *Just a Glance Away* (NIC) and *Much More Than This* (NIC) are more organized, as though in an attempt to standardize a form of mark making – like enlarged cross-hatching or a freehand equivalent of stippling. In *Same Old Lies* (NIC) the chippolatas seem as regimented as soldiers, like characters in an animated cartoon. They remind one of Magritte's painting *Golconde*, 1953, of city gents raining down on empty streets. In *Can't Imagine*, 1990 (NIC) the sausages have become like loaves reminiscent of the baguette clouds that float past the open window of Magritte's *La Légende dorée*, 1958.

The paintings of 1990-91 have a distinctly sexual flavour. In *Imagination is Silly*, 1991 (NIC), a giant chippolata appears alone like a huge cigar, worm or phallus. In *Just Molly and Me*, 1991 (NIC) two sausages are combined into a vaginal oval. In *One*, 1991 (NIC) the sausage is fattened into a central zip, a pun on Fontana's gashes and Barnett Newman's zips.

The wonder is that, while referring to loss of belief and affect, Wilkins' paintings remain fundamentally joyous and celebratory. On the one hand, they declare that painting and many of the suppositions on which it is based (such as originality, authenticity and so on) are dead, and on the other they demonstrate the irrepressible vitality of the medium. According to Wilkins' scenario, painting is like the Gorgon. Cut off one head and myriad others will sprout in its place.

RICHARD WILSON

20:50, 1987 (pp.254-5) has come to epitomize installation art in Britain, both for the clarity of the idea and the spectacular beauty of its realization. You smell it before you see it. The pungent aroma of sump oil permeates the entire gallery. Although the piece had been described to me, nothing prepared me for the ravishing, immaterial splendour of this paradoxical work.

A tank tap, set into a vertical steel plate, alerts you to the presence of large quantities of liquid. What you see, though, is a tapering steel walkway that inclines upward across the room, cantilevering dangerously out into space like a diving board; an effect that Richard Wilson refers to as 'rushed perspective'.

It takes courage to edge your way forward along the narrow gangplank, which turns out to be a trench rather than an elevated walkway. The path takes you into the heart of a sea of darkness: a lake of black oil that fills the room to halfway up the walls. The sides of the walkway reach waist height and protect you from the syrupy darkness that threatens to engulf you.

The room has been lined with a steel tank filled with 2,500 gallons of used engine oil whose blackness and density turn the pool into a perfect mirror. Although your other senses confirm the reality, your eyes tell you that you are suspended in space with the ceiling reflected far beneath your feet. And as the floor melts away, waves of vertigo sweep over you. 'What I like about the experience', says Wilson, 'is the psychological aspect, the fact that your mind tells you one thing, but you perceive something different.'

The piece is rife with contradictions. By half filling the gallery, the volume of the room appears to have been doubled – the work both fills and empties space. An invisible substance reveals details of the ceiling that would not otherwise be seen – the invisible lends visibility. A gloriously poetic installation is made from an environmental hazard: a pollutant that, when spilled from tankers, kills wild life and despoils coastlines.

If the initial impact of the work stems from its magical powers of deception, its lasting hold over the imagination arises from its ability to echo arcane fears. Civilizing order (the pristine gallery) has been overwhelmed by the unruly chaos of nature; the oil evokes the forces of darkness, whether they be death, the unconscious, the alien, the Flood or merely the formless. *20:50* anticipated the Gulf War and the transformation of Quwait into a land saturated in black oil. The fate of that landscape, cast into a purgatory of darkness, was like the apocalyptic realization of these fears.

High Rise, 1989 (p.253) is an equally paradoxical work. A greenhouse suspended halfway between floor and ceiling, as though blown there by a hurricane or swept there by a tidal wave, thrusts its way through the wall between two galleries, to be abandoned at an acute angle that Wilson refers to as 'a contraposto angle of drama'.

The idea was inspired by newspaper photographs of cars, boats and houses displaced by typhoons and earthquakes and by the hurricane which swept southern England, uprooting trees and flinging them across cars, houses and railway lines. 'It's not a question of disaster but of displacement,' says Wilson; 'not surreal so much as irregular.'

Two rooms are forcibly linked by a third chamber that shows no respect for boundaries. Glazed at one end, the intruding structure functions like an eccentric bay window, providing a view through to the work in the adjoining gallery. This would be regarded as a hostile act of trespass, if the greenhouse did not seem more the victim than the agent of catastrophe. The humour of the piece arises from the absurd notion that an aggressive act has been committed by a fragile aluminium structure masquerading as a window.

In the gallery elements such as wiring and heating and ventilation ducts are concealed so as not to distract from the art on display. By smashing through the wall, Wilson reveals the mechanics of the space – false walls (plasterboard over a wooden frame) line the gallery with a neutral envelope. 'I like the principle', says Wilson, 'of construction by removal, of creating a new order by taking something away.'

The status of greenhouses is ambiguous. Both urban and rural, temporary and permanent, part of house and garden, they exist midway between nature and culture, the wild and the cultivated. I once knew an artist who lived in a greenhouse erected inside the vast warehouse of his studio. The transparent shed defined a cosy domestic space within the alien cold of the industrial environment. Wilson's greenhouse also functions as a room within a room, a building within a building.

The work is like a metaphor for the relationship between artist and artworld. Beached half-way up the wall, the sculpture is trapped there like a fly in amber, totally dependent on the structure that supports it. Yet its presence is neither passive nor neutral; it refuses to be confined by existing boundaries and creates its own frame of reference and terms of residence. It exposes the mechanics of the structure that sustains it, demands flexibility and forces modification.

Facelift, 1991 (p.256) was the first free-standing sculpture that Wilson had made for ten years. The work stands on the floor yet, like the greenhouse, appears stranded or displaced. It resembles a caravan, but seems to have been involved in a crash or subjected to an act of God and, in the process, to have jack-knifed. Half the structure has swivelled 90° and keeled over on its side.

Wilson bought and dismembered a second-hand caravan. Its jerry-built tacki-ness made it too flimsy to use, so he built a more substantial structure of wood and aluminium that mimicked the original, then attached the panelling, doors and windows to the outside like veneer pegged onto an armature. The windows and one of the original curtains indicate the initial function of the nomadic dwelling, so achieving a paradoxical hybrid between hand-crafting and cheap mass-production, abstraction and figuration.

The idea of disaster clings to the work; in particular, the spectre of a road acci-dent. It reminds one of Warhol's *Disaster* series: newspaper photographs of hideous road crashes silkscreened onto canvas in repeating patterns to numbing effect. One shudders to think what would happen to the occupants of this flimsy packing-case, considered adequate for a mobile home, but proving too insub-stantial even for a static sculpture.

Caravans have the same peripheral status as greenhouses. While Wilson's greenhouse mimics the steel and glass structure of the gallery roof, the panelling of the caravan echoes the false walls that line the interior. Both are poor men's versions of the building which houses them. But they also refer to the world out-side: to makeshift dwellings inhabited, the world over, by the impoverished and homeless.

High Rise was first built in Sao Paolo where thousands live in shanty towns or squat under temporary shelters. Wilson recalls a salesman whose chairs were tied up the lamppost around which his family squatted. The area around Matt's Gallery in Hackney, where *20:50* was first installed, was incongruously filled with gypsy caravans whose occupants turned derelict urban streets into a squalid encampment.

Architecture structures the very fabric of our society and its institutions. Fine art, by comparison, has a peripheral status, but this very marginality can become a strength that enables it to hold a mirror up to the centre. Richard Wilson's work is not simply an addendum to the spaces it occupies. Both physically and metaphor-ically, his peripheral structures mirror and comment on the institutions which house them. They gain resonance by looking both ways – at the artworld, and beyond to the larger social architecture.

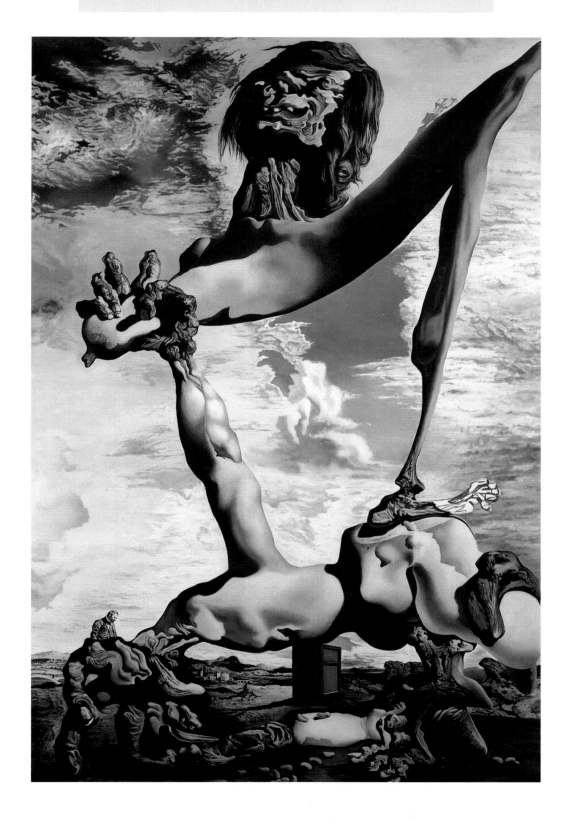

Dalí-Christ 1992 oil on canvas 274 x 183cm / 108 x 72"

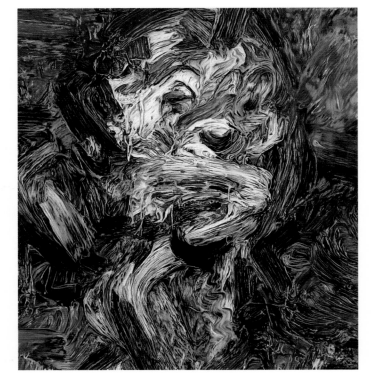

top **The Day the World Turned Auerbach** 1992 oil on canvas 56 x 50.5cm / 22 x 20"

bottom **The Creeping Flesh** 1991 oil on canvas 56 x 50.5cm / 22 x 20"

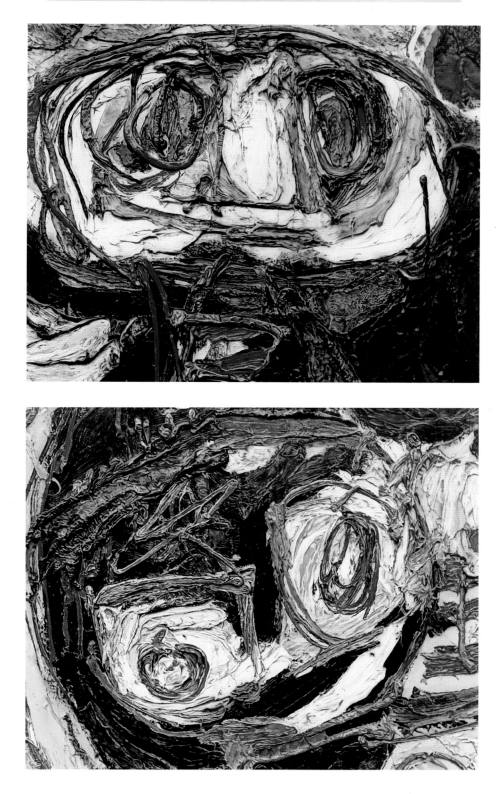

top **Mad Love** 1991 oil on canvas 61 x 73.5cm / 24 x 29"

bottom **The Body Snatchers** 1991 oil on canvas 61 x 73.5cm / 24 x 29"

Ornamental Despair (Painting for Ian Curtis) After Chris Foss 1994 oil on canvas 201 x 300cm / 79 x 118"

Double 6 1993 oil on linen 170 x 191cm / 67 x 75"

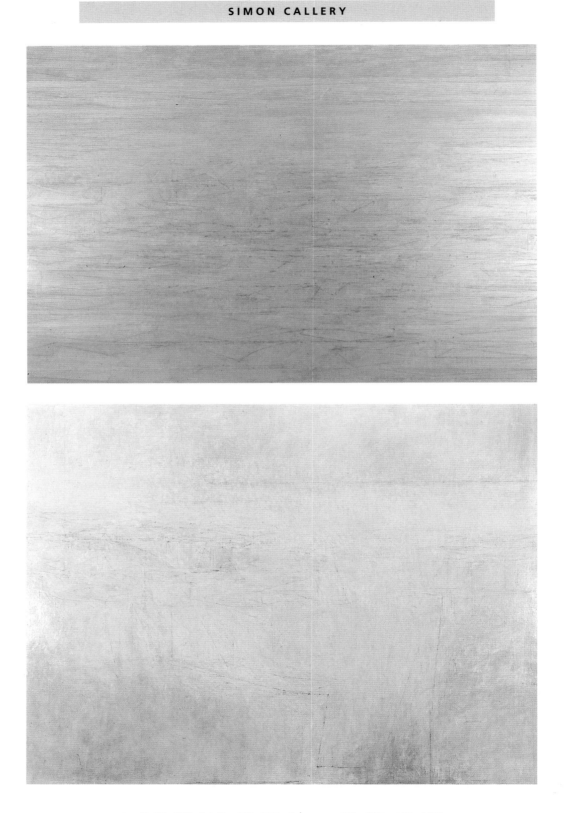

top **Untitled City Painting 159** 1992 oil on canvas 201 x 297cm / 79 x 117"

bottom **E14SE10** 1992 oil on linen 165 x 216cm / 65 x 85"

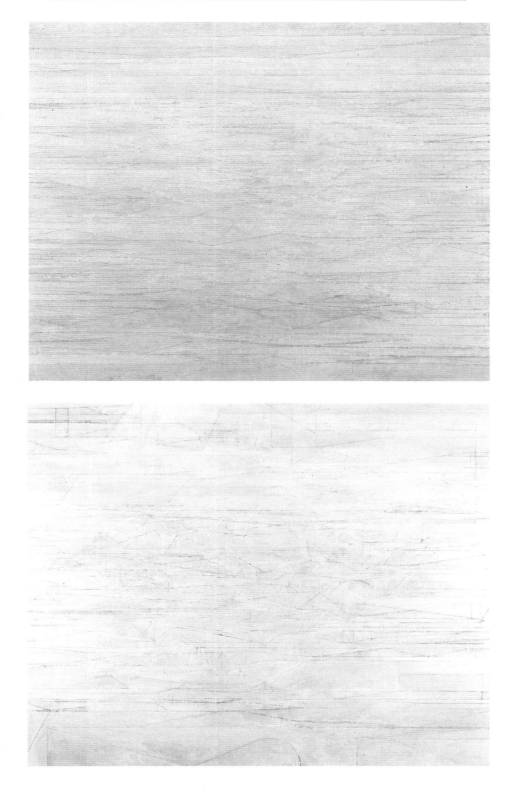

top **39°** 1992 oil on linen 169 x 207.5cm / 66½ x 82"

bottom **Nefos** 1993 oil on linen 200 x 250cm / 79 x 98½"

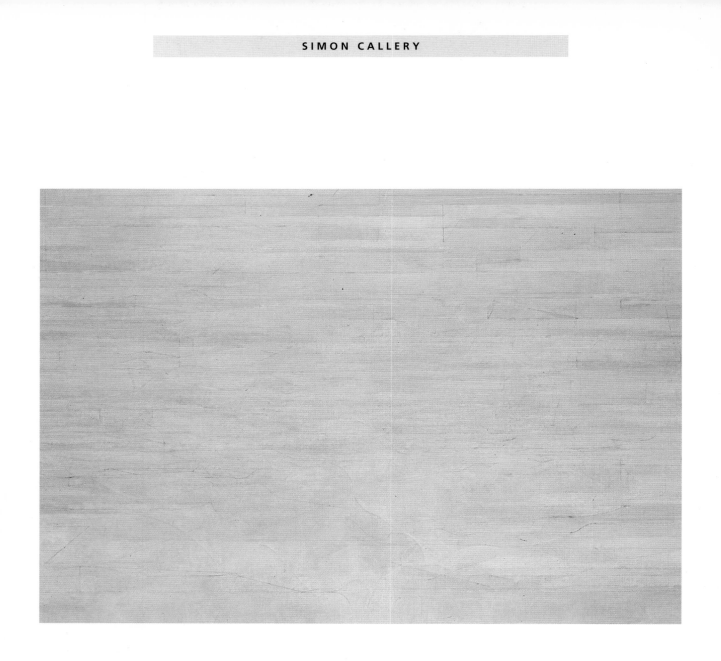

Borough & Trinity 1993 oil on canvas 260 x 370cm / 102½ x 146"

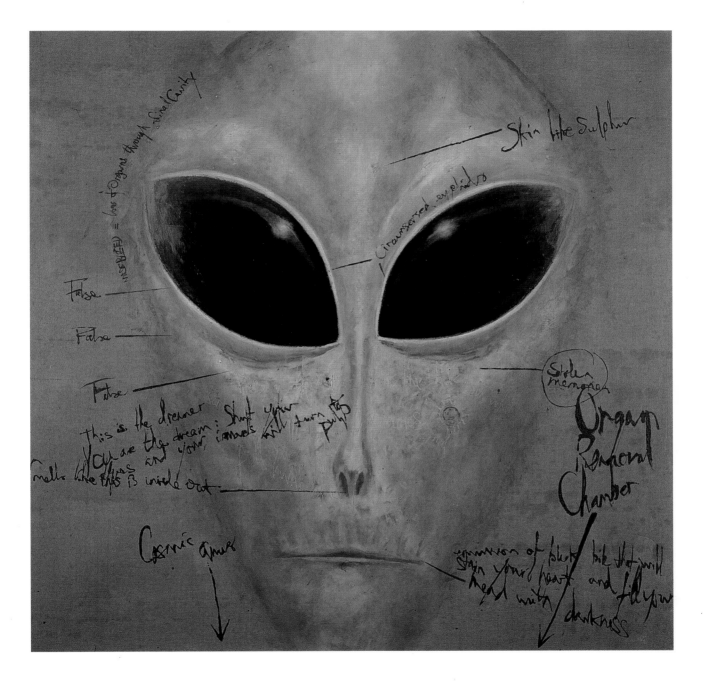

Anatomy of a Sky Creature 1993 oil on linen 213.5 x 213.5cm / 84 x 84"

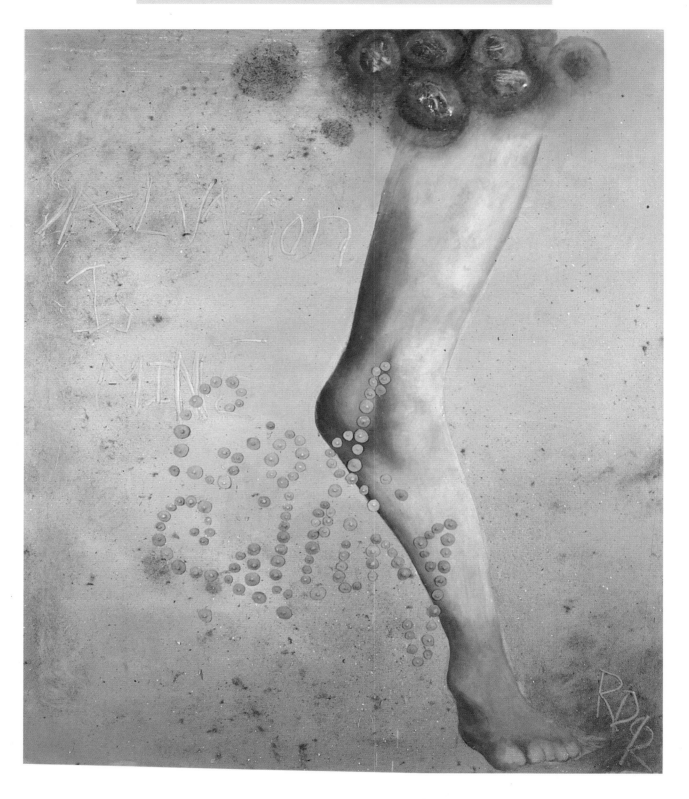

Venereal Daze 1992 oil and latex prosthetic on canvas 213.5 x 183cm / 84 x 72"

Jinx 1990 oil on linen 213.5 x 213.5cm / 84 x 84"

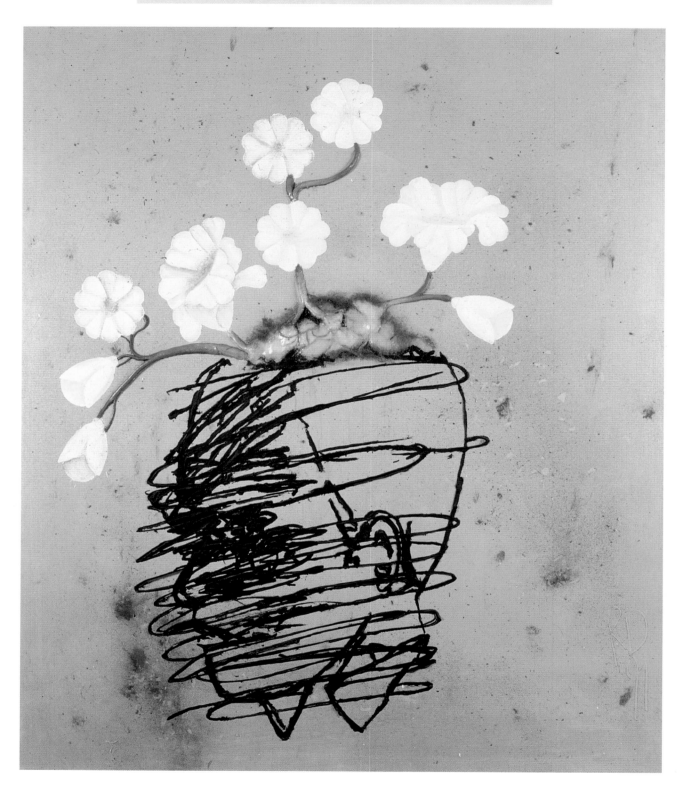

124 **Egg Bag** 1991 oil and latex prosthetic on canvas 213.5 x 183cm / 84 x 72"

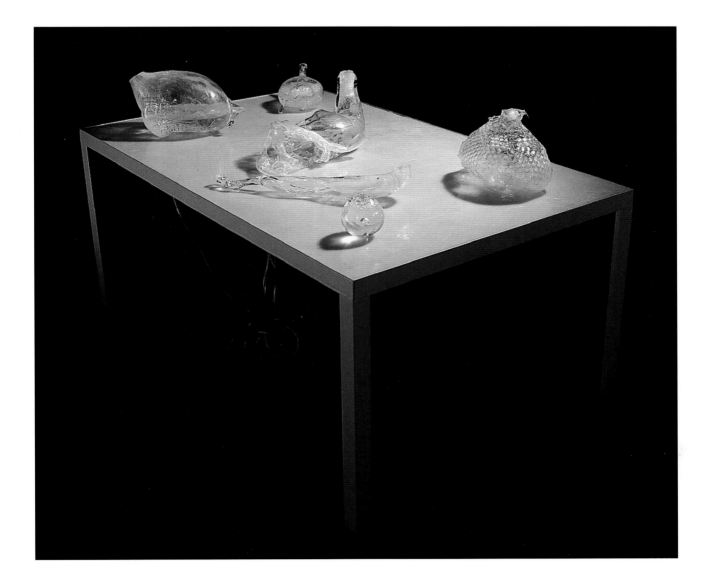

Bubbling Glass 1990 glass, water, wax, iron, air pump, plastic pipe 94 x 152.5 x 96.5cm / 37 x 60 x 38"

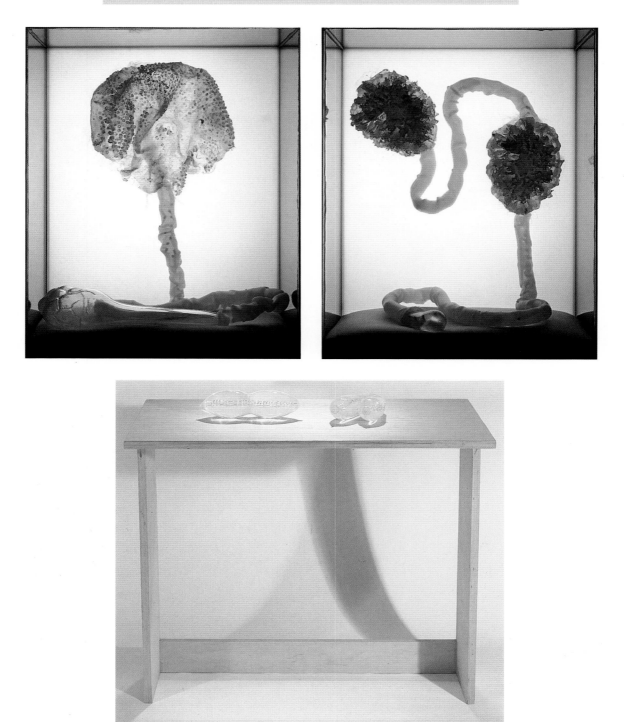

top left **Light Box 1** 1993 resin, wax, glass, latex, light 48.5 x 40 x 33cm / 19 x 16 x 13"

top right **Light Box 2** 1993 resin, wax, glass, latex, light 48.5 x 40 x 33cm / 19 x 16 x 13"

bottom **Silicon Teats** 1992 silicon, glass, pink water, wood 83.5 x 98 x 55cm / 33 x 38½ x 21½"

SIMON ENGLISH

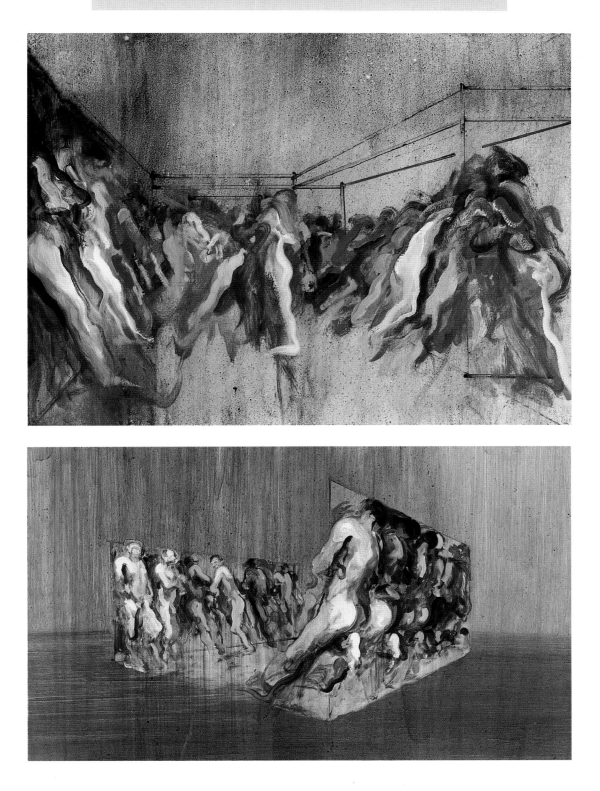

top **Box Deep 3** 1992 oil on PVC rigid 24 x 31.5cm / 9½ x 12½"

bottom **Wall 1** 1992 oil on PVC rigid 39 x 65cm / 15 x 25½"

127

Box II 1993 oil on canvas 200 x 600cm / 79 x 236"

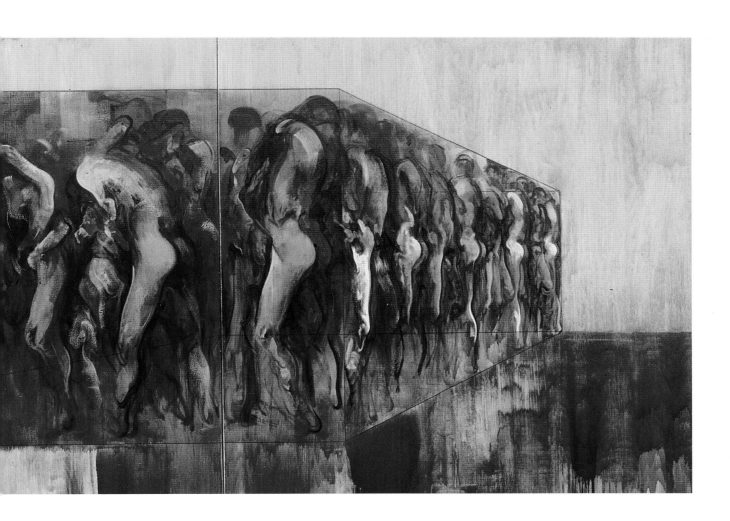

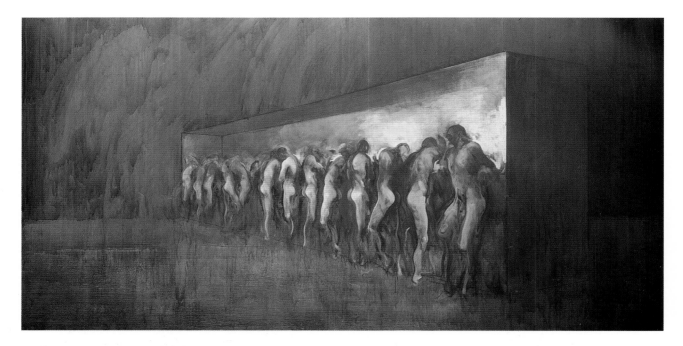

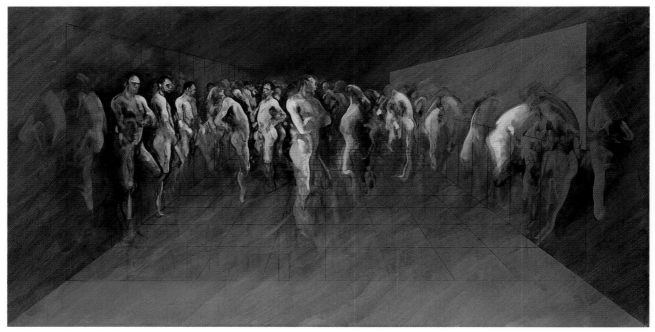

top **Line** 1993 oil on canvas 150 x 300cm / 59 x 118"

bottom **Grid** 1993 oil on canvas 150 x 300cm / 59 x 118"

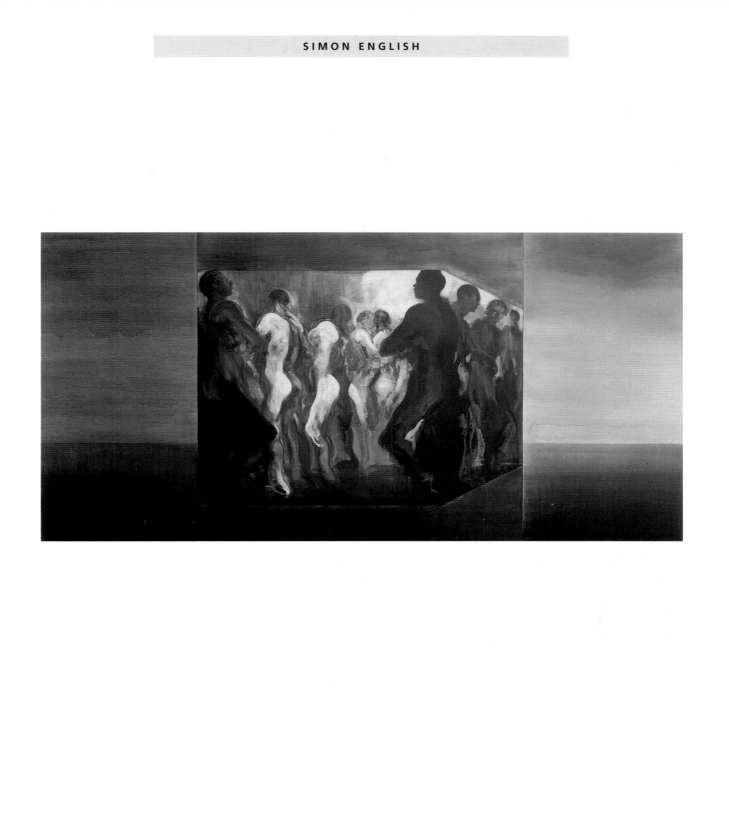

Box I 1993 oil on canvas 200 x 400cm / 79 x 157½"

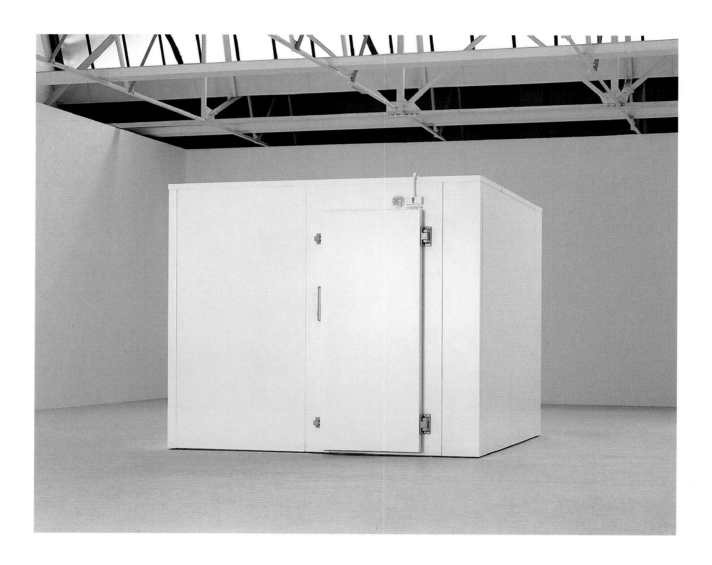

The Royal Box 1992 steel, aluminium, ice 279.5 x 279.5 x 241cm / 110 x 110 x 95"

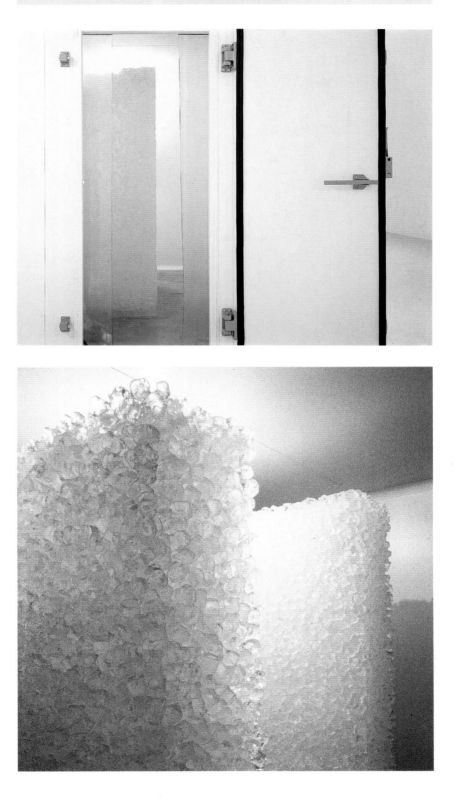

The Royal Box details

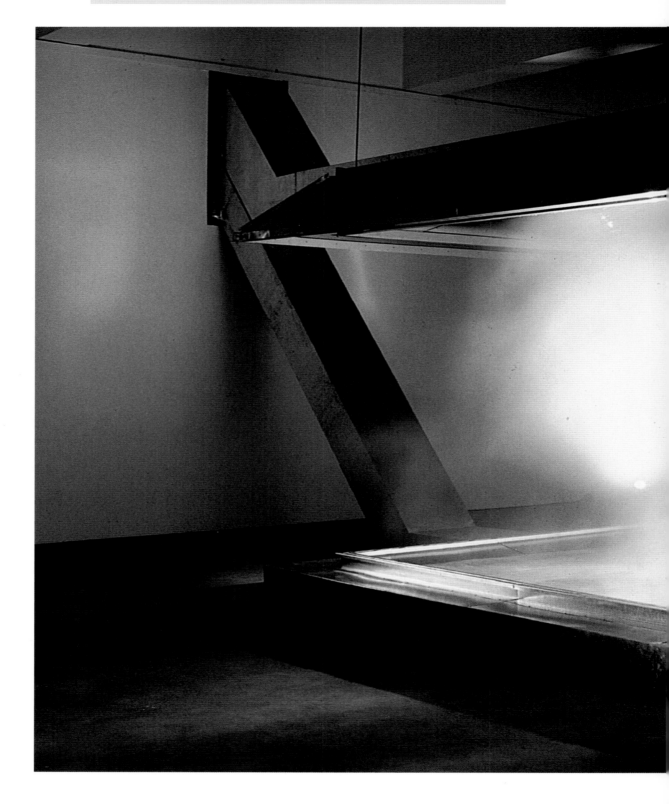

Steam Installation 1992 aluminium, water, steam 350 x 350cm / 138 x 138"

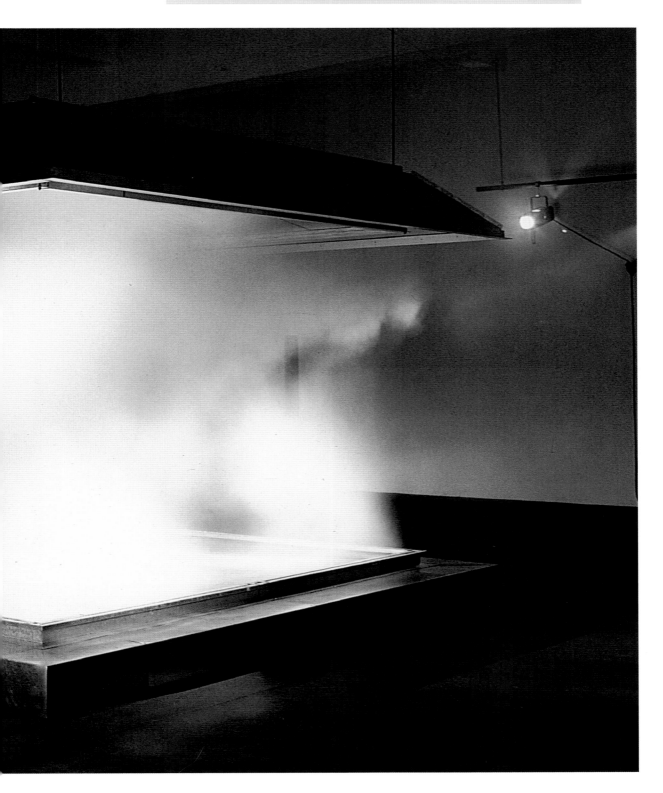

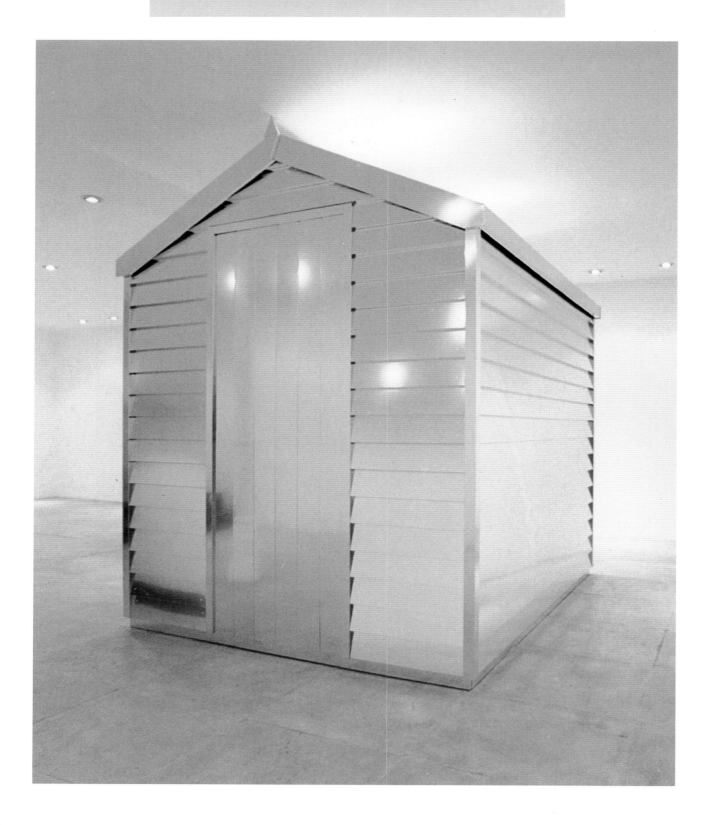

Untitled 1994 laminated polythene, wood 245 x 244 x 184cm / 96½ x 96 x 72½"

You Can't Touch This 1992-3 laminated polythene, wood dimensions variable

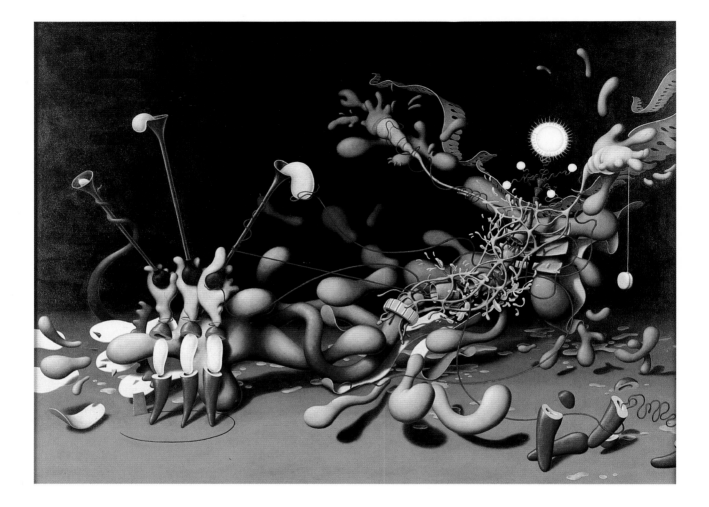

Enjoy Yourself 1991 oil on canvas 137x 183cm / 54 x 72"

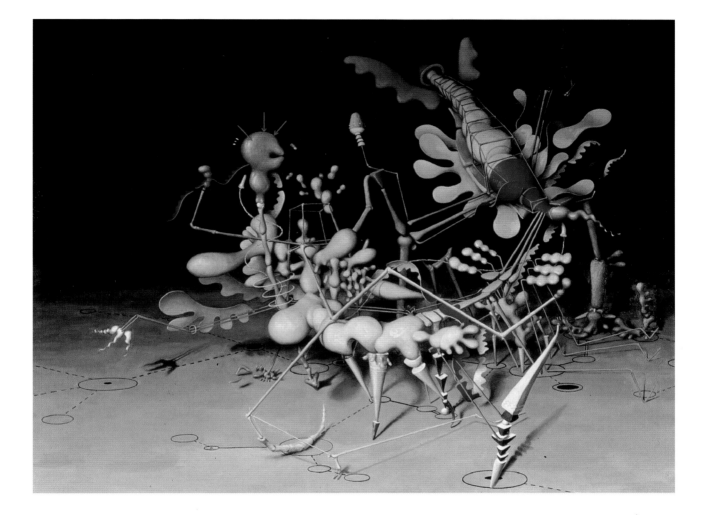

Mr Reasonable (Still Uncertain if He's a Vegetarian or a Cannibal) Prepares for the End of Season Ball 1990 oil on canvas 122 x 160cm / 48 x 63"

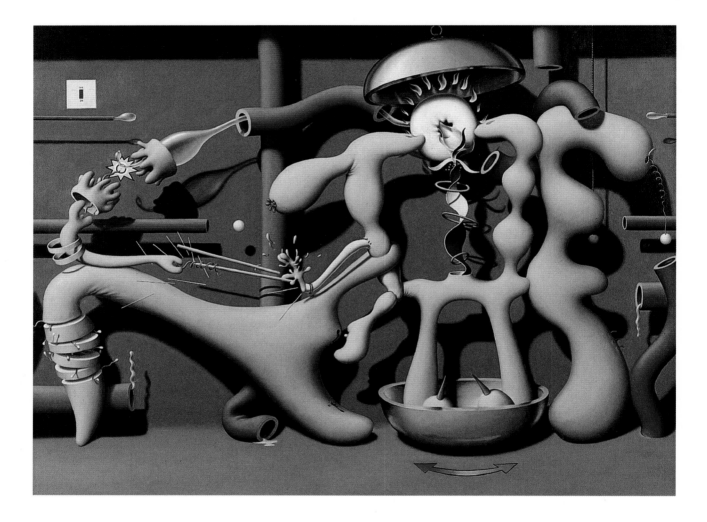

Rings and Strings and Things (No Wings, But There is Some Jelly as Always) ·1991 oil on canvas 137 x 183cm / 54 x 72"

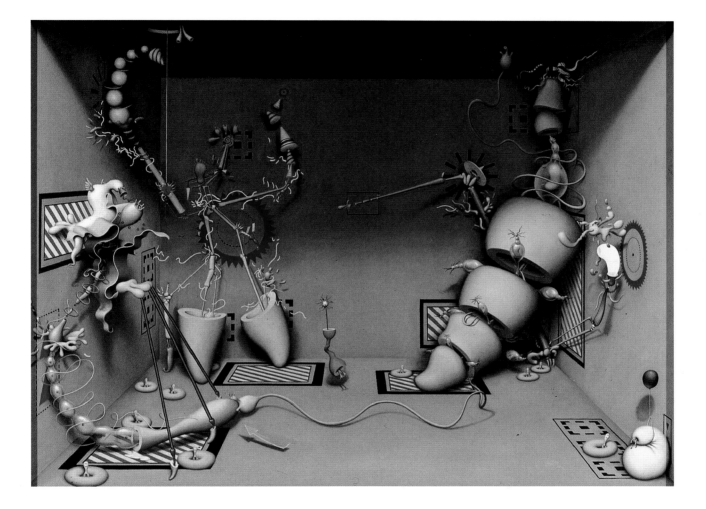

How Many Doughnuts Have You Collected? 1991 oil on canvas 137 x 183cm / 54 x 72"

Never Stand in the Middle of a Three Way Street 1991 oil on canvas 137 x 183cm / 54 x 72 "

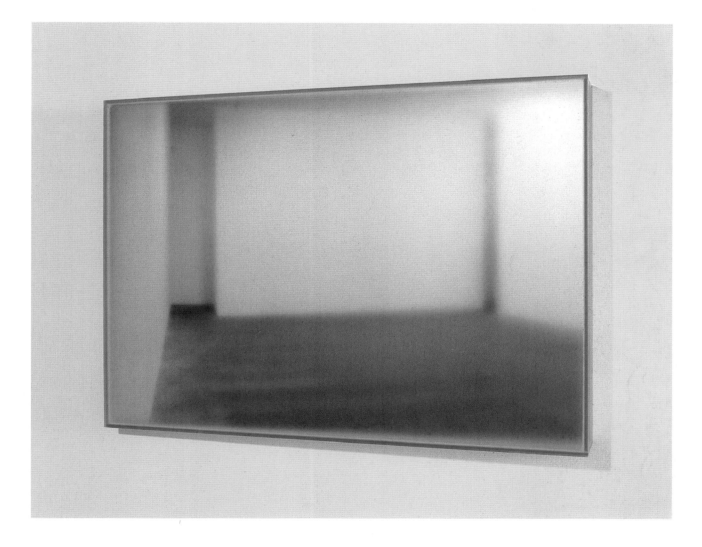

Untitled (Model) 1992 glass, MDF, photograph 151 x 242 x 28cm / 59½ x 95 x 11"

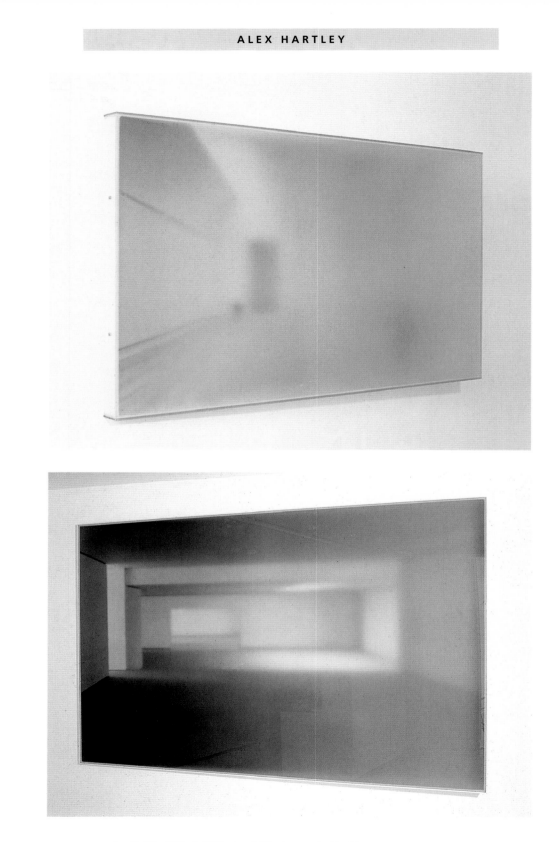

top **Untitled (Miro)** 1992 glass, MDF, photograph 60 x 85 x 11cm / 23½ x 33½ x 4½"

bottom **Untitled (Sackler)** 1992 glass, MDF, photograph 74 x 122 x 23cm / 29 x 48 x 9"

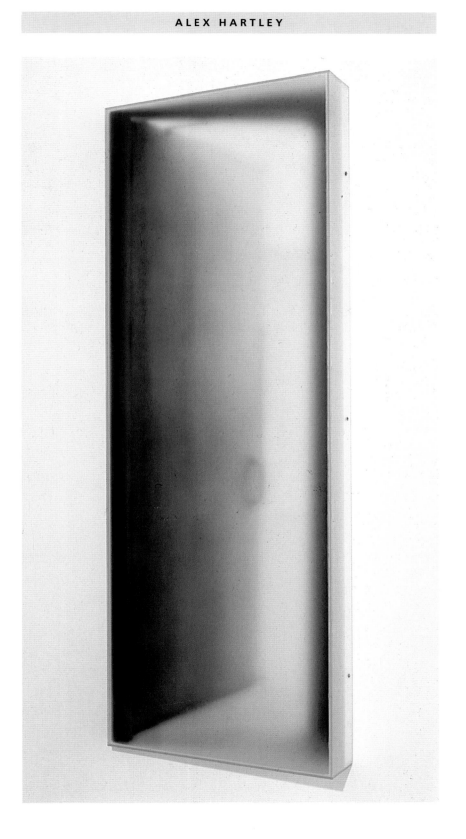

Untitled 1992 glass, MDF, photograph 154 x 58 x 14cm / 60½ x 23 x 5½"

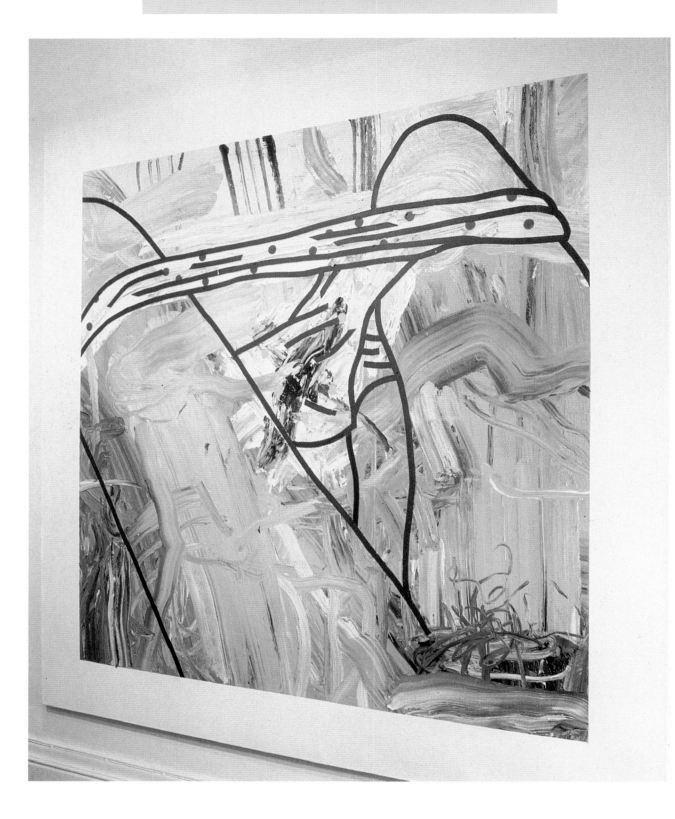

Half Way Up 1993 oil on canvas 213 x 213cm / 84 x 84"

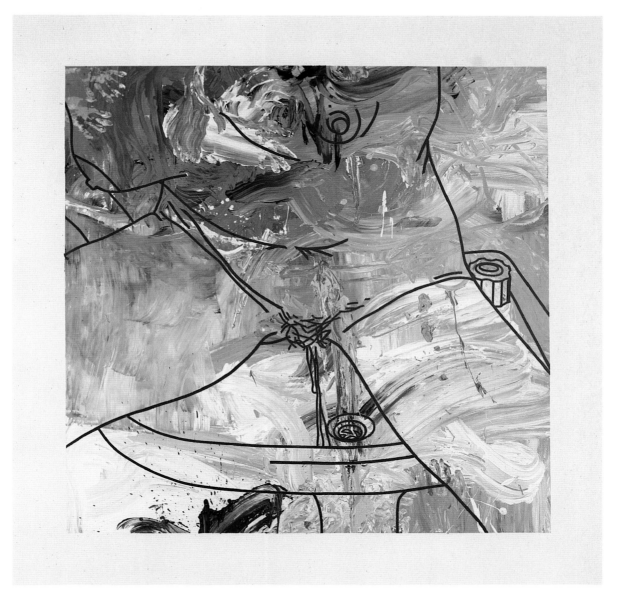

Golden Showers 1993 acrylic on canvas 244 x 244cm / 96 x 96"

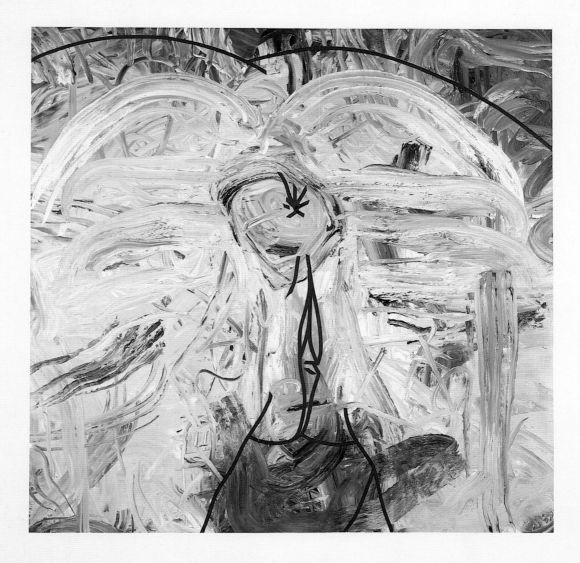

My Arse is Yours 1993 oil on canvas 213 x 213cm / 84 x 84"

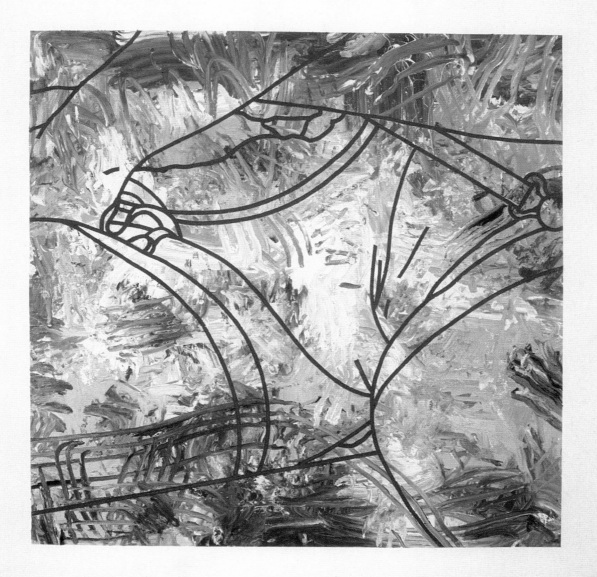

Reader's Wife I 1993-4 oil on canvas 213 x 213cm / 84 x 84"

Doggy 1993-4 oil on canvas 213 x 213cm / 84 x 84"

Julie from Hull 1994 oil and acrylic on canvas 244 x 244cm / 96 x 96"

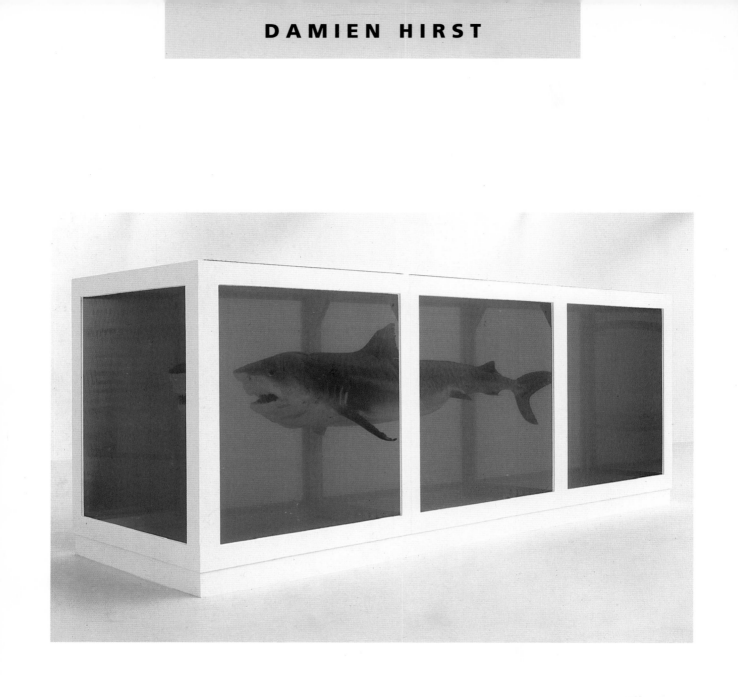

The Physical Impossibility of Death in the Mind of Someone Living 1991
tiger shark, glass, steel, formaldehyde solution 213 x 518 x 213cm / 84 x 204 x 84"

A Thousand Years 1990 glass, steel, MDF, cow's head, flies, maggots, insect-o-cutor, sugar, water 213 x 427 x 213cm / 84 x 168 x 84"

Isolated Elements Swimming in the Same Direction For the Purpose of Understanding 1991

MDF, melamine, wood, steel, glass, perspex cases, fish, 5% formaldehyde solution 183 x 274 x 30.5cm / 72 x 108 x 12"

Holidays 1989 drug bottles, cabinet 137 x 102 x 23cm / 54 x 40 x 9"

No Feelings 1989 drug bottles, cabinet 137 x 102 x 23cm / 54 x 40 x 9"

Acetic Anhydride 1991 gloss household paint on canvas 169 x 200cm / 66½ x 79"

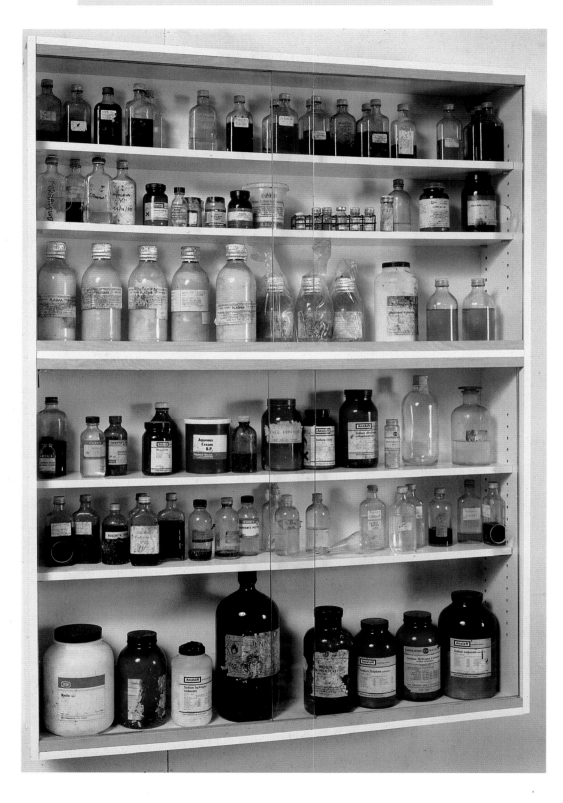

My Way 1990-91 old drug bottles, cabinet 137 x 102 x 23cm / 54 x 40 x 9"

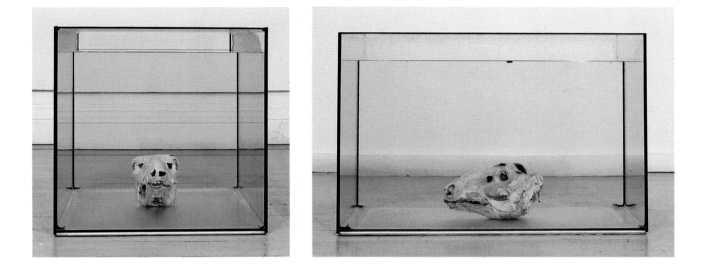

Stimulants (and the way they affect the mind and body) 1992
glass, silicone, polystyrene and two sheep's heads in formaldehyde 46 x 69 x 46cm / 18 x 27 x 18"

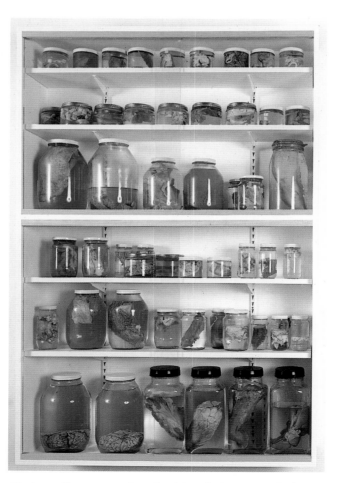

The Lovers (Spontaneous, Committed, Detached, Compromising) 1991
4 cabinets containing assorted jars of internal organs from 8 cows in a 5% formaldehyde solution each cabinet: 152 x 102 x 23cm / 60 x 40 x 9"

The Lovers detail

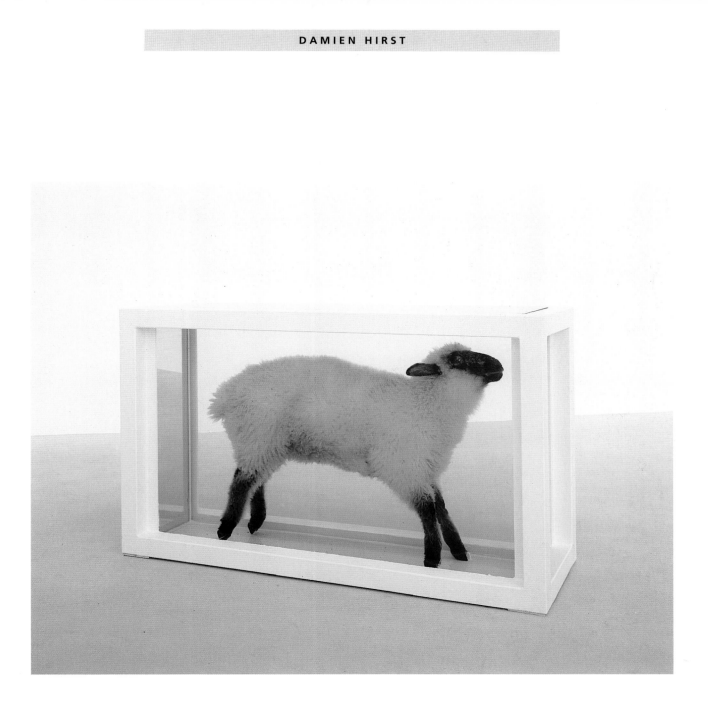

Away from the Flock 1994 steel, glass, lamb, formaldehyde solution 96.5 x 149 x 51cm / 38 x 59 x 20"

GARY HUME

Dolphin Painting 1 1990-91 gloss paint on MDF 4 panels, overall: 218 x 590cm / 86 x 232"

Two Three Leaf Clovers 1994 gloss paint on panel 241.5 x 155.5cm / 95 x 61"

Tony Blackburn 1994 gloss paint on panel 194 x 137cm / 76 x 54"

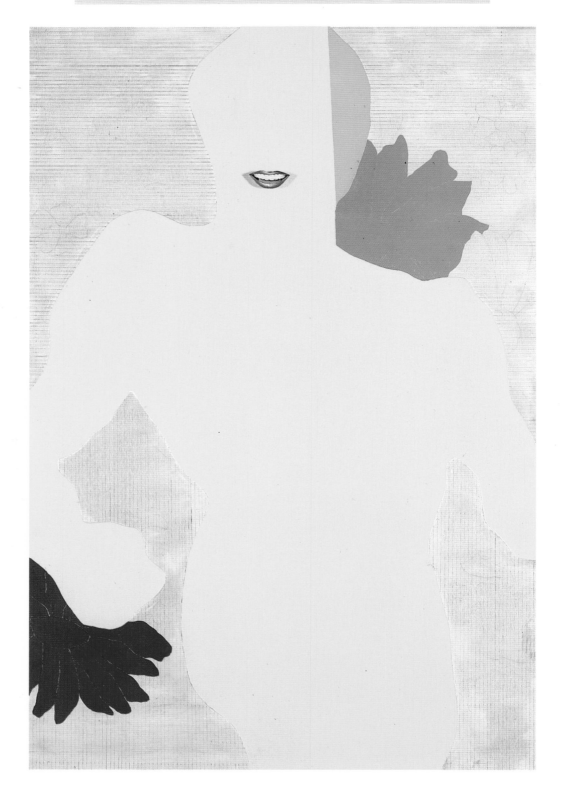

Man, Woman, Jealousy and Passion 1993 gloss paint, pencil, cardboard on panel 201 x 133cm / 79 x 52"

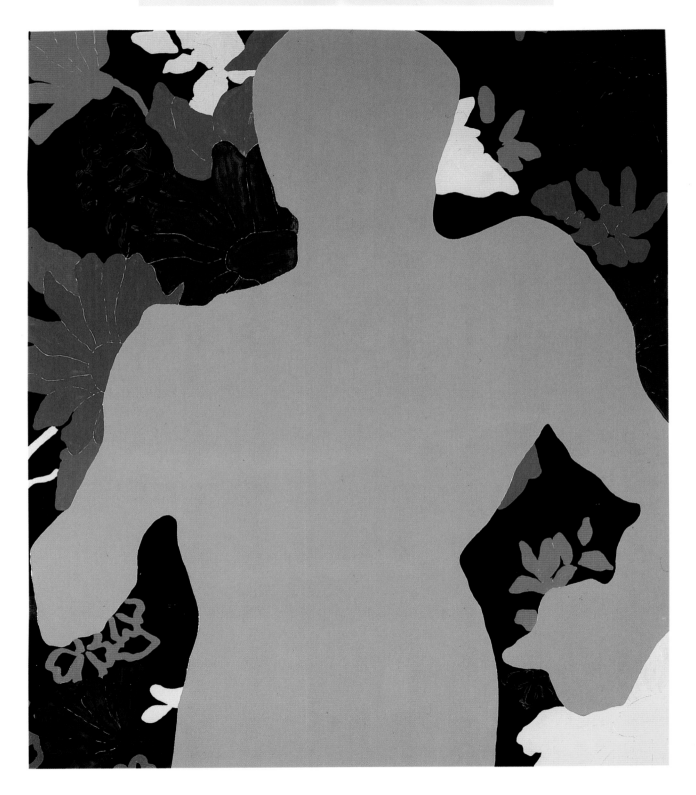

Vicious 1994 gloss paint on panel 218 x 181cm / 86 x 71"

Combat/Camouflage 1989 eggshell on canvas diptych, each: 46 x 61cm / 18 x 24"

top **Angels Flight/Billowy Clouds** 1990 eggshell on canvas diptych, each: 60 x 82.5cm / 23½ x 32½"

bottom **Still Water/Leaden Skies** 1990 eggshell on canvas diptych, each: 60 x 82.5cm / 23½ x 32½"

top **Desert Dawn/Cool Oasis** 1990 eggshell on canvas diptych, each: 60 x 82.5cm / 23½ x 32½"

bottom **Valley Slope/Weathered Stone** 1990 eggshell on canvas diptych, each: 60 x 82.5cm / 23½ x 32½"

Ink Pad I 1992 aluminium, cotton covered felt, MDF, black ink 244 x 305 x 2.5cm / 96 x 120 x 1"

Blue Print 1992 chair with felt ink pad seat, blue ink, framed print 122 x 46 x 91cm / 48 x 18 x 36"

top **House & Occupants I** 1991 photograph, glass 49.5 x 39 x 1.5cm / 19½ x 15 x ½"

bottom **House & Occupants II** 1991 photograph, glass 49.5 x 39 x 1.5cm / 19½ x 15 x ½"

Misfit 1994 wax, plaster, oil paint, human hair, clothing, glass eyes 60 x 85 x 192cm / 23½ x 33½ x 75½"

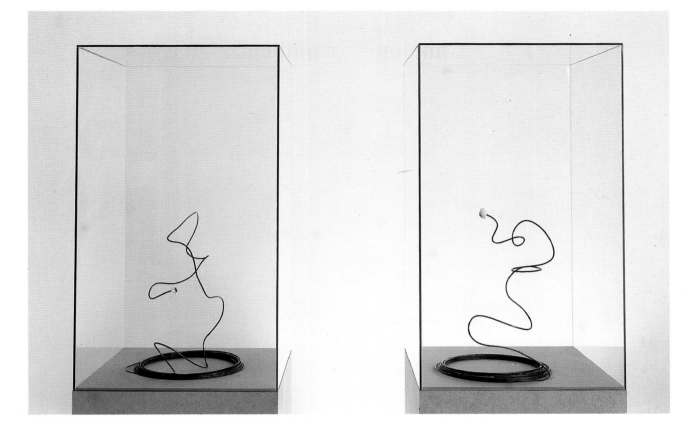

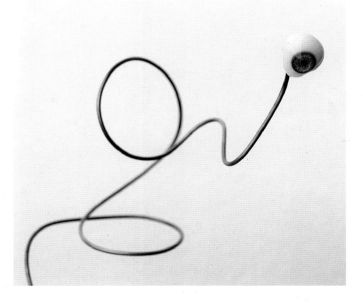

I Spy 1994 wood, glass, brass wire, glass eyes each: 170 x 40 x 40cm / 67 x 16 x 16"

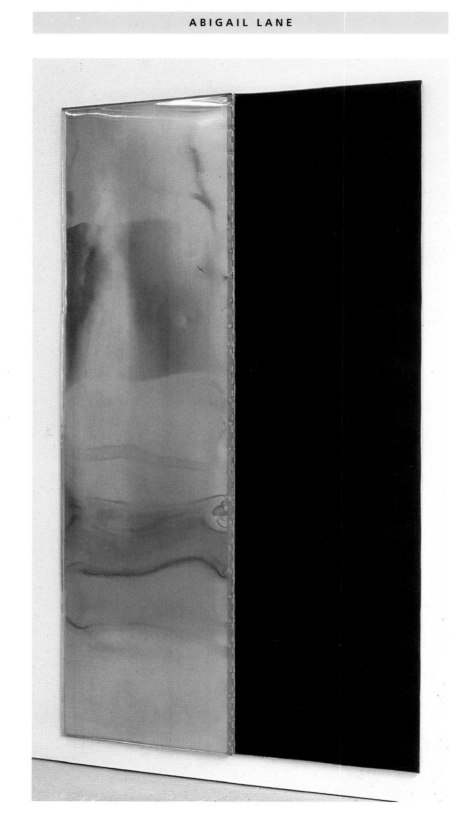

Ink Pad (Impression 1) 1991 aluminium, MDF, cotton covered felt, black ink 168 x 92 x 1.5cm / 66 x 36 x ½"

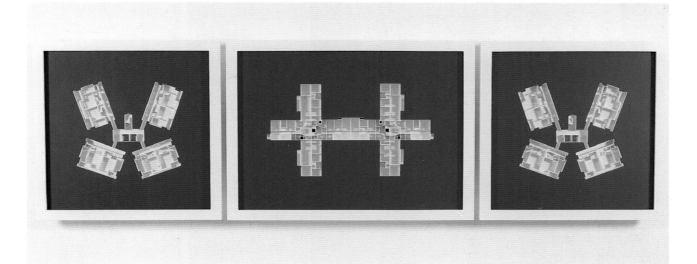

Highpoint 1990 MDF, wood products, glass, lacquer 76 x 258 x 15cm / 30 x 101 x 6"

UN Security Council, New York 1991 MDF, wood products, glass, lacquer 68 x 60 x 18cm / 27 x 23½ x 7"

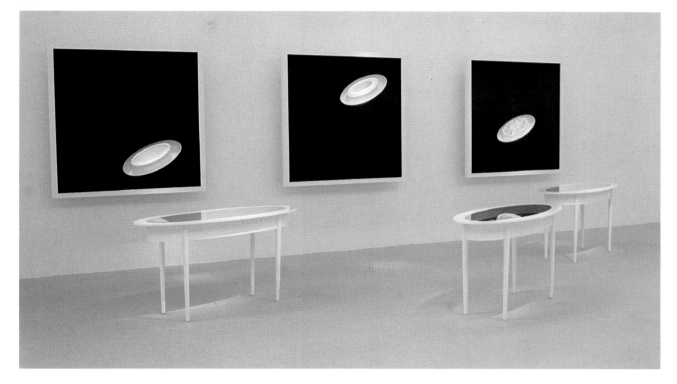

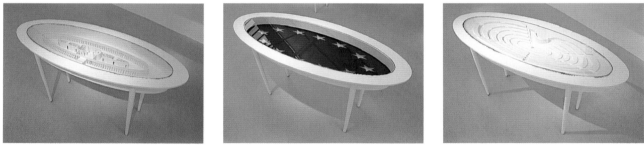

Surrounding Time 1990
MDF, poplar, wood products, glass, AC lacquer wall cabinets (3) each: 150 x 150 x 18cm / 60 x 60 x 7" tables (3) each: 80 x 150 x 60cm / 31½ x 60 x 24"
wall cabinets: The Colosseum, Rome; The Glaverbel HQ, Brussels; La Maison de Force, Ghent

Surrounding Time details
tables: VUB Building, Brussels University; EC Flag; Council of Europe, Strasbourg

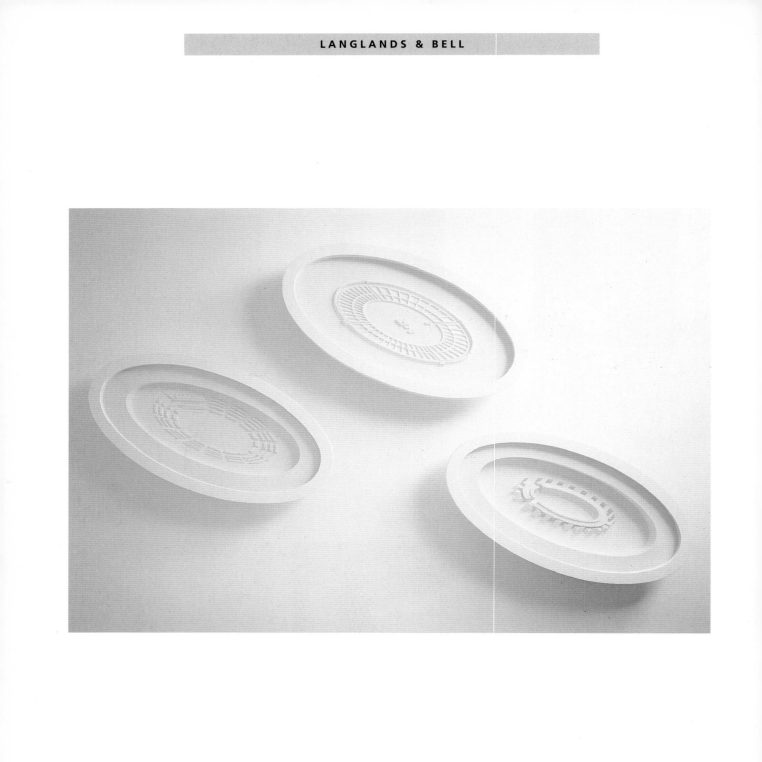

The Circular City 1990 MDF, wood products, glass, lacquer each: 96 x 50 x 15cm / 38 x 20 x 6"

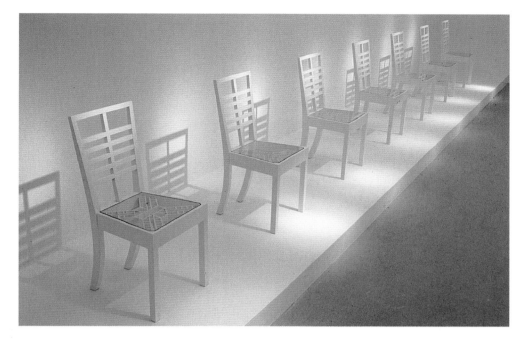

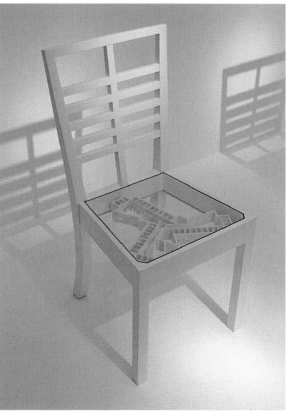

Maisons de Force 1991 beech, MDF, wood products, glass, paint, AC lacquer each: 92 x 42 x 40cm / 54 x 16½ x 16"
7 chairs containing 7 prison plants: San Diego, USA; Vienna, Austria: Suffolk, England; Rebibia, Italy; Hameln, Germany; Erlestoke, USA; Bridewell, Scotland

Maisons de Force detail Youth Custody Center, Erlestoke, Ohio

182 **Pilot Schemer** 1992 acrylic and interference acrylic on canvas 166 x 216cm / 65 x 85"

top **Notifier** 1992 day glo and interference acrylic on canvas 167 x 213cm / 66 x 84"

bottom **Channel** 1992 day glo and interference acrylic on canvas 169 x 215cm / 66½ x 84½"

top **Slowburn Escort** 1992 day glo and interference acrylic on canvas 171 x 215cm / 67 x 84½"

bottom **Thin Skin** 1992 acrylic and interference acrylic on canvas 170 x 215cm / 67 x 84½"

Fugitive's Fuel 1993 day glo, night glo and interference acrylic on canvas 215 x 306cm / 84½ x 120½"

Shadow No. 25 1993 oil on canvas 250 x 200cm / 98½ x 79"

top **Shadow No. 12** 1993 oil on canvas 140 x 300cm / 55 x 118"

bottom **Shadow No. 16** 1993 oil on canvas 170 x 300cm / 67 x 118"

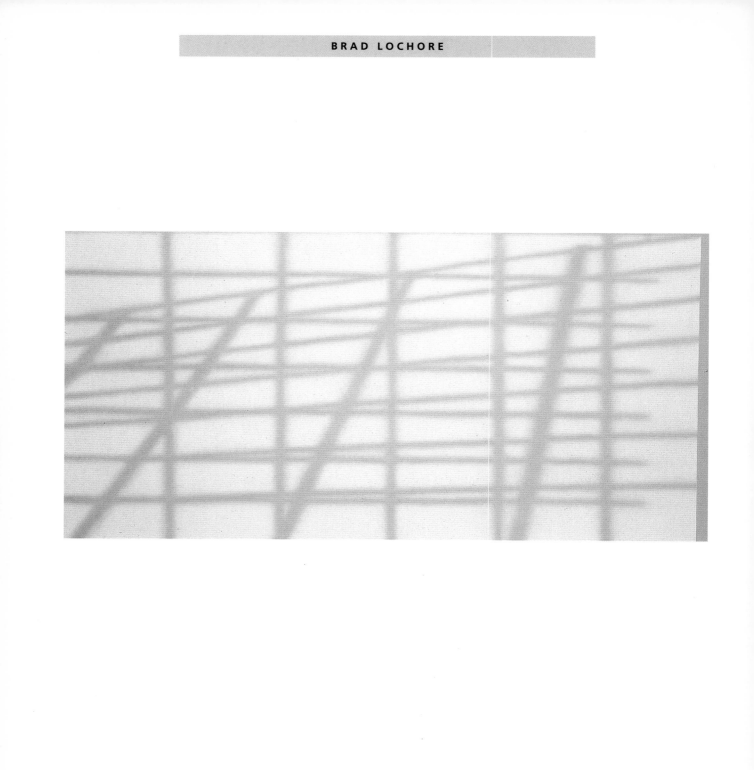

Shadow No. 26 1993 oil on canvas 150 x 300cm / 59 x 118"

Shadow No. 15 1993 oil on canvas 250 x 240cm / 98½ x 94½"

Fat, Forty and Flabulous 1990 photocopy on paper 214.5 x 312.5cm / 84½ x 123"

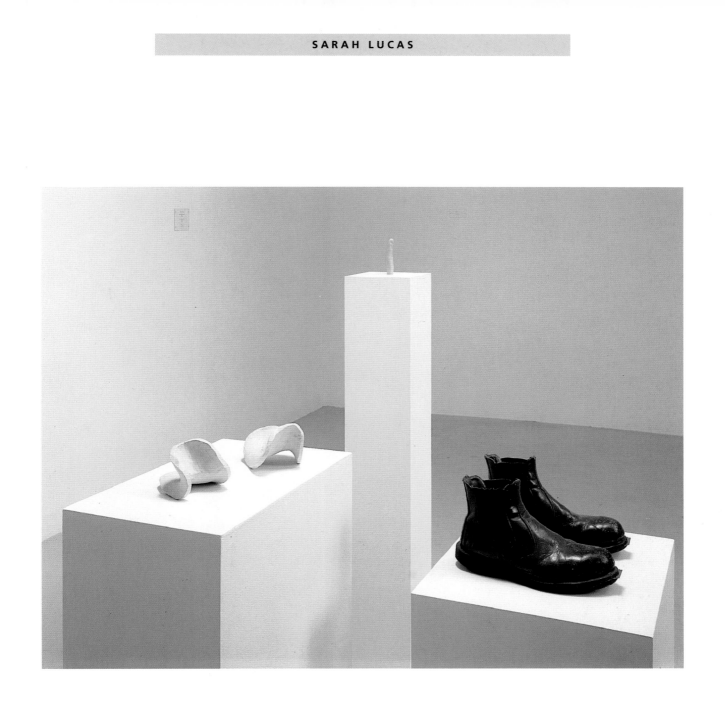

centre **Receptacle of Lurid Things** 1991 wax lifesize

left **Figleaf in the Ointment** 1991 plaster, hair lifesize *right* **1 - 123 - 123 - 12 - 12** 1991 boots with razor blades size seven

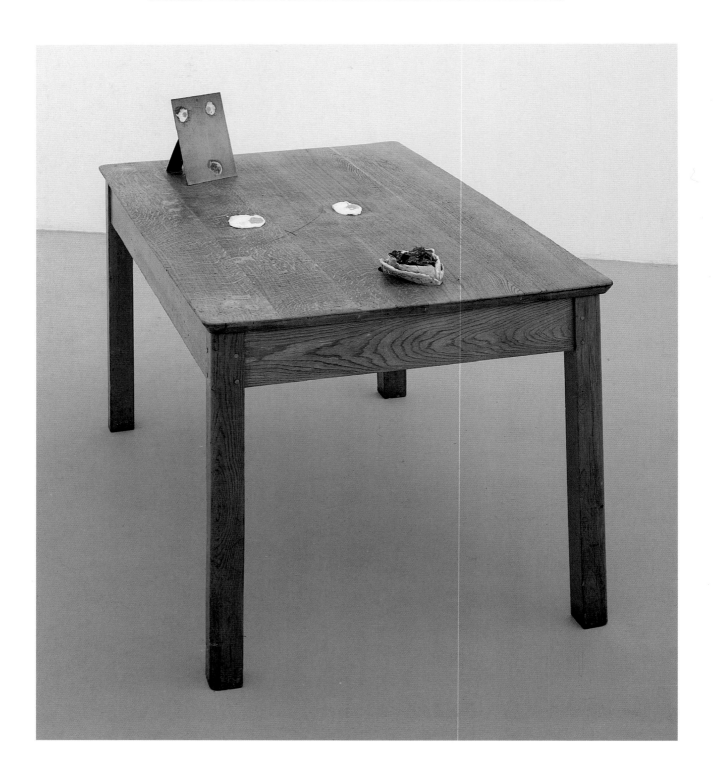

Two Fried Eggs and a Kebab 1992 photograph, fried eggs, kebab, table 76.2 x 152.4 x 89cm / 30 x 60 x 35"

top **Seven Up** 1991 photocopy on paper 218.5 x 312.5cm / 86 x 123"

bottom **Sod You Gits** 1990 photocopy on paper 216 x 315cm / 85 x 124"

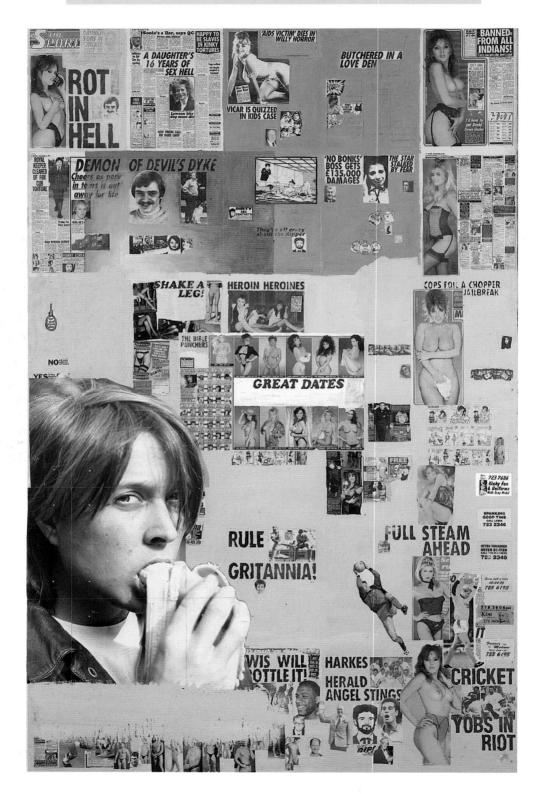

Great Dates 1992 collage, paint 223.5 x 143.5cm / 88 x 56½"

Self-portrait as a Rabbit 1992 cibachrome print on board 40 x 90cm / 16 x 35½"

Untitled 1993 dye sublimation print on board each: 12 x 18cm / 5 x 7"

Cell 1994 C-type print 183 x 213.5cm / 72 x 84"

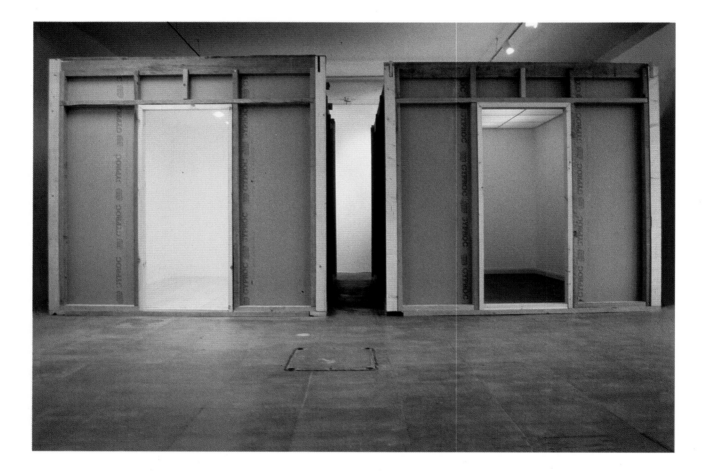

Blind Faith 1992 mixed media 244 x 244 x 366cm / 96 x 96 x 144"

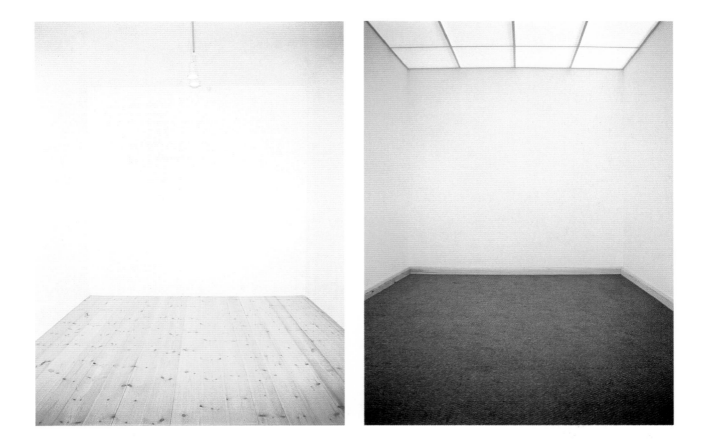

left **Hinge** 1993 snowcrete, plaster with plumbing components lavatory: 48 x 46 x 51cm / 19 x 18 x 20"

centre **Tap Tap Soap Chain Plug Waste** 1993 solid snowcrete, plaster with plumbing components basin on pedestal: 84 x 33 x 33cm / 33 x 13 x 13"

right **Tap Tap Chain Plug Handle Waste** 1993
snowcrete, plaster over polystyrene, steel mesh core with plumbing components bath: 28 x 51 x 147cm / 11 x 20 x 58"

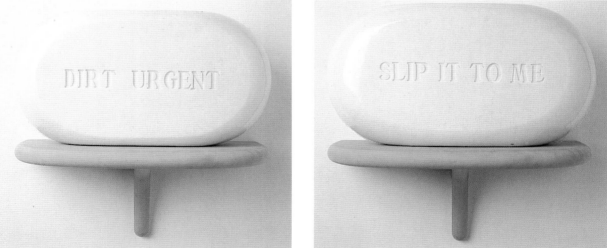

top **Submersive I** 1994 pink soap (over steel mesh and polystyrene core) 30.5 x 178 x 61cm / 12 x 70 x 24"
Submersive II 1994 blue soap (over steel mesh and polystyrene core) 28 x 170 x 67cm / 11 x 67 x 26½"

bottom left **Dirt Urgent** 1994 white shrinkwrapped soap, shelf 23 x 46 x 14cm / 9 x 18 x 5½"

bottom right **Resurrection (after Richard H.)** 1994 white shrinkwrapped soap, shelf 23 x 46 x 14cm / 9 x 18 x 5½"

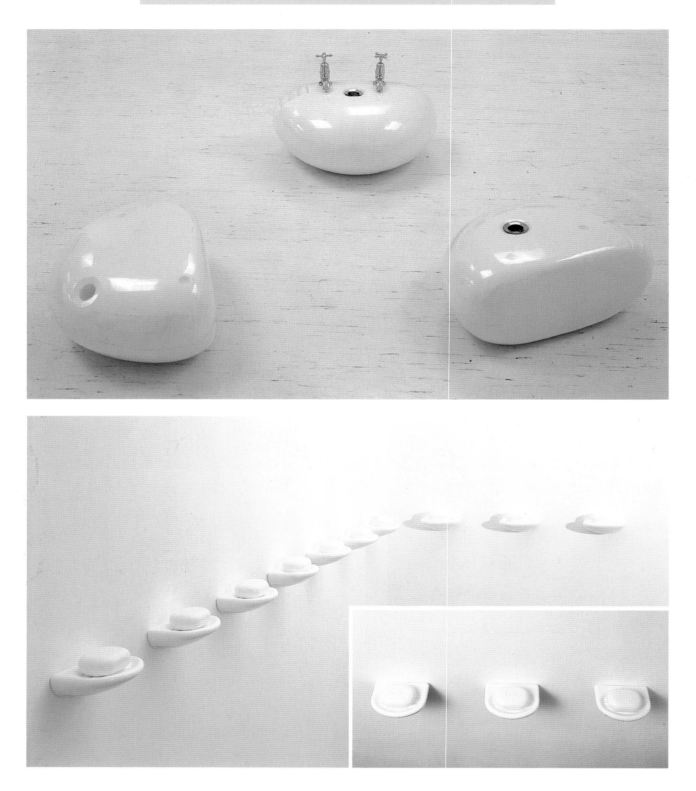

top **Dysfunction** 1994 soap, plumbing components 41 x 63.5 x 43cm / 16 x 25 x 17"

bottom **Wash (1) (Self - position 1 - London 23 March 1994)** 1994 18 white soap bars, 18 plaster soap dishes 8 x 13 x 8cm / 3 x 5 x 3" *inset* detail

Blue Riot 1994 oil on canvas 305 x 366cm / 120 x 144"

Small Blue Executive World 1993 oil on linen 183 x 183cm / 72 x 72"

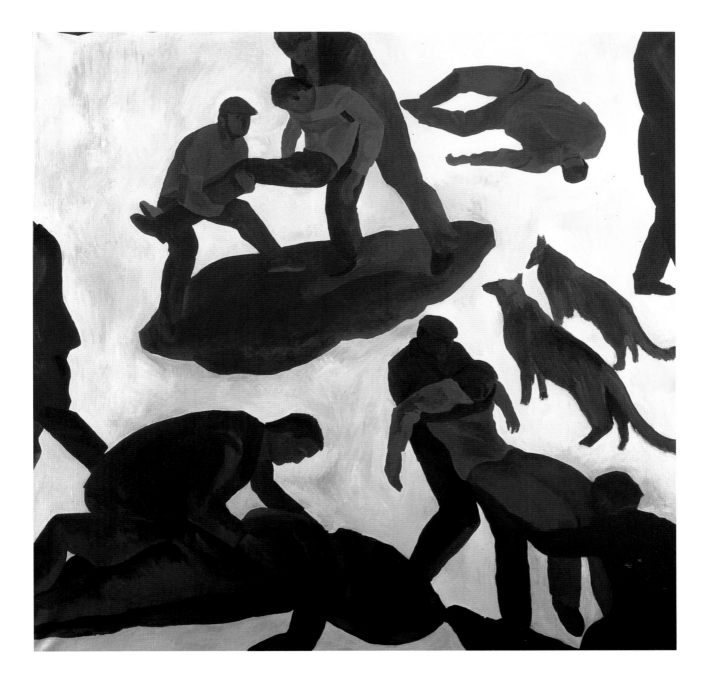

Blue Pieta 1992 oil on linen 183 x 183cm / 72 x 72"

Self 1991 blood, stainless steel, perspex and refrigeration equipment 208 x 63 x 63cm / 82 x 25 x 25"

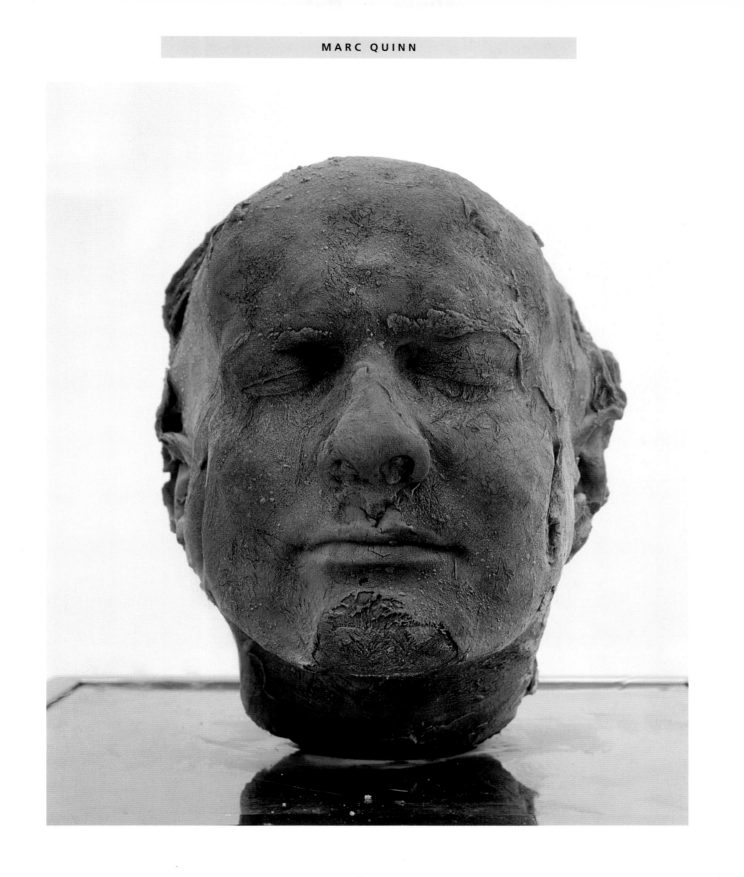

Self detail

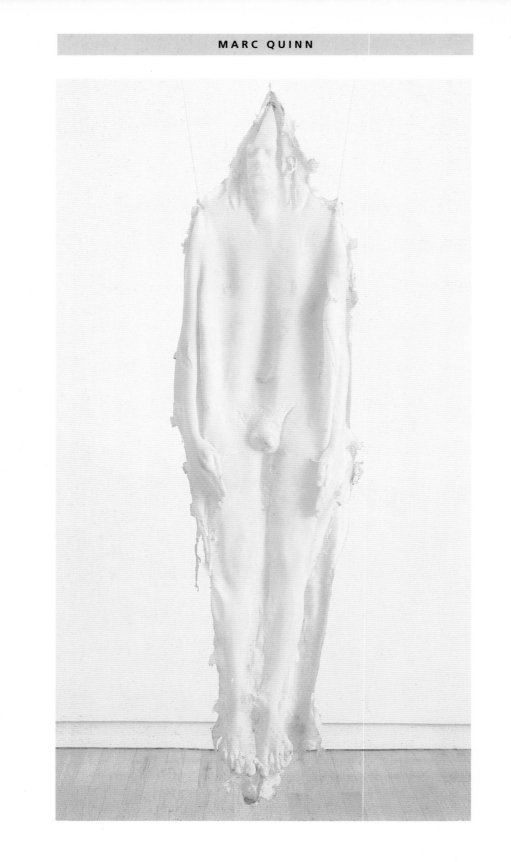

You Take My Breath Away 1992 latex rubber 180cm / 71" high

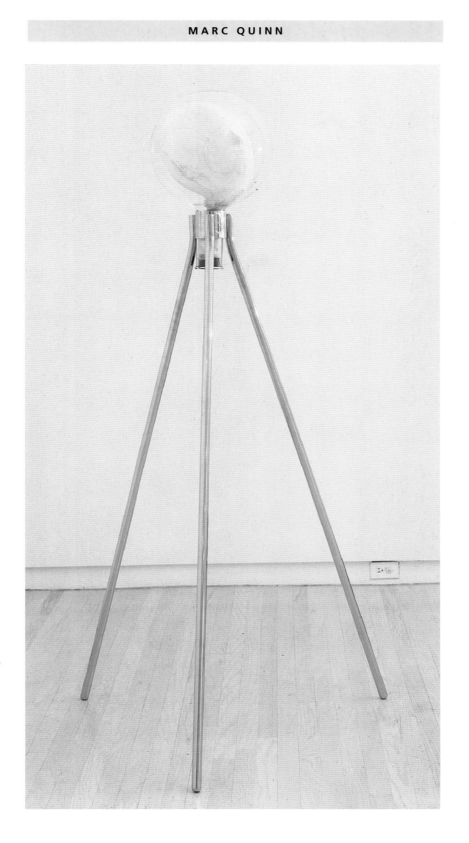

I Need an Axe to Break the Ice 1992 latex rubber, glass, and stainless steel 187 x 94 x 76cm / 73½ x 37 x 30"

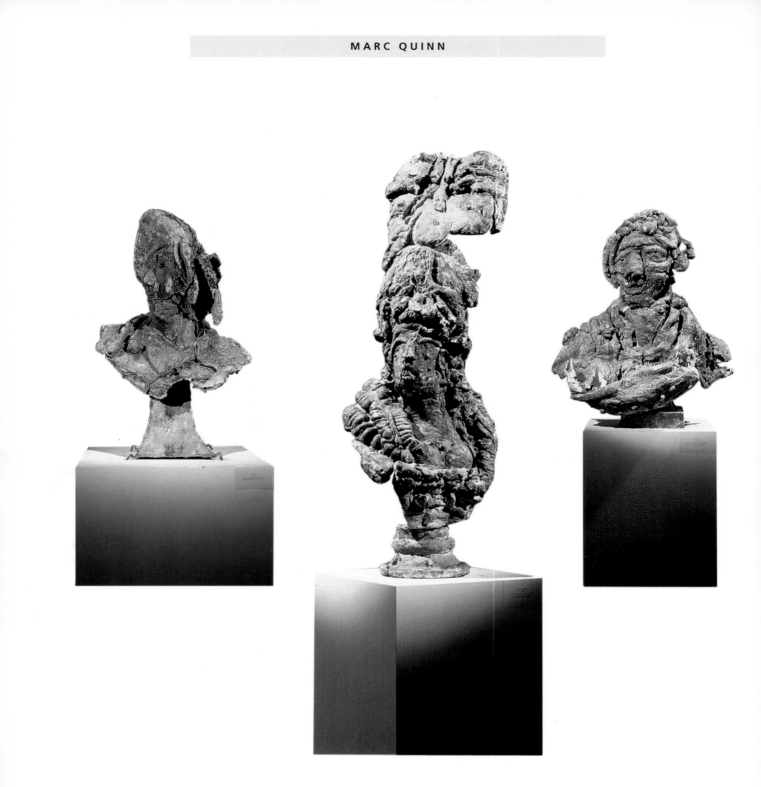

left **Doctor Pangloss** 1990 baked in dough, cast in bronze 89cm / 35" high

centre **Marie Antoinette** 1989 baked in dough, cast in bronze 125cm / 49" high

right **Louis XVI** 1989 baked in dough, cast in bronze 79cm / 31" high

Untitled (one on brown) 1989 oil on canvas 210 x 198cm / 83 x 78"

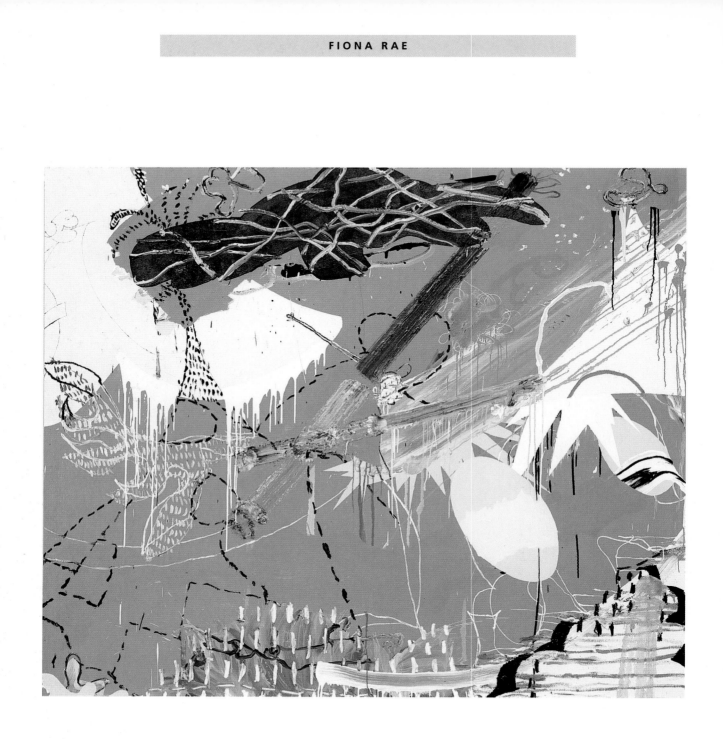

Untitled (blue) 1991 oil on canvas 183 x 213.5cm / 72 x 84"

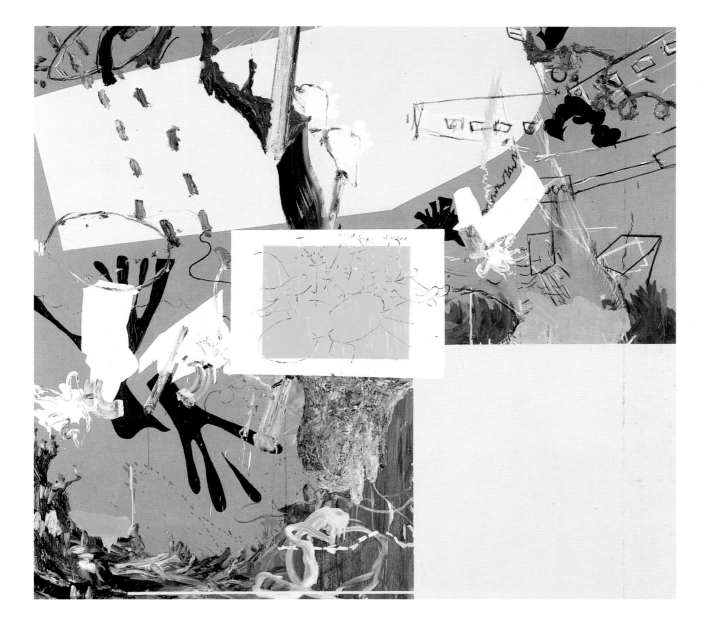

Untitled (purple and brown) 1991 oil and charcoal on canvas 198 x 213.5cm / 78 x 84"

EMMA RUSHTON

English Clergy 92 1992 wax figures, fabric, leather, hair, MDF plinths 51cm / 20" high

English Clergy 92 1992 wax figures, fabric, leather, hair, MDF plinths 51cm / 20" high

Glove Compartment Nos. 2,3,4 1993 photographs, steel, glass, leatherette, perspex
large photos each: 57 x 48cm / 22 x 19" small photos each: 20 x 20cm / 8 x 8"

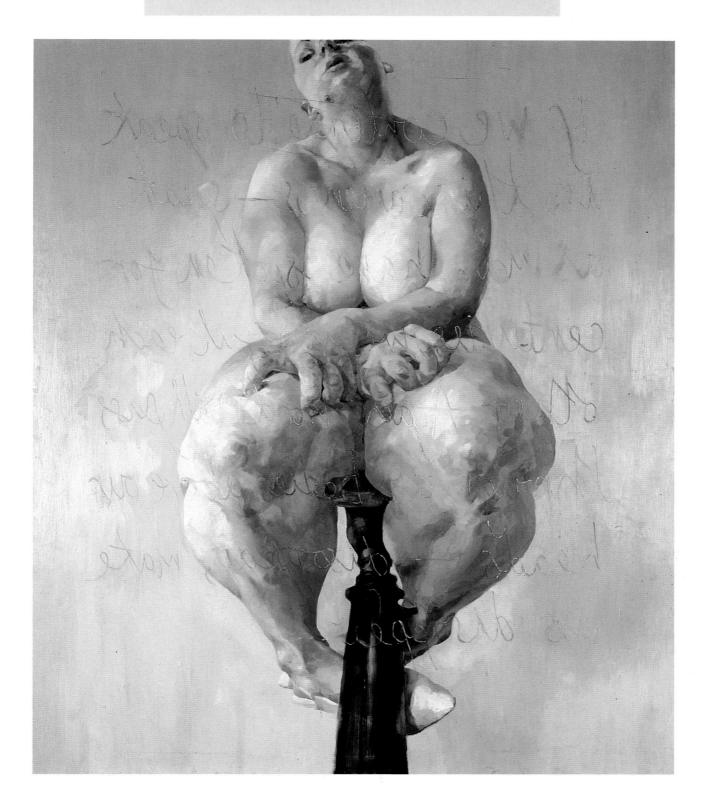

Propped 1992 oil on canvas 213.5 x 183cm / 84 x 72"

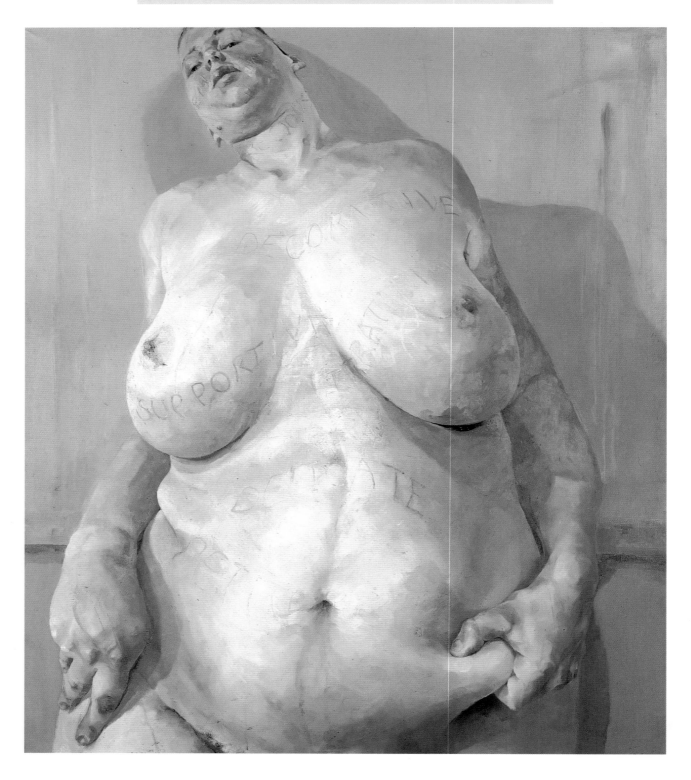

Branded 1992 oil on canvas 213.5 x 183cm / 84 x 72"

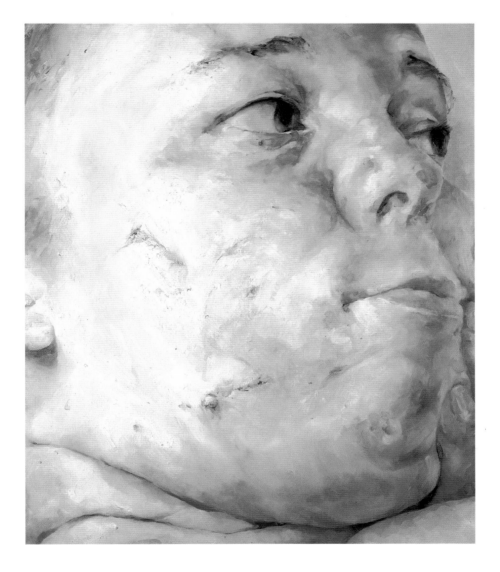

Interfacing 1992 oil on canvas 122 x 102cm / 48 x 40"

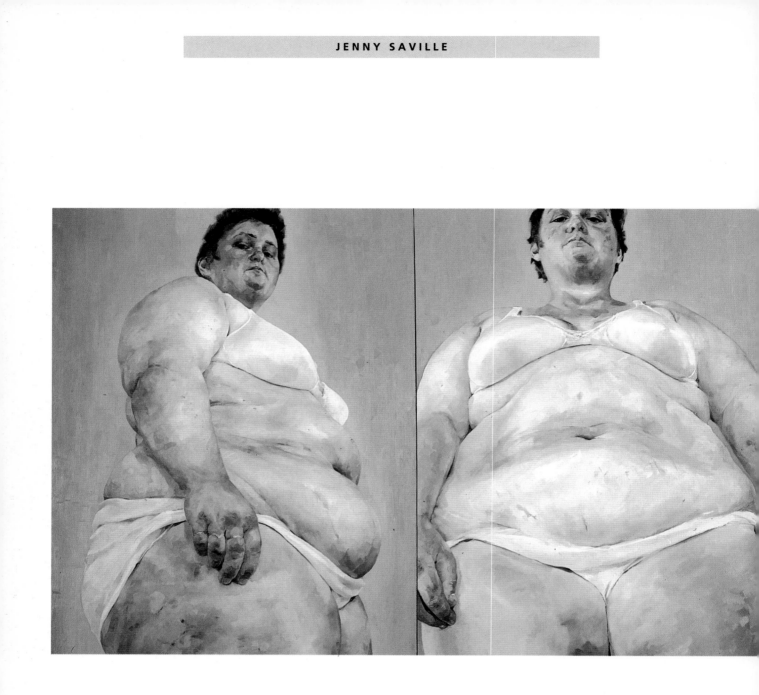

Strategy (South Face/Front Face/North Face) 1993-4 oil on canvas triptych, overall: 274 x 640cm / 108 x 252"

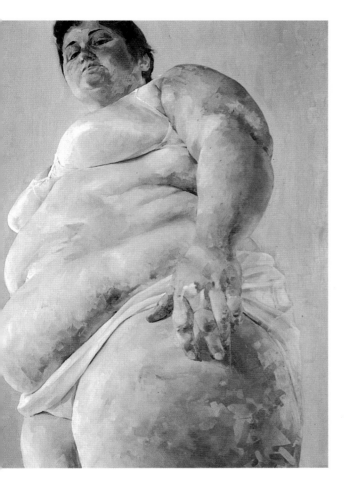

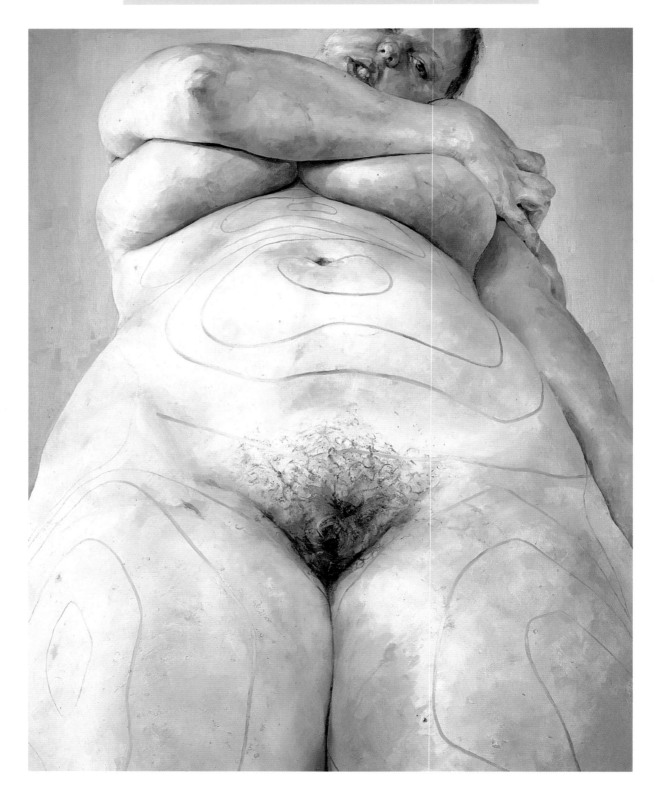

Plan 1993 oil on canvas 274.5 x 213.5cm / 108 x 84"

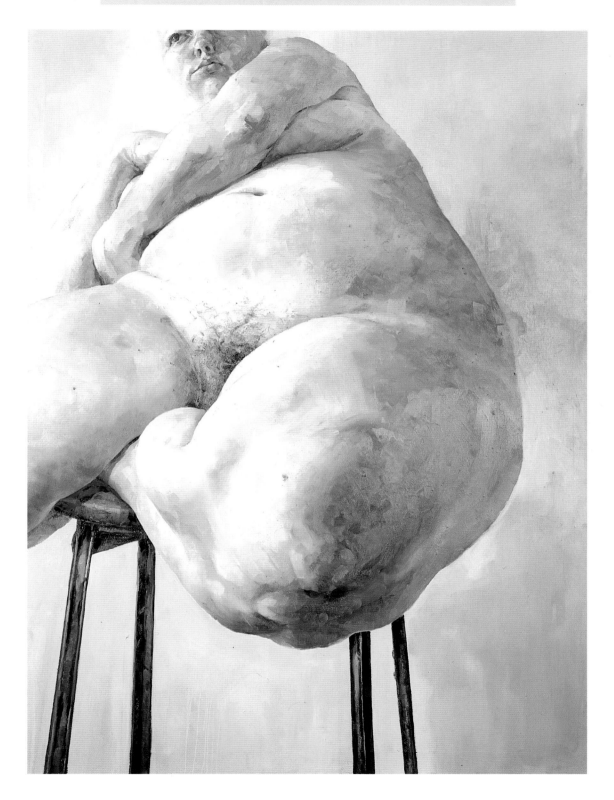

Prop 1993 oil on canvas 213.5 x 183cm / 84 x 72"

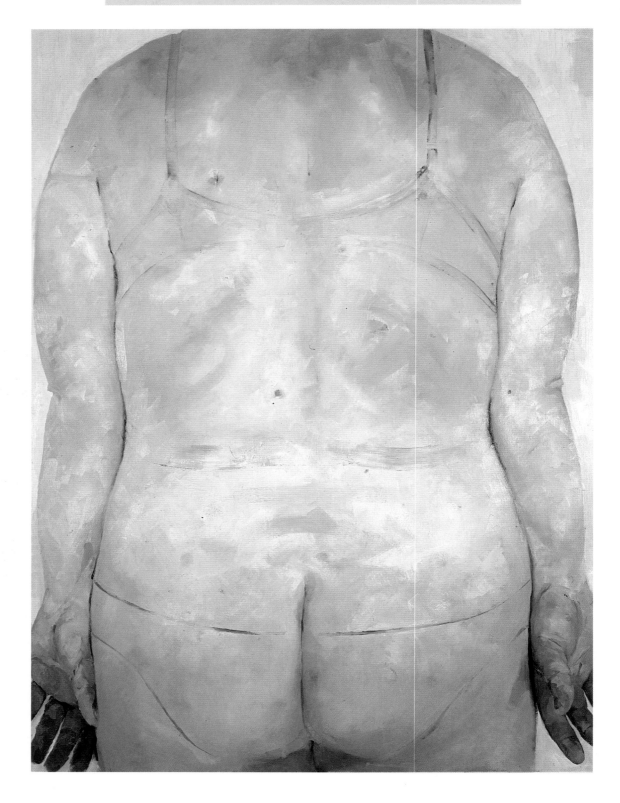

Trace 1993-4 oil on canvas 213.5 x 165cm / 84 x 72"

In Between 1993 brass, butter, halogen bulb, refrigeration unit 10 x 32.5 x 50cm / 4 x 13 x 20"

Sacred 1993 MDF, gesso, watercolour, tinplate, refrigeration unit 122.5 x 127.5 x 55cm / 48 x 50 x 22"

Sacred detail of ice frosting

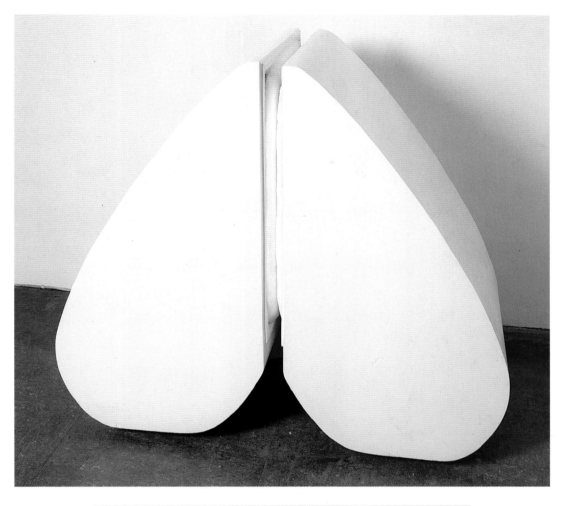

Between 1992 MDF, skin ply, plastic coating, brass, refrigeration unit 127 x 115.5 x 62cm / 50 x 45½ x 24½"

Between detail of ice frosting

Untitled (Pregnant Schoolgirl) 1993 plaster, enamel paint 150 cm / 59" high

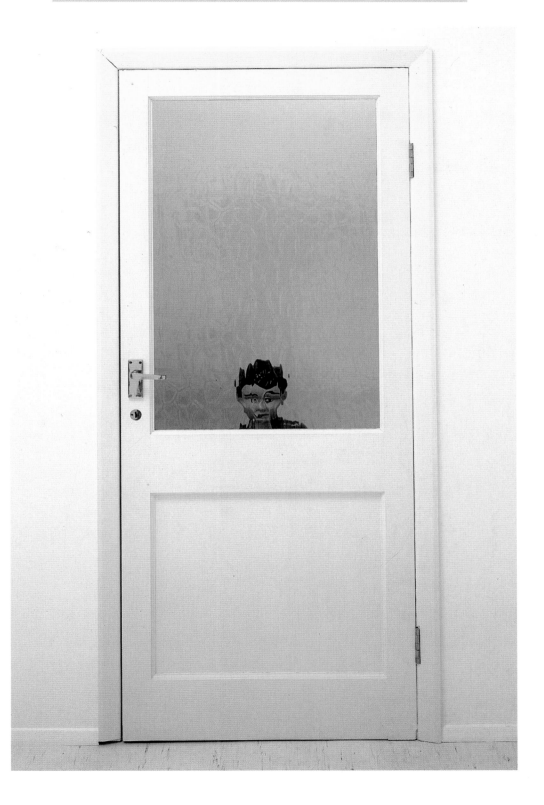

'The Boy from the Chemist is Here to See You' 1993 fibreglass charity collection boy, pebbled glass door dimensions variable

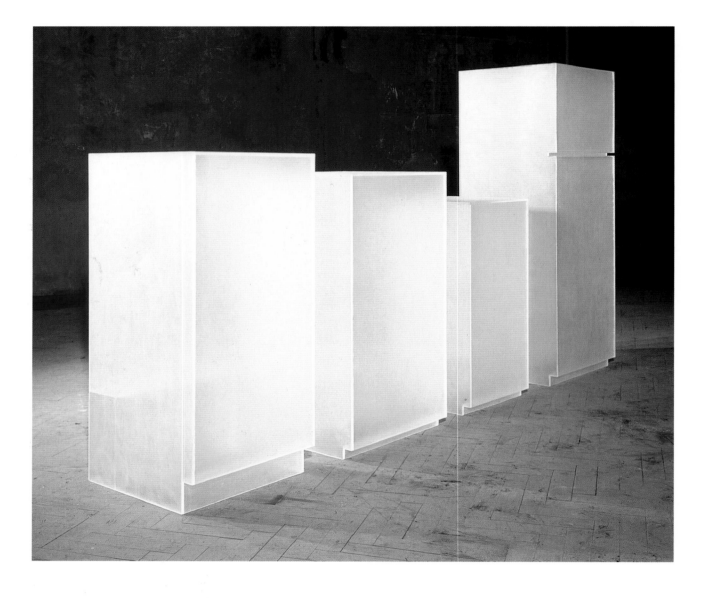

Untitled (Quadruple Fridge) 1991 clear acrylic sheet 156 x 280 x 54.5cm / 61½ x 110 x 21½"

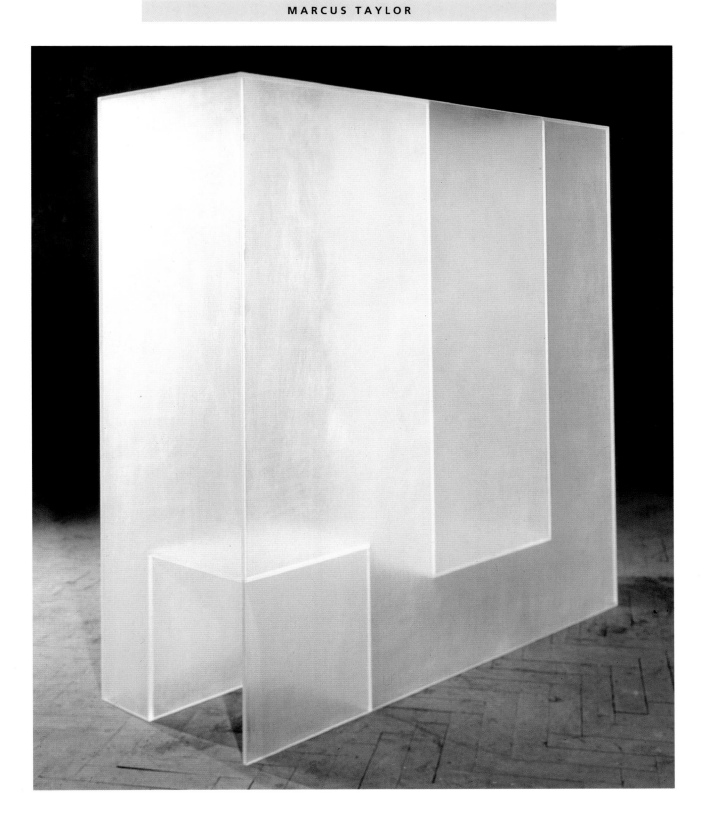

Untitled (Abstract I) 1991 clear acrylic sheet 148 x 148 x 52cm / 58 x 58 x 20½"

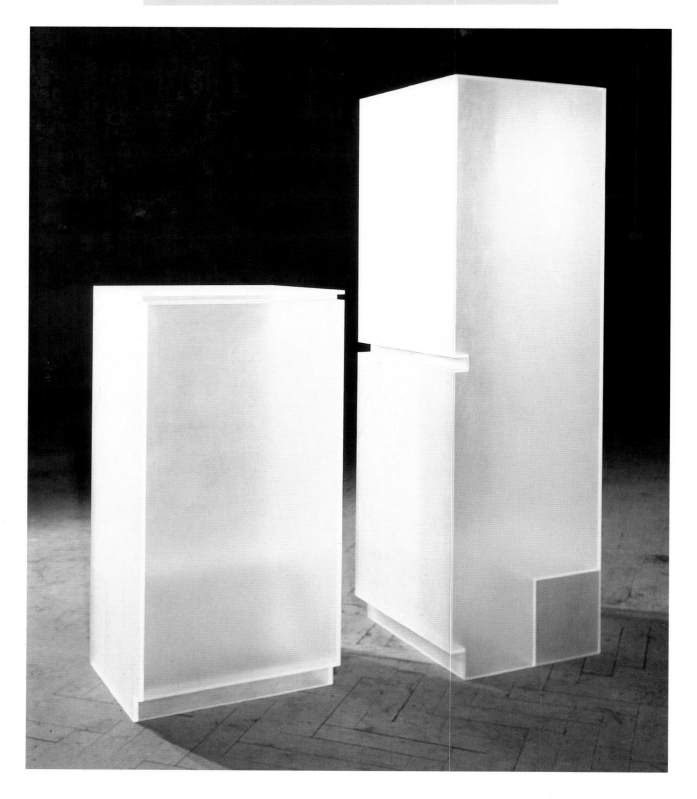

Untitled (Double Fridge) 1991 clear acrylic sheet 152 x 120 x 50cm / 60 x 47 x 20"

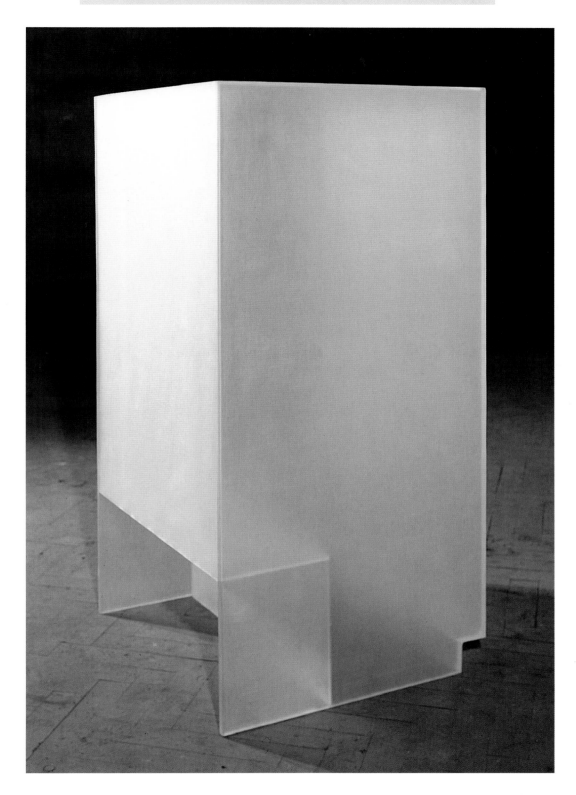

Untitled (Upright Fridge) 1991 clear acrylic sheet 124 x 66 x 61cm / 49 x 26 x 24"

Title 1990 pigment on canvas 183 x 274cm / 72 x 108"

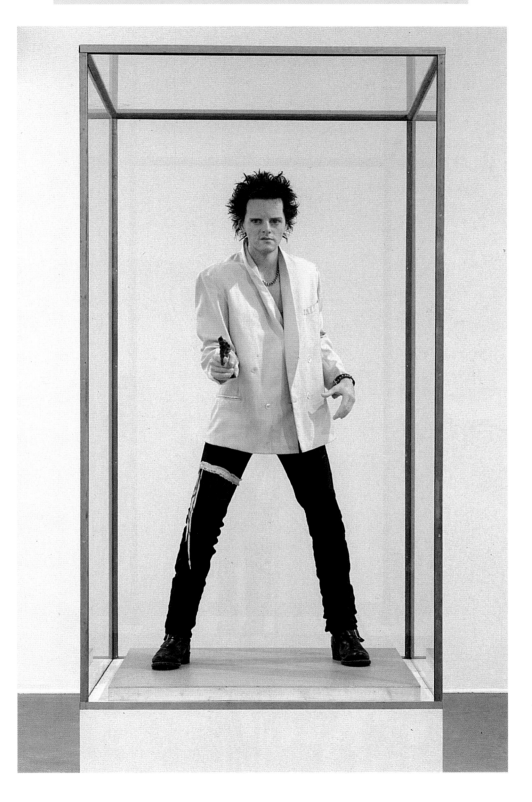

Pop 1993 glass, brass, MDF, fibre glass, wax, clothing and gun 279 x 115 x 115cm / 110 x 45 x 45"

Epiphany May 1992 permane.it marker on surveillance mirror 48cm / 19" diameter

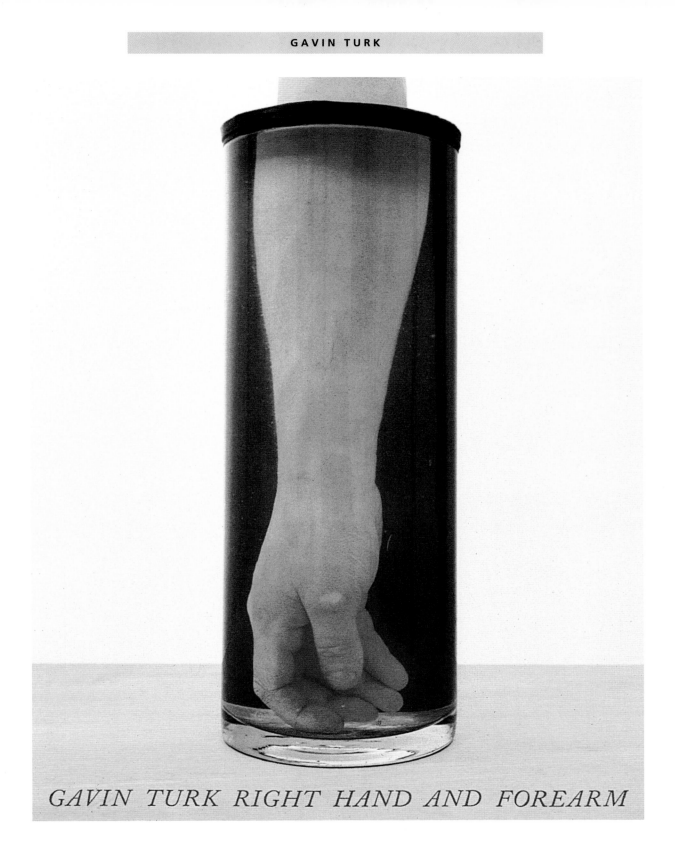

GAVIN TURK RIGHT HAND AND FOREARM

Gavin Turk Right Hand and Forearm 1992 silkscreen on paper 86 x 68cm / 34 x 27"

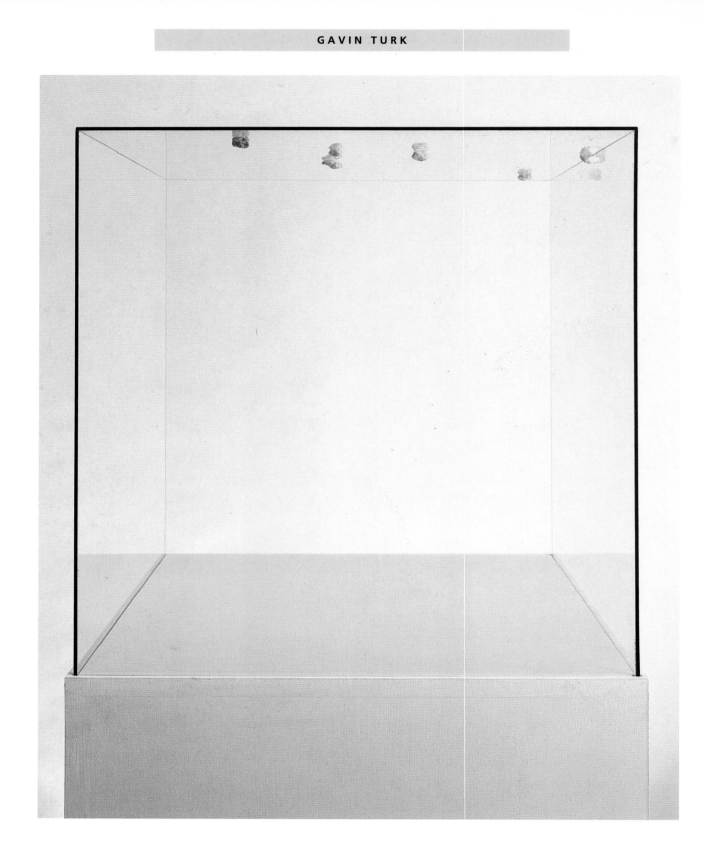

Floater 1993 chewing gum, glass, wood 145 x 40 x 40cm / 57 x 16 x 16"

Capital 1990 oil on canvas 266.5 x 145cm / 105 x 57"

Capital 1990 oil on canvas each 266.5 x 145cm / 105 x 57"

Capital 1990 oil on canvas each 266.5 x 145cm / 105 x 57"

Race, Class, Sex 1992 oil on canvas each 230 x 300cm / 90½ x 118"

Race, Class, Sex 1992 oil on canvas each 230 x 300cm / 90½ x 118"

Olympic Chickens (I) 1993 photograph on aluminium 41 x 51cm / 16 x 20"

Olympic Chickens (II-X) 1993 photographs on aluminium 41 x 51cm / 16 x 20"

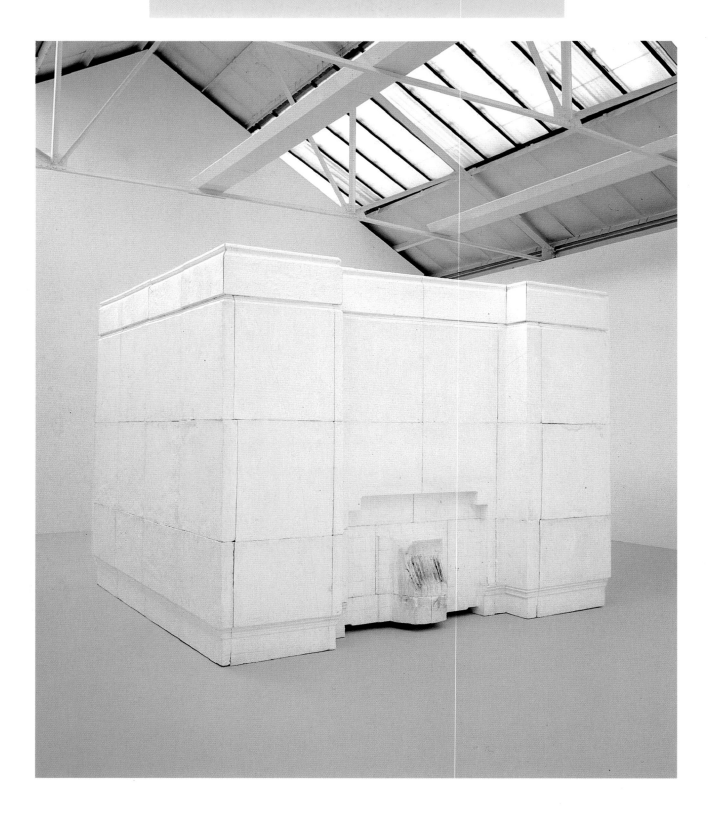

Ghost 1990 plaster on steel frame 269 x 355.5 x 317.5cm / 106 x 140 x 125"

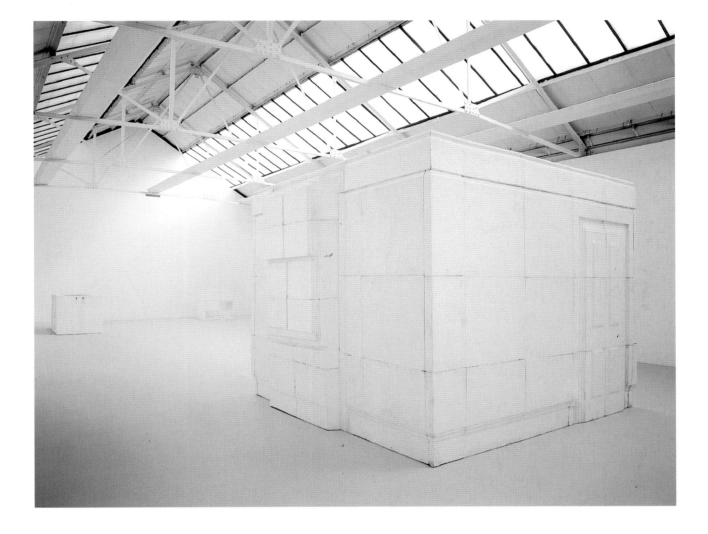

Ghost back view

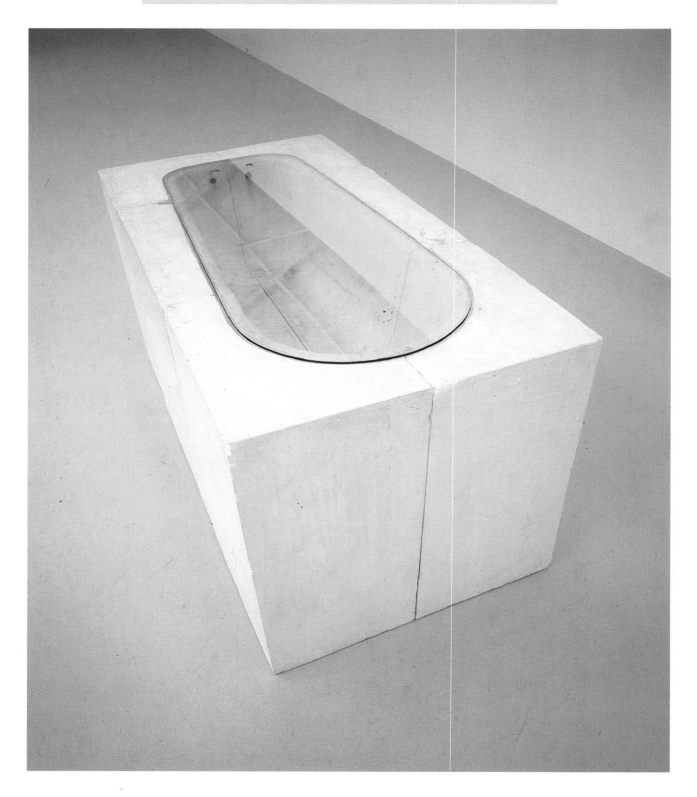

Untitled (Bath) 1990 plaster, glass 103 x 105.5 x 209.5cm / 40½ x 41½ x 82½"

Untitled (Square Sink) 1990 plaster 107 x 101 x 86.5cm / 42 x 40 x 34"

Dancing in the Dark 1993 acrylic on canvas 244 x 366cm / 96 x 144"

Winterwonderland 1993 acrylic on canvas 244 x 366cm / 96 x 144"

Walking 1993 acrylic on canvas 244 x 366cm / 96 x 144"

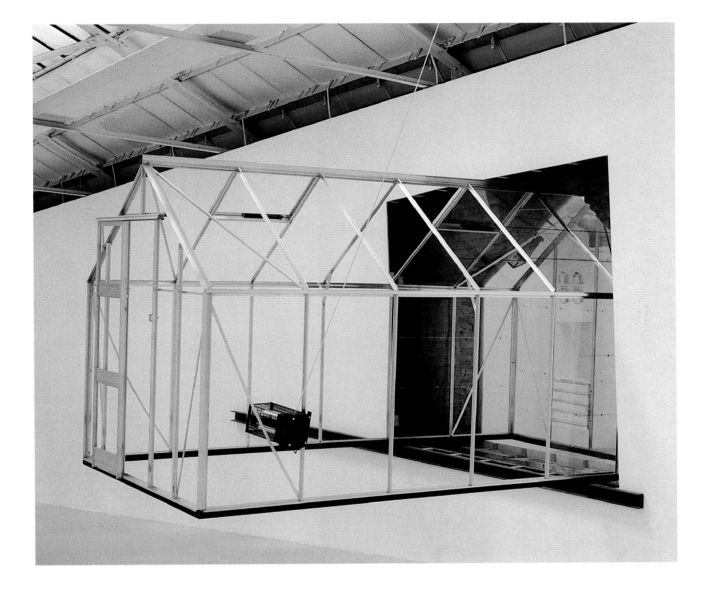

High Rise 1989 glass greenhouse, existing wall, steel beams, 2 insect-o-cutors installation: 244 x 396 x 366cm / 96 x 156 x 144"

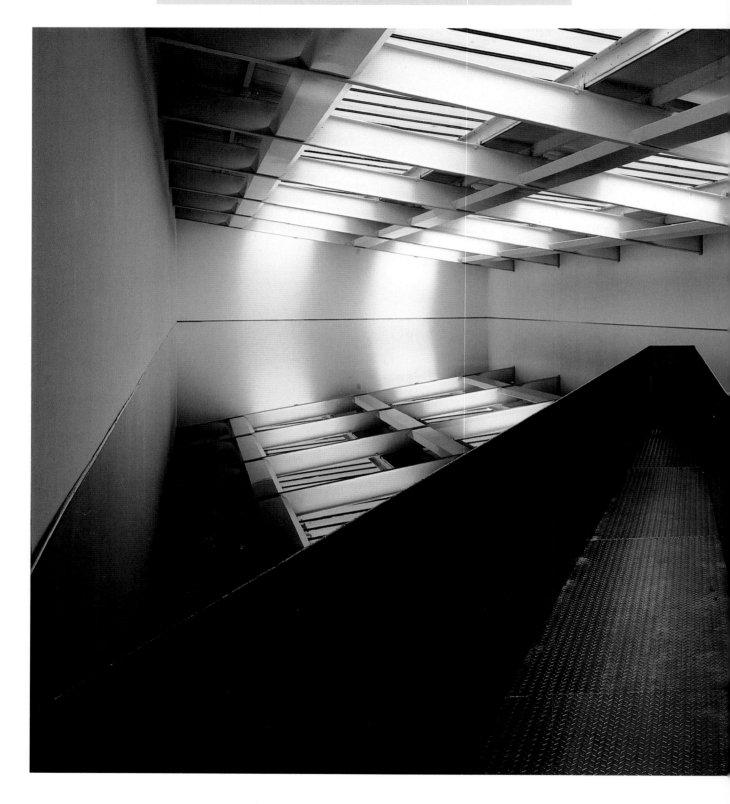

254 **20:50** 1987 used sump oil, steel dimensions variable

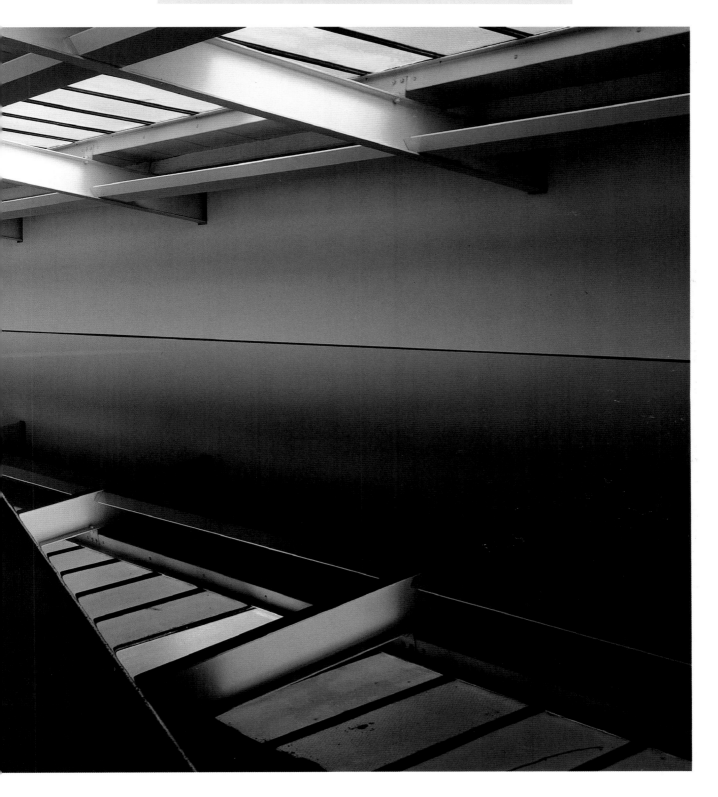

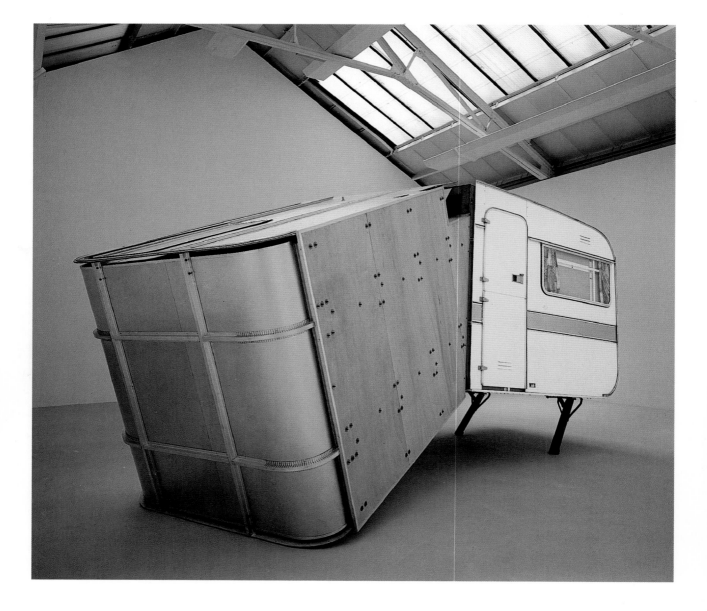

Facelift 1991 wood, steel, aluminium, cloth 274 x 269 x 188cm / 108 x 106 x 74"

GLENN BROWN

Born

Hexham, Northumberland 1966

Education

1984-5 Norwich School of Art (Foundation)

1985-8 Bath Academy of Art (BA Hons Fine Art)

1990-92 Goldsmiths' College (MA)

Lives and works in London

SIMON CALLERY

Born

London 1960

Education

1979-80 Berkshire College of Art and Design (Foundation)

1980-83 Cardiff College of Art
(BA Hons Fine Art Sculpture)

Lives and works in London

ROD DICKINSON

Born

Bournemouth 1965

Education

1985-6 Bournemouth College of Art (Foundation)

1986-9 Kingston Polytechnic (BA Hons Fine Art Painting)

Lives and works in London

KATHARINE DOWSON

Born

London 1962

Education

1984-5 Heatherly School of Art (Foundation)

1985-8 Camberwell School of Arts & Crafts
(BA Hons Fine Art Sculpture)

1989-92 Royal College of Art (MA Sculpture)

Lives and works in London

SIMON ENGLISH

Born

West Berlin 1959

Education

1977-8 Bournemouth College of Art (Foundation)

1978-81 Central School of Art and Design

(BA Hons Fine Art Painting)

Lives and works in London

ROSE FINN-KELCEY

Born

Northampton

Education

Northhampton School of Art (Foundation)

Ravensbourne College of Art (BA Hons Painting)

Chelsea School of Art (MA Painting)

Lives and works in London

JOHN FRANKLAND

Born

Rochdale 1961

Education

1979-80 Rochdale College of Art (Foundation)

1980-83 Goldsmiths' College (BA Hons Fine Art)

Lives and works in London

JOHN GREENWOOD

Born

Leeds 1959

Education

1977-8 York College of Arts & Technology (Foundation)

1978-81 Cheltenham College of Art & Technology

(BA Hons Fine Art)

1988-90 Royal College of Art (MA)

Lives and works in London

ALEX HARTLEY

Born

West Byfleet 1963

Education

1983-4 Camberwell School of Arts & Crafts (Foundation)

1984-7 Camberwell School of Arts & Crafts
(BA Hons Sculpture)

1988-90 Royal College of Art (MA)

Lives and works in London

MARCUS HARVEY

Born

Leeds 1963

Education

1982-6 Goldsmiths' College (BA Hons Fine Art)

Lives and works in London

DAMIEN HIRST

Born

Bristol 1965

Education

1986-9 Goldsmiths' College (BA Hons Fine Art)

Lives and works in London and Berlin

GARY HUME

Born

Kent 1962

Education

1985-6 Liverpool Polytechnic (Foundation)

1986-8 Goldsmiths' College (BA Hons Fine Art)

Lives and works in London

No photograph at artist's request

ALEX LANDRUM

Born

Wallasey, Merseyside 1955

Education

1984-7 Leeds Polytechnic (BA Hons Fine Art)

1987-8 Chelsea School of Art (MA Fine Art Sculpture)

1988 Bursten Award

Chelsea School of Art (MA History of Art)

Lives and works in London

ABIGAIL LANE

Born

Penzance 1967

Education

1985-6 Bristol Polytechnic (Foundation)

1986-9 Goldsmiths' College (BA Hons Fine Art)

Lives and works in London

LANGLANDS & BELL

Born

Ben Langlands London 1955

Nikki Bell London 1959

Education

1977-80 Middlesex Polytechnic (BA Hons Fine Art)

Live and work in London

DAVID LEAPMAN

Born

London 1959

Education

1977-8 St Martin's School of Art (Foundation)

1978-81 Goldsmiths' College (BA Hons Painting)

1988-9 Chelsea School of Art (MA Painting)

Lives and works in London

BRAD LOCHORE

Born

New Zealand 1960

Education

1986-9 Byam Shaw School of Art (Dip Fine Art)

1989-90 Kunst Akademie Dusseldorf, Germany

1990-92 Goldsmiths' College (MA)

Lives and works in London

SARAH LUCAS

Born

London 1962

Education

1982-3 Working Mens' College

1983-4 London College of Printing (BA Hons Fine Art)

1984-7 Goldsmiths' College (MA)

Lives and works in London

STEPHEN MURPHY

Born

London 1962

Education

1984-7 St Martins' School (BA Hons Fine Art Painting)

1990-92 Goldsmiths' College (MA)

Lives and works in London

RENATO NIEMIS

Born

London 1958

Education

1976-9 Imperial College (BSc Hons Physics, ARCs)

1987-8 Harrow College (Foundation)

1988-91 Camberwell School of Arts & Crafts (BA Hons Fine Art)

1991-2 Chelsea School of Art (MA Sculpture)

Lives and works in London

HADRIAN PIGGOTT

Born

Aldershot 1961

Education

1980-83 Exeter University (BSc Geology)

1990-93 Royal College of Art (MA Sculpture/Ceramics)

Lives and works in London

JOANNA PRICE

Born

Campile, Ireland 1956

Education

1975 Sorbonne, Paris (French and Philosophy)

1976-8 University College, London

(Philosophy and Ecomonics)

1979-82 City and Guilds of London Art School (Dip Sculpture)

Lives and works in London

MARC QUINN

Born

London 1964

Education

1982-5 Cambridge University

(BA Hons History & History of Art)

Lives and works in London

FIONA RAE

Born

Hong Kong 1963

Education

1983-4 Croydon College of Art (Foundation)

1984-7 Goldsmiths' College (BA Fine Art)

Lives and works in London

EMMA RUSHTON

Born

Pickering, North Yorkshire 1965

Education

1985-6 York College of Arts and Technology (Foundation)

1986-9 Brighton Polytechnic (BA Hons Sculpture)

1990-92 Royal College of Art (MA Sculpture)

Lives and works in London

JENNY SAVILLE

Born

Cambridge 1970

Education

1988-92 Glasgow School of Art (BA Hons Fine Art)

Lives and works in London

JANE SIMPSON

Born

London 1965

Education

1984-5 Winchester School of Art (Foundation)

1985-8 Chelsea School of Art (BA Hons Fine Art Sculpture)

1990-93 Royal Academy Schools (Postgraduate Certificate)

Lives and works in London

KERRY STEWART

Born

Paisley, Scotland 1965

Education

1985-9 University of Edinburgh

(MA Hons Art History and German)

1989-90 Chelsea School of Art (Foundation)

1990-93 Chelsea School of Art (BA Hons Sculpture)

Lives and works in London

MARCUS TAYLOR

Born

Belfast 1964

Education

1981-2 Ulster Polytechnic (Foundation)

1983-6 Camberwell School of Arts & Crafts (H. Dip. Fine Art)

1986-8 Slade School of Art, London (BA Fine Art)

Lives and works in London

GAVIN TURK

Born

Guildford 1967

Education

1985-6 Kingston Polytechnic (Foundation)

1986-9 Chelsea School of Art (BA Hons Sculpture)

1989-91 Royal College of Art

Lives and works in London

MARK WALLINGER

Born

Chigwell, Essex 1959

Education

1977-8 Loughton College (Foundation)

1978-81 Chelsea School of Art (BA Hons Painting)

1983-5 Goldsmiths' College (MA)

Lives and works in London

CARINA WEIDLE

Born

Novo Hamburgo, Brazil 1966

Education

1985-8 Fine Art School of Parana, Brazil

1989-92 Goldsmiths' College (MA)

Lives and works in London

RACHEL WHITEREAD

Born

London 1963

Education

1982-5 Brighton Polytechnic (BA Hons Sculpture)

1985-7 Slade School of Art (H. Dip. Sculpture)

Lives and works in London

JOHN WILKINS

Born

Colchester 1951

Education

1969-71 Colchester School of Art (Foundation)

1971-4 St Martin's School of Art (BA Hons Painting)

1974-7 Royal College of Art (MA Painting)

Lives and works in London

RICHARD WILSON

Born

London 1953

Education

1970-71 London College of Printing (Foundation)

1971-4 Hornsey College of Art (BA Hons Fine Art)

1974-6 Reading University (MA Fine Art)

Lives and works in London

Portraits by Anthony Oliver

EXHIBITIONS HELD AT THE SAATCHI GALLERY

March - October 1985

Donald Judd, Brice Marden, Cy Twombly, Andy Warhol

December 1985 - July 1986

Carl André, John Chamberlain, Dan Flavin, Sol Lewitt, Robert Ryman, Frank Stella

September 1986 - July 1987

Anselm Kiefer, Richard Serra

September 1987 - January 1988

New York Art Now (Part 1)

Ashley Bickerton, Ross Bleckner, Robert Gober, Peter Halley, Jeff Koons, Tim Rollins & K.O.S, Haim Steinbach, Philip Taaffe, Meyer Vaisman

February - April 1988

New York Art Now (Part 2)

Ashley Bickerton, Carroll Dunham, Robert Gober, Peter Halley, Tishan Hsu, Jon Kessler, Jeff Koons, Allan McCollum, Peter Schuyff, Doug & Mike Stam

April - October 1988

Leon Golub, Philip Guston, Sigmar Polke, Joel Shapiro

November 1988 - April 1989

Jennifer Bartlett, Eric Fischl, Elizabeth Murray, Susan Rothenberg

April - October 1989

Robert Mangold, Bruce Nauman

November 1989 - February 1990

Leon Kossoff, Bill Woodrow

March - November 1990

Frank Auerbach, Lucian Freud, Richard Deacon

January - July 1991

Richard Artschwager, Cindy Sherman, Richard Wilson

September 1991 - February 1992

Mike Bidlo, Manuel Ocampo, Andres Serrano

March - October 1992

Young British Artists I

John Greenwood, Damien Hirst, Alex Landrum,

Langlands & Bell, Rachel Whiteread

October - December 1992

Out of Africa

Contemporary African artists

from the Pigozzi Collection

February - July 1993

Young British Artists II

Rose Finn-Kelcey, Sarah Lucas, Marc Quinn,

Mark Wallinger

September - December 1993

American Art in the 20th Century

presented by The Royal Academy of Arts, London

January - July 1994

Young British Artists III

Simon Callery, Simon English, Jenny Saville

September 1994

A Positive View

a photographic exhibition presented by *Vogue*

November 1994 - February 1995

Paula Rego,

John Murphy, Avis Newman

ACKNOWLEDGEMENTS AND PHOTOGRAPHIC CREDITS

We gratefully acknowledge the kind assistance of the following, who have helped us in putting together this book: Anderson O'Day Gallery, Anna Bornholt Associates, Jibby Beane, Benjamin Rhodes Gallery, Juanita Boxill, BT Contemporaries, Cabinet Gallery, Chisenhale Gallery, Cohen Gallery NY, Laurent Delaye, Hales Gallery, Interim Art, Karsten Schubert Limited, Lisson Gallery, Matt's Gallery, Anthony Reynolds Gallery, Serpentine Gallery, Todd Gallery, Victoria Miro, White Cube Gallery, Glen Scott Wright, Waddington Galleries.

In addition we are grateful to the following for the use of photographs in this book: Anthony Oliver and Keith Cardwell, Andrew Crowley, Prudence Cuming Associates Limited, Hugo Glendinning, Alex Hartley, Andrew Holligan, Langlands & Bell, Stephen Murphy, Renato Niemis, Sue Ormerod, Simon Periton, John Riddy, Richard Thomas, Carina Weidle, Peter White, Stephen White, Gareth Winters, Edward Woodman.